Visions from America

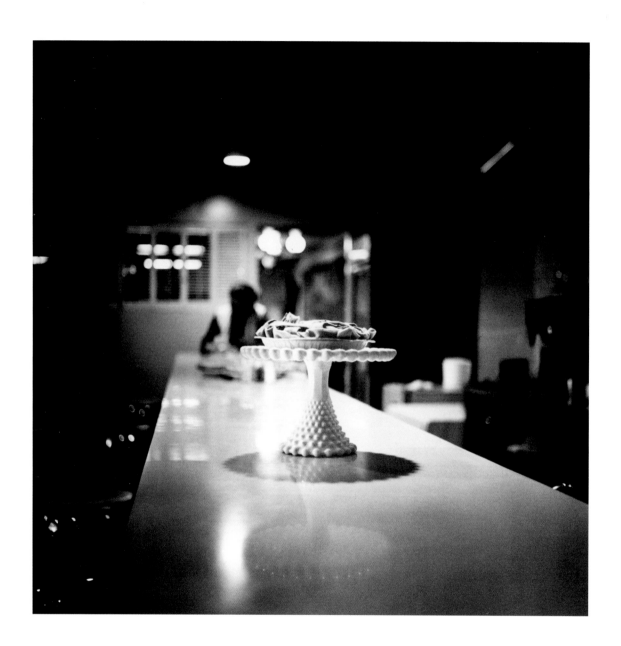

Visions from America
Photographs from the
Whitney Museum of American Art
1940–2001

Sylvia Wolf
With an essay by Andy Grundberg
Preface by Sondra Gilman Gonzalez-Falla

Prestel

Munich • Berlin • London • New York
Whitney Museum of American Art, New York

This book was published on the occasion of the exhibition *Visions from America: Photographs from the Whitney Museum of American Art, 1940–2001*, at the Whitney Museum of American Art, New York, June 27–September 22, 2002.

A portion of the proceeds from the sale of this book benefits the Whitney Museum of American Art and its programs.

Cover & p. 237: Joel Sternfeld, *Wet 'n Wild Aquatic Theme Park, Orlando, Florida, September 1980*, 1980. Chromogenic color print, 17 x 21 1/4 in. (43.2 x 54 cm). Gift of Anne and Joel Ehrenkranz 2000.3. © Joel Sternfeld, courtesy Pace/MacGill Gallery, New York
Frontispiece: Kristin Capp, *Diner, Palacios, Texas*, 1996. Gelatin silver print, 14 1/2 x 14 1/2 in. (36.8 x 36.8 cm). Purchase, with funds from Richard Kirshenbaum 2001.156

Library of Congress Cataloging-in-Publication Data

Whitney Museum of American Art.
 Visions from America : photographs from the Whitney Museum of American Art, 1940–2001 / Sylvia Wolf and Andy Grundberg.
 p. cm.
 Includes index.
 ISBN 3-7913-2787-9
 1. Photography--United States. 2. Photography, Artistic. 3. Whitney Museum of American Art--Photograph collections. 4. Photograph collections--New York (State)--New York. I. Wolf, Sylvia, 1957- II. Grundberg, Andy. III. Title.
 TR6.U62 N499 2002
 779'.0973'0747470--dc21

 2002007114

Prestel books are available worldwide. Visit our website at www.prestel.com or contact one of the following Prestel offices for further information.

Prestel Verlag
Mandlstrasse 26, 80802 Munich
Tel. +49 (89) 38 17 09-0, Fax +49 (89) 38 17 09-35
email: sales@prestel.de

4 Bloomsbury Place, London WC1A 2QA
Tel. +44 (20) 7323-5004, Fax +44 (20) 7636-8004
email: sales@prestel-uk.co.uk

175 Fifth Avenue, New York 10010
Tel. +1 (212) 995-2720, Fax +1 (212) 995-2733
email: sales@prestel-usa.com

Visions from America: Photographs from the Whitney Museum of American Art, 1940–2001 was organized by Sylvia Wolf, Sondra Gilman Curator of Photography; Yukiko Yamagata, senior curatorial assistant in photography; and Carrie Springer, special projects assistant.

This publication was produced by the Publications and New Media Department at the Whitney Museum of American Art:

Director: Garrett White
Editorial: Rachel Wixom, Managing Editor; Thea Hetzner, Assistant Editor; Libby Hruska, Assistant Editor
Design: Makiko Ushiba, Senior Graphic Designer; Christine Knorr, Graphic Designer
Production: Vickie Leung, Production Manager
Rights and Reproductions: Anita Duquette, Manager, Rights and Reproductions; Jennifer Belt, Photographs and Permissions Coordinator; Dante Ruzinok, Intern
Assistant: Carolyn Ramo

Text editor: David E. Brown
Proofreader: Libby Hruska
Catalogue design: Christine Knorr
Printing: Meridian Printing, East Greenwich, Rhode Island

Printed and bound in the United States

Contents

Foreword

Visions from America highlights the primary concerns of American artists since the Second World War, from the New York School to the advent of digital photography. The Whitney Museum of American Art began an ongoing commitment to photography ten years ago, in 1992, with the first meeting of the Photography Collection Committee formed a year earlier. Under the leadership of my predecessor, David A. Ross, Sondra Gilman Gonzalez-Falla became the founding chair of that committee and led the Whitney to stake out a position advocating new American photographic art while also collecting retrospectively. This approach, which is consonant with the Whitney's mission as a whole, has led to the creation of an outstanding photography collection in a very short time. Mrs. Gilman Gonzalez-Falla is among those patrons who reshape an institution, and we are most grateful for her vision and tenacity.

This publication celebrates our first decade of active collecting, and includes more than 160 works made between 1940 and 2001. The work of the 158 artists represented here forms part of a collection numbering some two thousand photographs. Numerous gifts are part of this selection, alongside purchases made by the members of our Photography Collection Committee, which has enjoyed the able stewardship of Steven Ames since 1999. The gifts attest to the Whitney's important role as an advocate of American art and artists, and the recognition of that role by so many generous patrons. Artists, collectors, foundations, and members of the trade have parted with many treasures, and we warmly thank them all.

The Whitney's collection of photography has concentrated on emerging talent. Our first full-time incumbent in the position of Sondra Gilman Curator of Photography is Sylvia Wolf. Since joining the Whitney in 1999, Wolf has been a formidable champion of the creativity of this nation's artists and a

thoughtful guide to our twentieth-century past. In conceiving the present exhibition and publication, Wolf has given us a lasting testament to what a decade of generosity and imagination can produce, and has challenged us to build on it forcefully in the decades to come.

Maxwell L. Anderson
Alice Pratt Brown Director

Preface

I fell in love with photography two decades ago, when I first saw the work of Eugene Atget. It was an epiphany: I had never seen a photograph that had not been taken by somebody's father, grandfather, mother, uncle, or aunt. I bought three Atgets and have not stopped acquiring photographs since.

Time passed and I became involved with the Whitney, which I felt was at the center of the most exciting American art of the time. In 1991, at a Board of Trustees retreat, the idea of creating a photography acquisition committee arose and was enthusiastically embraced by our Trustees and by David Ross and Leonard Lauder, the Museum's director and president, respectively, at the time. The stars must have been in the right alignment, for I was asked to take on the joyous task of leading the Photography Collection Committee. A wonderful journey began. News immediately spread through the photography world that the Whitney was not only showing photography, but establishing a permanent collection as well. Photographers, dealers, and collectors responded with excitement and unprecedented generosity.

A dedicated Committee, together with the Museum's curators, happily participated in selecting works for purchase. To create order, curatorial voices were channeled through Elisabeth Sussman and Adam Weinberg. With gifts and purchases a diverse collection was formed; as the years passed, the Committee grew, the collection grew, and the photography world grew. We knew the Museum needed a space dedicated to photographic exhibitions, as well as a single expert to take on all curatorial responsibilities. I was delighted when Max Anderson, the Whitney's Alice Pratt Brown Director, appointed Sylvia Wolf to this challenging position. Three years ago I passed my baton on to Steve Ames, who continued to build on the accomplishments of the Committee's first years.

In little more than a decade, the Whitney's photography collection has not only realized but exceeded my greatest dreams. My thanks go to the members of our Committee, our curators, our directors, our staff, and the entire photography community. All of them made possible this collection, and now this exhibition and book.

Sondra Gilman Gonzalez-Falla

Acknowledgments

This book would not have been possible without the support and dedication of several members of the Whitney Museum staff. Maxwell L. Anderson, Alice Pratt Brown Director, deserves a special debt of gratitude for providing this opportunity to celebrate a decade of collecting photography at the Whitney. Sincere thanks go to all those who work with the collection every day, in particular four individuals who made objects available for this project: Suzanne Quigley, head registrar; Barbi Spieler, senior registrar; Joshua Rosenblatt, head preparator; and Kelley Loftus, assistant paper preparator. Christy Putnam, associate director for exhibitions and collections management, provided crucial support from the start of the project. Garrett White, director of the Whitney's Department of Publications and New Media, was instrumental in realizing this book in the face of a dauntingly tight schedule. Anita Duquette, manager of rights and reproductions, oversaw the visual documentation of the works for this publication while also lending to the project her extensive knowledge of the Whitney's history and her unflagging good humor. Jennifer Belt, photographs and permissions coordinator, faithfully secured rights for reproductions. Christine Knorr created the artful design of the book, and oversaw its production. David E. Brown edited the texts with insight and precision, and Libby Hruska proofread the book with great care. Works from the collection were skillfully photographed by Matt Flynn and expertly carried to the printed page by Daniel Frank and the gifted staff at Meridian Printing. The book is made available to an international audience thanks to Jürgen Tesch at Prestel Verlag.

I am particularly grateful to Andy Grundberg for bringing his extensive knowledge of photography's interaction with art in the postwar era to the task of placing the Whitney's photography collection in historical context. Heartfelt

11

thanks go to Sondra Gilman Gonzalez-Falla for outlining photography's emerging presence at the Whitney in her preface. I am also indebted to Adam Weinberg for reading an early draft of the introduction. I have relied heavily on the skill and dedication of Tami Thompson, curatorial intern. Yukiko Yamagata, senior curatorial assistant in photography, provided the broad-ranging support that is the bedrock of all photography program activities. I am grateful to the dealers, historians, artists, and colleagues at sister institutions who aided in our research, and I offer my enduring appreciation for their assistance. Carrie Springer, special projects assistant, managed with grace and intelligence the seemingly insurmountable task of compiling and confirming all information related to this project. Her dedication made the book possible.

In addition to those who are actively at work on the collection today, this publication celebrates the efforts of numerous individuals who have long demonstrated a devotion to photography and to contemporary American art. Every member of the Photography Collection Committee, past and present, has made a distinct contribution to the collection under the successive leadership of Mrs. Gilman Gonzalez-Falla and Steven Ames. The Whitney's photography collection reflects the eye and intelligence of several former Whitney curators, in particular May Castleberry, Thelma Golden, John G. Hanhardt, Lisa Phillips, Elisabeth Sussman, and Adam Weinberg. Countless collectors, artists, foundations, estates, and dealers have shown extraordinary good will to the Whitney through their gifts to the permanent collection. In addition to those credited in this book's list of illustrations, we add our sincere thanks to all patrons of the Whitney's photography program.

There would be no photography program at all if not for the vision and determination of Mrs. Gilman Gonzalez-Falla. Her formation of a collecting initiative for photographs at the Whitney, her dedication to an exhibition space, and her commitment to the preservation of photographic works in the collection make her the true guardian angel of photography at this institution. Those efforts, and the efforts of all who share her passion for photography at the Whitney, are reflected on every page of this publication.

Sylvia Wolf
Sondra Gilman Curator of Photography

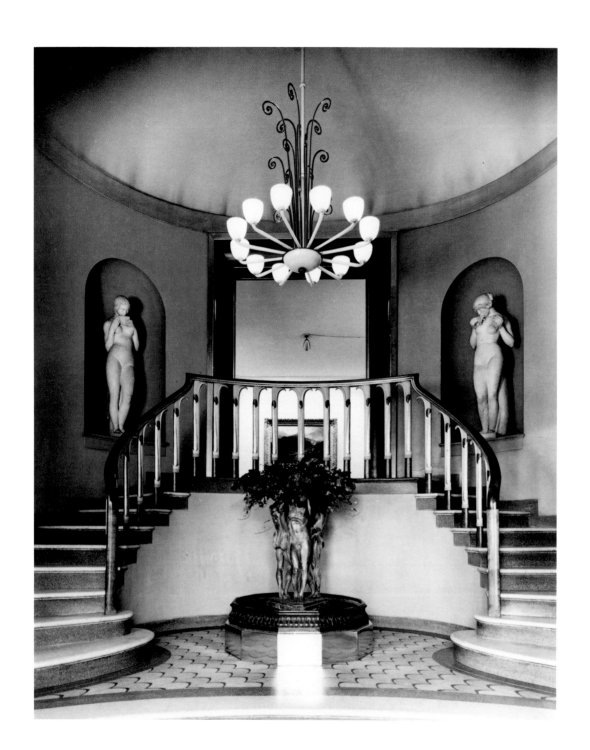

Introduction

Sylvia Wolf

When the Whitney Museum of American Art opened its doors on November 16, 1931, its founder, Gertrude Vanderbilt Whitney, had already devoted more than twenty-three years to the promotion, presentation, and collection of American art. At the organizations that preceded the Museum—the Whitney Studio, the Whitney Studio Club, and the Whitney Studio Galleries—she mounted some ninety exhibitions representing hundreds of artists. She also actively bought art by living American artists, a practice that was uncommon at a time when collectors still looked to the Continent for artistic excellence. At the core of Mrs. Whitney's thinking, and of the mission of the museum she would form, was a passionate advocacy for American art, matched with a willingness to take risks and a desire to foster a vibrant community of contemporary artists. The result of her advocacy, some seven hundred works of art from her personal collection, became the cornerstone of the Whitney Museum of American Art.

Today, the Museum's holdings include nearly fourteen thousand objects, among them some two thousand works of photographic art. Photography has been featured in the Whitney's exhibition program for more than thirty years, through single-artist retrospectives, thematic exhibitions, and in the Whitney Biennial. In 1991, the Museum expanded its commitment to photography by initiating an effort to build a collection of twentieth- and twenty-first century American photographs. Little more than ten years later, the Museum's holdings in photography reveal a broad diversity of artistic vision. Among the collection's strengths are pictures that chronicle human behavior—street photographs, for instance, or images that challenge social stereotypes. Another area of concentration is photography's interaction with contemporary artistic

practice in all disciplines. Rather than treat photography as an autonomous art with its own pictorial language, the Whitney has consistently engaged with photography as a medium used by artists who approach it as one of several means of artistic expression. This engagement can be traced to the early part of the century, to the days before the Museum was founded.

The roster of exhibitions during Mrs. Whitney's early years of activity, from 1907 to 1930, confirms that painting and sculpture were her principal areas of focus.[1] But photographs did not escape her attention. Works by Baron Adolf de Meyer, Arnold Genthe, Gertrude Kasebier, Edward Steichen, Alfred Stieglitz, and Clarence White were included in the second of three exhibitions on portraiture, titled *To Whom Shall I Go for My Portrait*, shown at the Whitney Studio in 1917. Mrs. Whitney owned photographs herself, and in February 1920, she mounted a show of portraits of American Indians by Edward S. Curtis from her personal collection. While painters made up most of the artists in Mrs. Whitney's circle, photographers, too, were in her midst. Charles Sheeler, along with fellow painters and photographers Conrad Cramer and Yasuo Kuniyoshi, was among the charter members of the Whitney Studio Club. As part of his career as a commercial photographer, Sheeler photographed the Whitney Studio Club (fig. 3) and also worked on assignment for *The Arts*, a popular journal supported by Mrs. Whitney. In 1924, he exhibited his own photographs and paintings in an exhibition at the Whitney Studio Club.

When the Whitney Museum of American Art was founded in January 1930, New York venues for exhibiting photographs included Alfred Stieglitz's An American Place (1929–46), which mounted two exhibitions of the founder's photographs as well as shows of Ansel Adams's and Eliot Porter's work. Photographs by Edward Weston and László Moholy-Nagy could be seen at the Delphic Studios (1929–33), and the Levy Gallery (1931–49) opened its doors only weeks before the Whitney. Founded by Julien Levy, who would become the principal American champion of European avant-garde photography, the Levy Gallery was inaugurated in early November 1931 with a retrospective exhibition of American photographs organized in cooperation with Alfred Stieglitz.[2] In the New York museum sector, photographic activity was on the rise. In 1929, eight of the twenty-two newly acquired photographs by Stieglitz were exhibited in the recent accession room of The Metropolitan Museum of Art. Three years later, The Museum of Modern Art presented its first exhibition

of photographs, a display of commissioned works organized by Lincoln Kirstein, titled *Murals by American Painters and Photographers*. In 1937, Beaumont Newhall organized MoMA's seminal exhibition *A History of Photography*; the accompanying catalogue would become the standard history of the medium for decades. And in 1940, MoMA founded the nation's first curatorial department in photography under Newhall's auspices.[3] Other museums that exhibited and collected photographs around this time included The Art Institute of Chicago, the Museum of Fine Arts, Houston, and the San Francisco Museum of Modern Art.

Mrs. Whitney's early efforts to include photographs in her exhibitions notwithstanding, the medium lay dormant in the Museum's programming until 1969, when a retrospective exhibition of the art of Charles Sheeler was mounted. The exhibition, organized by the National Collection of Fine Arts, Smithsonian Institution, contained 170 works, among them thirty-five photographs, including still lifes, cityscapes, and images from Sheeler's now famous assignment to photograph Ford Motor Company's River Rouge Plant.[4] That same year, the Whitney organized *Human Concern/Personal Torment: The Grotesque in American Art*, an exhibition containing work by eighty-seven artists, including photographers Frederick Sommer, Jerry N. Uelsmann, and Diane Arbus. These two exhibitions set the tone for the Whitney's treatment of photography in the years to come—as part of the creative thinking of artists using multiple media, and as a thematic investigation into the world in which we live.

Fig. 1 (p. 14) Berenice Abbott, *Foyer of the Whitney Museum at 8th Street*, 1938. Gelatin silver print, 9 5/8 x 7 5/8 in. (24.4 x 19.4 cm). Purchase, with funds from Joanne Leonhardt Cassullo and The Dorothea L. Leonhardt Fund at The Communities Foundation of Texas, Inc. 99.4

Fig. 2 (left) Edward Steichen, *Gertrude Vanderbilt Whitney*, 1937. Gelatin silver print, 16 5/8 x 13 7/16 in. (42.2 x 34.1 cm). Gift of the family of Edith and Lloyd Goodrich 89.7

Fig. 3
Charles Sheeler, *Office Interior, Whitney Studio Club, 10 West 8th Street*, c. 1928. Gelatin silver print, 7 1/2 x 9 3/8 in. (19.1 x 23.8 cm). Gift of Gertrude Vanderbilt Whitney 93.24.1

In the 1970s, photography was treated in a similar fashion. A retrospective exhibition of the art of Thomas Eakins, for example, displayed photographic portraits and figure studies along with Eakins's paintings, watercolors, and drawings. A 1973 exhibition of work by sculptor and video artist Bruce Nauman featured photographs made in conjunction with the artist's performances, including the first photographs acquired by the Whitney—eleven color images that make up Nauman's *Untitled* (1966–67). Also in 1973, an exhibition of more than 375 paintings, drawings, posters, and sculptures by Lucas Samaras included his first photographic piece, *Autophotographs* (1971), which was composed of 405 Polaroid self-portraits.

The Whitney's interest in photography as part of artistic practice did not preclude an appreciation of the medium for its expression of humanist values. In 1972, two exhibitions of documentary photographs were shown—one of images made throughout the world by *Life* magazine photographer David

Douglas Duncan, the second an exhibition that documented the internment of Japanese Americans during the Second World War in photographs by Ansel Adams, Dorothea Lange, Russell Lee, and others.[5] The decade also saw two large surveys of the medium's history. *Photography in America*, a 1974 show organized by Whitney curator Robert Doty, was a historical exhibition of work by eighty-six photographers. Five years later, David Travis, curator of photography at The Art Institute of Chicago, was invited to examine American photography at the beginning of the century as part of a series of exhibitions celebrating the Whitney's fiftieth anniversary. Titled *Photography Rediscovered: American Photographs, 1900–1930*, the show drew from corporate, private, and institutional collections nationwide.[6] In his preface to the exhibition catalogue, Whitney director Tom Armstrong wrote, "We hope that the exploratory nature of this survey exhibition foretells a new dimension of more photography in our exhibition activities."[7]

The future indeed brought an increase in the number of photographs included in Whitney exhibitions, starting with the Whitney's biannual exhibitions of contemporary art. Although the Whitney Biennial now regularly contains photographs, this was not always the case. From the *First Biennial Exhibition of American Painting* in 1934 until 1973, when the show's name was changed to *1973 Biennial Exhibition of Contemporary American Art* to reflect a wider focus, painting dominated the roster. Photography made its first Biennial appearance in the 1977 show, with photographic narratives by John Baldessari, industrial landscapes by Lewis Baltz, a photographic diptych by Robert Cumming, and picture sequences by Duane Michals. The selection of these four artists gives evidence of the Museum's early interest in photographs that were generated by ideas about photographic representation, rather than in photographs that documented the world at large.

The 1981 Biennial contained a much broader and more inclusive representation of photographs, with works by twenty photographers out of 114 participants—a ratio of nearly 18 percent, among the highest of any Biennial to date. On view were portraits, landscapes, still lifes, and scenes staged to be photographed by Robert Adams, Harry Callahan, Jo Ann Callis, Robert Cumming, Jan Groover, Robert Mapplethorpe, and William Wegman, among others. In addition to photography's presence in Whitney Biennials, retrospective exhibitions organized by the Museum brought the career achievements

of photographic artists to Whitney audiences, among them Cindy Sherman (1987); Robert Mapplethorpe (1988); Richard Prince (1992); Richard Avedon (1994); Nan Goldin (1996); Edward Steichen (2000); and Michal Rovner (2002).[8] Thematic exhibitions addressed specific aspects of photography's history, such as *Perpetual Mirage: Photographic Narratives of the Desert West* (1996), while exhibitions that presented art from multiple disciplines in a social and cultural context often had strong photographic components, for example *Black Male: Representations of Masculinity in Contemporary American Art* (1994–95; fig. 4) and the two-part exhibition *The American Century: Art and Culture, 1900–2000* (1999–2000). In addition, photography exhibitions were organized by students in the Whitney's Independent Study Program. Many of these were displayed at the Whitney's branch museums or through its international touring exhibitions program.[9]

While a museum's exhibition history gives a visible indication of its attitude toward the art and ideas of its time, the permanent collection provides the most lasting evidence of an institution's contribution to the field. Following the Whitney's first purchase of photographs in 1970, additional photographic works were added to the collection over the next two decades. Notable acquisitions from this era include Lucas Samaras's *Skull & Milky Way* (1966; p. 77) and John Baldessari's *Ashputtle* (1982; fig. 5). In 1991, Whitney Trustee and longtime photography collector Sondra Gilman Gonzalez-Falla led an initiative, with support from then director David A. Ross, to form a committee devoted solely to the purchase of photographs. At the time the Photography Collection Committee was founded, the Museum owned fewer than fifty photographic works. Since the first meeting of the Committee in 1992, the photography collection has grown to more than two thousand objects. Mrs. Gilman Gonzalez-Falla served as Committee Chair from 1991 to 1999, when she passed responsibility on to Steven Ames.

Photographs are considered for acquisition by the Photography Collection Committee on the recommendation of Whitney curators; between 1991 and 1998, they included May Castleberry, Thelma Golden, John G. Hanhardt, Lisa Phillips, Elisabeth Sussman, and Adam D. Weinberg. In 1998, when Maxwell L. Anderson became the seventh director of the Whitney, the Museum's curatorial structure was reorganized from a centralized system to medium- and period-based departments. With this shift, a curatorial depart-

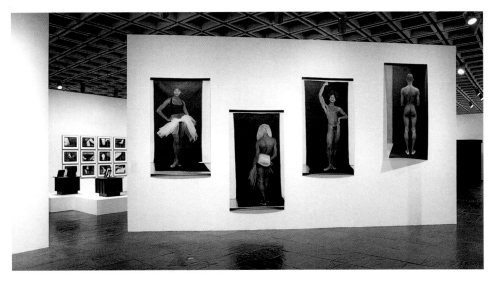

Fig. 4
Installation view
of *Black Male:
Representations
of Masculinity in
Contemporary
American Art*
(November 10,
1994–March 5,
1995). Near wall:
Lyle Ashton Harris,
Constructs, 1989

ment dedicated to photography was established. That year, Mrs. Gilman Gonzalez-Falla endowed the position of curator of photography, which the author assumed in 1999.

The mission of the Whitney in all disciplines is to collect the finest examples of American art from the twentieth and twenty-first centuries. In keeping with Gertrude Vanderbilt Whitney's own willingness to take risks on new talent, the photography collection includes work by young artists who are in the early stages of their careers. It also recognizes senior photographers who have inspired younger generations. In recent years, the definition of what qualifies as American art has expanded to encompass art made by any artist living and working in the United States, regardless of their birthplace. Consequently, the Whitney celebrates, exhibits, and collects works by artists who maintain a primary residence in the United States; among those in the photography collection are Adam Fuss, Vera Lutter, and Vik Muniz.

In addition to collecting single works by a range of artists, the Museum is building concentrations of photographs by individual practitioners as well as groups of images that address specific issues or eras. Among the artists the Museum has collected in depth are Lewis Baltz, Larry Fink, Ralph Gibson, and James Welling. Current concentrations in the photography collection

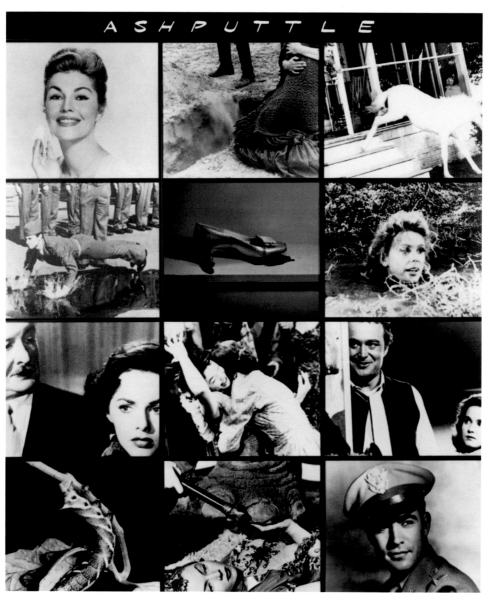

Fig. 5
John Baldessari,
Ashputtle, 1982
(original in color).
Eleven gelatin
silver prints, one
silver dye bleach
print (Cibachrome),
one text panel,
84 x 72 in. (213.4 x
182.9 cm) overall.
Purchase, with
funds from the
Painting and
Sculpture
Committee
83.8a–m

include black-and-white images of city life taken by photographers working in New York from the 1940s through the 1960s. Often referred to as the New York School, this loosely defined collection of photographers includes Diane Arbus, Louis Faurer, Sid Grossman, William Klein, Saul Leiter, Leon Levinstein, Helen Levitt, and Lisette Model. Another area of focus encompasses work by artists who are fluent in media other than photography, for instance Matthew Barney, Mel Bochner, Dennis Oppenheim, and Kiki Smith. In addition, the Whitney is committed to collecting, in depth, works by selected artists across media boundaries, including Chuck Close, Roni Horn, Lucas Samaras, and Lorna Simpson. Photographers who challenge social and sexual stereotypes or provide personal views of their intimate communities are also represented, among them Nan Goldin, Peter Hujar, Mark Morrisroe, and Catherine Opie. Contemporary innovators Craig Kalpakjian and Iñigo Manglano-Ovalle, who draw on photographic sensibilities to probe the boundaries of new imaging technologies, are recent additions to the collection.

The Photography Collection Committee's purchasing activity focuses primarily on the art of the present, and yet the story of contemporary photography cannot be told without an understanding of the past. Significant examples of the work of American masters are needed to provide a historical context for the study and appreciation of today's photographic art. The Whitney made a commitment to collecting photographs late in the century, at a time when interest in the medium and its history was reaching unprecedented levels. This afforded the Museum a broad base of patrons and viewers, but it also entailed negotiating a marketplace of escalating prices and diminished availability of quality vintage photographs. A number of gifts made by artists, dealers, estates, and collectors have allowed the Museum to gradually build its holdings of works from the early and middle decades of the century. Among the significant bodies of work the Whitney has acquired through gifts in the past decade are photographs by Ilse Bing (fig. 6), Harold Edgerton, Andreas Feininger, Ralph Eugene Meatyard, and Weegee.

With the commitment to build a collection of photographs comes an obligation to exhibit them, to study them against the backdrop of other works of art, and to preserve them for future audiences. In 1998, the fifth floor of the Whitney's Marcel Breuer building was renovated and galleries were built in order to place selections from the Museum's permanent collection on view.

At that time, Sondra Gilman Gonzalez-Falla further promoted the Whitney's photography program by supporting the designation of a gallery devoted exclusively to the display of photographs. Today, the Sondra Gilman Gallery presents three to four exhibitions each year, ranging from photography collection highlights, as in the inaugural exhibition of April 1998 (fig. 7), to new bodies of work by individual artists, including Roni Horn and Vik Muniz (2000). Also featured are contemporary reflections on historically significant photographs, as in Susan Meiselas's 1970s images of carnival strippers (1999), and current work by American masters, such as recent nudes by Irving Penn (2001–02). The gallery is also a place to see work by emerging artists. In 2001, the *First Exposure* series of exhibitions was launched; it offers the first solo museum showing of photographic work by a young artist. All Whitney photography exhibitions enhance the growth of the collection. In three years' time, more than fifty works by artists exhibited in the Sondra Gilman Gallery have been added to the collection through purchase or gift.

Apart from acquiring and exhibiting works in its permanent collection, a museum's mandate is to preserve those objects under its care. In 2001, the Whitney formed a conservation department and appointed as its director Carol Mancusi-Ungaro, former director of conservation at the De Menil Collection. Over the next five years, the Whitney will broaden its commitment to the care, preservation, and technical research of the permanent collection. Plans are already underway, with grant support from the National Endowment for the Humanities and the Institute of Museum and Library Sciences, to build cold storage for the Whitney's collections of photography, video, and film. By providing state-of-the-art storage facilities, the Museum will ensure that the photographs in its permanent collection will have a long life and will remain in the condition the artists intended at the time of their making.

At its founding in 1930, the mission of the Whitney was twofold: to collect the art of "contemporary liberal artists [who] have had difficulties 'crashing the gate,'" and to create a "depot where the public may see fine examples of America's artistic production."[10] On the one hand, this mission calls for taking risks; on the other, it requires solidifying the base from which those risks may be measured. It calls for making leaps of faith, while applying rigor and connoisseurship. In the past decade, the Whitney's efforts in collecting photo-

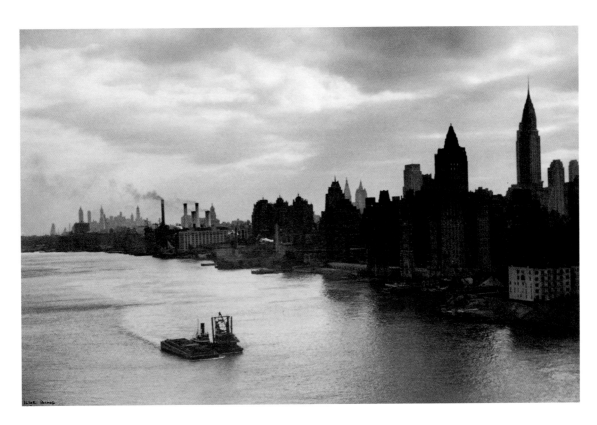

Fig. 6
Ilse Bing, *East River
with Boat, New York*,
1936. Gelatin silver
print, 13 7/8 x 16 in.
(35.2 x 40.6 cm).
Bequest of Ilse Bing
Wolff 2001.376

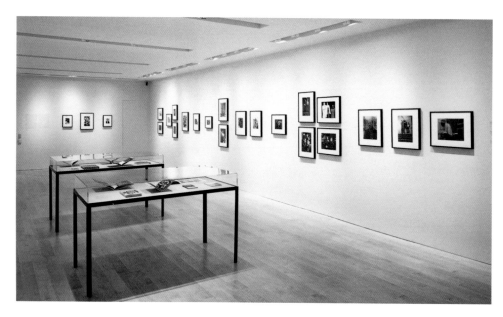

Fig. 7
Installation view
of permanent
collection works
in the inaugural
exhibition of the
Sondra Gilman
Gallery, April
1998

graphy have been consistent with this mission. Today, the photography collection reflects the wisdom, courage, and dedication of those who formed it. Each member of the Photography Collection Committee, every artist, dealer, or collector who has given a work of photographic art to the Museum, and all the Whitney curators who have added photographs to the collection have contributed to its character and complexity. After ten years of active collecting, this publication and the exhibition it accompanies offer an opportunity to review and appreciate what has been acquired to date, and by extension, to identify areas in need of expansion. In responding to those needs, the purpose is not to arrive at a collection that is a fixed and comprehensive whole. On the contrary, it is to foster the growth of the collection as a vital organism, which is shaped by the climate of the times and the work of the artists themselves. The challenge, of course, lies in assessing art as it is being made. But therein also lies the thrill. With contemporary art, it is not the destination that is the goal, but the journey that is the source of enlightenment.

Notes

1. On the general history of the Museum, see Avis Berman, *Rebels on Eighth Street: Juliana Force and the Whitney Museum of American Art* (New York: Atheneum, 1990); Flora Miller Biddle, *The Whitney Women and the Museum They Made: A Family Memoir* (New York: Arcade Publishing, Inc., 1999); and Beth Venn and Adam D. Weinberg, *Frames of Reference: Looking at American Art, 1900–1950. Works from the Whitney Museum of American Art* (New York: Whitney Museum of American Art; Berkeley: University of California Press, 1999).

2. For activity at the Levy Gallery, see Ingrid Schaffner and Lisa Jacobs, eds., *Julien Levy: Portrait of an Art Gallery* (Cambridge: The MIT Press, 1998) and David Travis, *Photographs from the Julien Levy Collection: Starting with Atget* (Chicago: The Art Institute of Chicago, 1976).

3. For an outline of photography's presence at The Museum of Modern Art, see Peter Galassi, *American Photography 1890–1965 from The Museum of Modern Art, New York* (New York: The Museum of Modern Art, 1995).

4. Unless otherwise noted in the text or in a footnote, all exhibitions cited in this introduction were organized by the Whitney Museum of American Art.

5. *Executive Order 9066: The Internment of 110,000 Japanese Americans* was organized by the California Historical Society.

6. This exhibition was later shown at The Art Institute of Chicago.

7. David Travis, *Photography Rediscovered: American Photographs, 1900–1930* (New York: Whitney Museum of American Art, 1979), p. 8.

8. Four of these artists were exhibited at the Museum in a Biennial early in their careers: Nan Goldin (1985), Robert Mapplethorpe (1981), Richard Prince (1985), and Cindy Sherman (1983).

9. The Whitney was the venue for several important traveling exhibitions, including *Paul Strand: An American Vision* (1992) and *Robert Frank: Moving Out* (1995), both organized by the National Gallery of Art, Washington, D.C.; *Barbara Kruger* (2000), organized by the Los Angeles Museum of Contemporary Art; and *Kenneth Josephson: A Retrospective* (2001), organized by The Art Institute of Chicago.

10. Berman, *Rebels on Eighth Street*, pp. 278, 280.

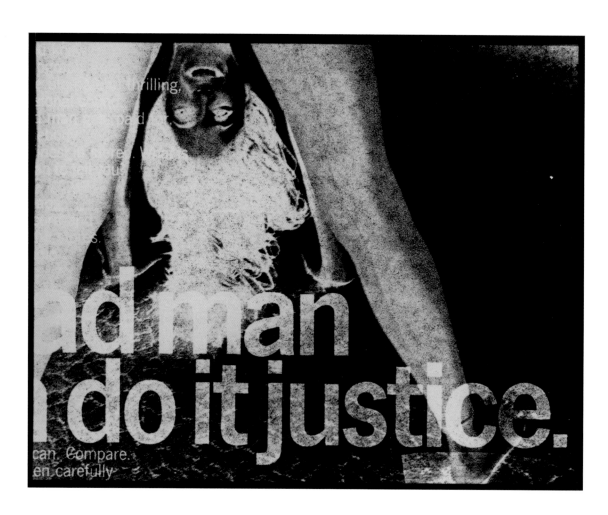

thrilling

ad

ad man
do it justice.

can. Compare.
en carefully

Fig. 1
Robert Heinecken,
Untitled, from *Are
You Rea*, 1966–68.
Gelatin silver print,
6 1/16 x 7 3/4 in.
(15.4 x 19.7 cm).
Gift of the artist
and Pace/MacGill
Gallery 93.54

A Medium No More (Or Less): Photography and the Transformation of Contemporary Art

Andy Grundberg

During the final fifty years of the century just past, contemporary art changed in so many crucial respects that if a reviewer had been cryogenically frozen in 1950 only to be thawed out in the year 2000, he or she would find most of the art we now enjoy to be incomprehensible. But one fact would be readily apparent to even the most discombobulated critic: where once contemporary art was synonymous with painting and sculpture, it now consists of a broad spectrum of media—foremost among them photography and its sister lens-based forms, film and video. The domain of photography, film, and video is readily apparent in the precincts of commercial galleries and in museums that show contemporary art; one need only review the catalogues of recent Whitney Biennials to see the degree to which lens-based mediums, and photography in particular, play a leading role in today's art. In 1950 this was not the case; indeed, photography was virtually invisible. How did this transformation from stagehand to star take place, and why?

The question is not uncomplicated. The story of how photographs came to be an integral presence in the art world does not have a single, linear narrative. Nor is it accurate to say that two independent histories, one of photography and the other of art (read: painting and sculpture), came together at last. Rather, there are three interlinked narratives to consider, each of which has its own complexities. We might refer to these narratives, albeit approximately and crudely, as the history of photographers making art, the history of artists making photographs, and the history of hybridity in contemporary art.

The first two of these histories take us back before the twentieth century, before the birth of modernism, to the middle of the nineteenth century when photography was in its infancy. Almost from the medium's birth, photographers tried to establish their own discourse about the art of their enterprise, relying primarily on the aesthetic belief that reproducing Nature was art's highest calling. Photography presented some challenges in this regard—it was limited to black and white, after all, and even its gray tones did not represent all colors equally—yet its descriptive verisimilitude was unimpeachable. Painters, at first covertly and later openly, began to use photographs as aids to sketching and composition, implicating themselves in the camera's naturalism.[1] Even the Impressionists, who ostensibly were reacting to photography's chromatic insufficiency (as well as to academic painting and other factors long a part of the art historical narrative), found themselves irresistibly drawn to the camera—Edgar Degas and Pierre-Auguste Renoir in particular. Yet none of these painters felt that the camera was a sufficient instrument of art on its own, since it seemed to preclude the use of the imagination.

With modern art, as it came to be practiced and understood in the first half of the twentieth century, photographers and painters shifted their aesthetic claims to emphasize the self-sufficiency of their chosen media. As a result, the influence of art movements such as Cubism on modern photography was ignored or suppressed; Paul Strand, the photographer most obviously indebted to Pablo Picasso and Georges Braque, chose to speak of his work as "pure" photography, unencumbered and uncontaminated by other forms of art. His friend Charles Sheeler, whose photographs are no less important than Strand's, allowed his photography career to be downplayed so that collectors and critics could better consider the value (in terms of both aesthetics and the market) of his paintings.[2]

Nonetheless, painters and photographers in those years were often pursuing similar aims. One can see this in Constantin Brancusi's photographs of his sculpture studio, which echo the spatial volumes encoded in his three-dimensional work, or in the debt to Surrealism embedded in the early photographs of Henri Cartier-Bresson, or in Man Ray's photographic collaborations with Marcel Duchamp. Clearly, there were linkages between photographers making art and artists making photographs even when the discourse of early modernism made them covert. And so it was that in the

postwar years, as modernism aged, mutated, and eventually lost its hegemonic authority, the role of photography in contemporary art became increasingly obvious.

It would be simplistic to describe the current photographic condition of contemporary art merely as a merger or synthesis of these two narratives—photography as an intentional art, and photographs in the service of painting, sculpture, and other artistic media—even though they have been winding around each other like paired strands of DNA for 150 years. One must also look at the last fifty years to consider the ambitions and discourses of art as a whole, to step outside the modernist view that the nature of the medium used to make art dictates the conditions and meanings of that art.

For purposes of this essay, and in relation to this exhibition of selections from the Whitney Museum's collection of photographs, I will refer to our current, postmodern condition with a term that inherently disputes the self-sufficiency of medium: hybridity. Whatever the shortcomings of the term, I would argue that it is the condition of hybridity that has allowed photography and its sister lens-based media of film and video to assume leading roles in the art of the last fifty years. Ironically, they have arrived as art media just at the moment when distinguishing one medium from another no longer seems to matter.[3]

Photographers Making Art

For photographers in the late 1940s and throughout the 1950s, the dominant aesthetic presence to emulate or rebel against was Alfred Stieglitz. Although Stieglitz died in 1946, after a lifetime of promoting photography and later American painting as significant forms of art, his legacy endured for at least two more decades.[4] This was due in part to the power of his idea that photographic meaning was essentially metaphoric, embedded in the "equivalence" of the portrayal of the subject and the feelings and intentions of the photographer. But it also was due to the extent to which these years were the heyday of Abstract Expressionism and the New York School of painting. Photographers who subscribed to Stieglitz's beliefs could make ambiguous, unidentifiable

images that were simultaneously "pure," in the sense of using straightforward photographic technique, and contemporary, in the sense that they could be read as abstract pictorial displays. Their major distinction from abstract painting was that they lacked any signs of the hand of their makers.

Case in point: Minor White's well-known image *Beginnings* (1962; p. 69). In prosaic terms, the picture's subject is a collection of ice crystals on a windowpane, some of them melted into sheet ice, and a handful of bright orbs of light. But the image is perhaps more interesting if we accept it formally as a display of highlights and shadows in which space is as free-floating as the meanings we may attach to it. (Apparently, frost on windows was a popular motif of the time; Paul Caponigro made a similar picture, called *Frosted Window*, three years earlier.) White, along with Wynn Bullock, Frederick Sommer, Ralph Eugene Meatyard, and other photographers, sought out subjects and used techniques that allowed them to show the world as mysterious, otherworldly, and inherently surrealistic. And while they would insist that their pictures were demonstrations of the unique qualities of photography, the results sometimes bear an uncanny resemblance to copy photographs of Abstract Expressionist paintings.

The photographer who had the most deeply rooted connection to Abstract Expressionism was Aaron Siskind. An erstwhile New York City schoolteacher and member of the Photo League, an organization that advocated socially concerned documentary photography, Siskind gravitated to the Tenth Street painting scene where he befriended Franz Kline, Barnett Newman, and other abstract painters. He soon abandoned his documentary ambitions in favor of a graphically dense, semiotically complex style of black-and-white abstraction, much of it appropriated from graffiti, defaced signs, spilled tar, and other kinds of crude "writing." Siskind's *Chicago 1* (1949; p. 70), exhibits the flattened picture space and bold traces of gestural activity that typify his work.

In 1951 Siskind moved to Chicago to join Harry Callahan in teaching at the Institute of Design (I.D.). Originally established by László Moholy-Nagy as the New Bauhaus, the school had a tradition of interest in photography as the primary method of studying the first principles of light. Callahan and Siskind were sympathetic to Moholy-Nagy's experimental conception of the medium but injected a more pragmatic, and arguably more American, awareness of a

picture's content in their teaching. Callahan set an example by using his wife, Eleanor, as his subject for exploring such techniques as double exposures and light projections. *Eleanor, Detroit* (c. 1941; p. 71) is an early example of Callahan's ability to combine formal experimentalism with feelings of personal intimacy. Callahan's and Siskind's students absorbed the I.D. idea of photography as an art of both formal rigor and broader meaning; among their pupils represented in the Whitney's collection are Marvin E. Newman, Kenneth Josephson, Ray K. Metzker, Linda Connor, and Emmett Gowin.

A far more radical postwar notion of what the art of photography might be was formed in New York City from an amalgam of documentary practices indebted to the Photo League, the Depression-era Federal Art Project and Farm Security Administration photography project, and to the example of Walker Evans, whose work had been exhibited and published by The Museum of Modern Art in 1938. Social-documentary photographers as well as the growing ranks of photojournalists also looked to *Life* magazine as a model of how photography could impact American culture. Taking photojournalism as their stylistic starting point, but rebelling against what they saw as its conformity, a new generation of postwar photographers sought ways to individualize their pictures while at the same time commenting on the broad state of American society. In this way, they felt, they could make a new kind of art with the camera.

Robert Frank (p. 51) is the best-known artist of this group, which has come to be called the New York School of photography. Frank's 1959 book *The Americans* became a landmark because of its style and content. Frank rejected technical polish; among his photographic "mistakes" were allowing the grain of his film to show prominently and embracing featureless black shadows. He also focused his sympathies on the underclass, depicting the rest of American life as hopelessly banal and conformist. Frank was by no means alone in his alienated, existential point of view. Photographers such as Louis Faurer, Sid Grossman, Saul Leiter, and Helen Levitt had earlier turned their cameras on people outside the boundaries of middle-class propriety and upper-class celebrity, using New York's diverse population as their source material. And Frank's book was preceded in 1956 by William Klein's equally discomfiting and graphically hyperactive volume, *Life is Good and Good for You in New York: Trance Witness Revels*. Like Frank, Klein broke the conven-

tional rules of photographic technique, using blurs, tight close-ups, and reflections to personalize his photographs and differentiate them from run-of-the-mill photojournalism. And like all of these photographers, Klein consciously used the stylistic tropes of amateur "snapshot" photography to give his work a feeling of spontaneity.

These image makers are often called "street photographers," but while the label denotes an aspect of their subject matter and their behavior, it does not suggest how important their revolt was against the prevailing aesthetic of art photography as defined by Ansel Adams, Minor White, Beaumont and Nancy Newhall, and other powerful voices of the time. Equally important, their pictures were a sign of resistance against abstraction, since they depended on social reality for much of their meaning and emotional power. Their preoccupation with urban life, social conformity and its opposite, social deviance, and popular, public culture was as much a quest to "act in the gap" between art and life, in Robert Rauschenberg's oft-quoted phrase, as Pop art was to be in the early 1960s.[5] They also were the direct precursors of Diane Arbus, Lee Friedlander, and Garry Winogrand, the three photographers in the important 1967 show *New Documents*, organized by the eminent photography curator at The Museum of Modern Art, John Szarkowski.

In 1962 Szarkowski had replaced Edward Steichen at the helm of what was one of only a few museum departments of photography in the country. Certainly it was the most influential, and it remained so during Szarkowski's more than twenty-five-year tenure largely because of his eloquent advocacy for photographs as works of art. For Szarkowski, photography was a "different kind of art," fundamentally different from painting and other descriptive methods.[6] For him, no less than for Alfred Stieglitz, photography's aesthetic claims rested on its inherent and unique qualities, which he defined in formal terms: vantage point, time, framing, etc. But he also allowed that the subject of a photograph—what he called "the thing itself," after a 1924 daybook entry by Edward Weston—was one of its distinguishing and most powerful attributes.[7]

Szarkowski was most interested in photographs that approached the condition of the vernacular, such as amateur snapshots, newspaper pictures, and commercial studio photography. In 1976, he presented William Eggleston's casual-looking color photographs in a major exhibition at The Museum of

Modern Art called *William Eggleston's Guide*. The exhibition was widely derided, in part because Szarkowski claimed that Eggleston was the first to master the challenge of making an art of color photography, but it was also typical of the curator's taste for naturalism. Pictures like Eggleston's *Greenwood, Mississippi* (1973; p. 99) show none of the striving for metaphoric or artistic effect that Szarkowski reacted against; if anything, its artfulness is carefully hidden from view so that one might better enjoy the tawdriness of the scene. But as anti-Stieglitzian as this aesthetic is, it remains rooted in a notion that the art of photography lies in the "pure" use of the camera and light-sensitive materials.

Artists Making Photographs

The same year that Szarkowski began working at The Museum of Modern Art, photography entered into the discourse of the art world based entirely on its everyday, non-art cultural presence. In 1962, Robert Rauschenberg and Andy Warhol began to make paintings by silk-screening photographic images onto canvas. In Rauschenberg's case, the method was akin to collage; he melded a variety of images onto a single canvas. Warhol took a more radical approach, repeating the same image in rows and columns.

Seen from the perspective of the progress of their work, this incorporation of the photographic image was not a huge leap. Rauschenberg had been using collage techniques since the 1950s, when he began incorporating found objects in his "combines," which were part sculpture and part painting. He also took photographs, beginning in his student years at Black Mountain College, although they were primarily diaristic. Warhol had been producing multiples of single images since the 1960s began, most famously in his series of hand-painted Campbell's Soup cans. His fascination with photographic images included its most unexalted forms, such as coin-operated photo booth portraits. But from today's vantage point, the two artists helped open the gates for a new kind of art that forswore abstraction and, equally important, relied on photographic images for its subject matter and on photographs as its chosen means of expression.

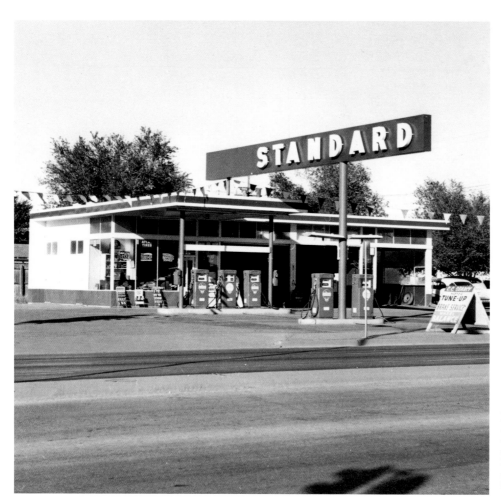

Fig. 2 (left) and
Fig. 3 (opposite)
Ed Ruscha,
*Twentysix
Gasoline Stations*,
1963. Forty-eight
page book, 7 1/8 x
5 5/8 x 3/16 in.
(18.1 x 14.3 x .5
cm) closed
dimensions.
Frances Mulhall
Achilles Library;
Special Collections

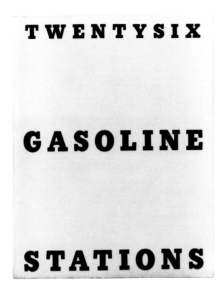

Artists who were discontent with abstraction, and with the idea of art as a self-generated, self-expressive enterprise, seized on photography—as well as film and, in the mid-1960s, video—as an instrument of rebellion. As much as performance, installation, mail art, collaboration with dancers, and other forms of material and "dematerialized" art, photography represented a turn toward the social among contemporary artists. It also registered artistic discontent with an art-world system that seemed geared more to the needs of curators and collectors than to the inner necessities of artists themselves. But it was photography's status as a register of culture, rather than its claims to being a fine art medium, that most appealed to artists of the 1960s and early 1970s.

A year after Warhol and Rauschenberg began to silk-screen photographs onto canvas, a young Los Angeles artist named Ed Ruscha published a small book reproducing twenty-six photographs of gasoline stations, cogently titled *Twentysix Gasoline Stations* (1963; figs. 2 and 3). Essentially a record of gas stops along Route 66 between Los Angeles and Oklahoma City, where the artist grew up, the book is a tribute to vernacular architecture and the banal consistency of the American roadside. Its photographs, taken by Ruscha in unremarkable, uninflected fashion, are just as vernacular as the gas stations themselves. While modest in appearance, *Twentysix Gasoline Stations* was designed as a multiple artwork; its first edition consisted of four hundred numbered copies.[8]

Twentysix Gasoline Stations marked the beginning of a fifteen-year period in which Ruscha produced artists' books simultaneously with his paintings and drawings. Among the better-known of his sixteen titles are *Some Los Angeles Apartments* (1965), *Every Building on the Sunset Strip* (1966), and *Thirtyfour Parking Lots in Los Angeles* (1967). Although received at the time

as West Coast versions of the Pop art sensibility then rampant in New York, Ruscha's books proved much more influential as avatars of Conceptual art, and especially of Conceptualist attitudes toward seriality, procedural rigor, and the documentary nature of photographic information.

Dan Graham's color photographs of everyday architecture and public spaces are cases in point. As published in *Arts Magazine* to accompany Graham's article "Homes for America" in the 1966–67 year-end issue, the earliest of these pictures are in one sense illustrations of Graham's insight that industrial standardization of forms and materials, as seen through the lens of home building, was akin to the Minimalist notion of sculpture. Other images, like *2 House Home, Staten Island, New York, 1978* (1978; p. 106), which is half of a diptych in the Whitney collection, show an equal interest in the vagaries of decoration and finish.

Robert Smithson's photographs for his December 1967 *Artforum* article, "The Monuments of Passaic," are equally indebted to Ruscha, showing urban details and infrastructure in straightforward, almost casual fashion. (The piece is a record of a day trip from New York City to New Jersey's Meadowlands.) Photographs were key instruments for Smithson because, like other so-called Earth artists of the late 1960s and early 1970s, so much of his work was inaccessible and/or performance based. Even Smithson's most well-known work, *Spiral Jetty*, is known to most followers of contemporary art through the mediation of still photographs and film.

Both Sol LeWitt and Mel Bochner, two of the most important figures in the transition from Minimalism to Conceptual art, turned to photographs to document certain of their conceptual procedures and sculptural ideas. Bochner's *Roll* (p. 88), an eight-print series from 1968, uses video images to distort an unchanging scene of four cubes on a gridded ground. LeWitt's occasional photo pieces, including the recent *Untitled (Cube)* (1998; p. 186), customarily use an overall grid format to show gradual changes in size, time, and perspective. Other Conceptualists left Minimalism's grasp altogether. Joseph Kosuth's classic *'One and Three Chairs [ety.]'* (fig. 4), and its sibling, *One and Three Umbrellas*, both 1965, made the photograph's semantic role a central issue. *'One and Three Chairs [ety.]'* consists of a folding chair, a wall panel with the dictionary definition of a chair printed on it, and on another panel a photograph of the chair. Hans Haacke likewise put photography in

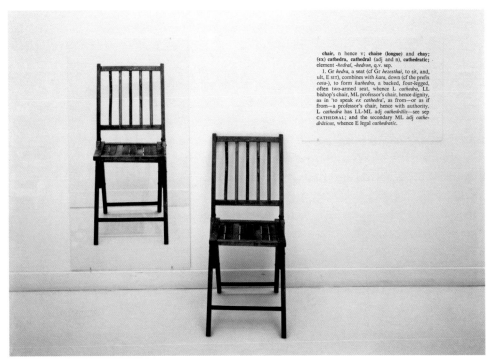

Fig. 4
Joseph Kosuth,
'One and Three
Chairs [ety.]',
1965. Gelatin
silver print
mounted on
board, and chair,
dimensions vari-
able. Collection
of the artist;
courtesy Sean
Kelly Gallery

the same category as language in his controversial 1971 photo/text piece
Shapolsky et al. Manhattan Real Estate Holdings: A Real Time Social System,
which traced the real estate empires of several Manhattan slumlords. Such
"systemic" approaches as Haacke's fell under the term "information art."[9]

Vito Acconci, whose Conceptualist performances invariably direct atten-
tion to his own body, created a series of photo/text pieces based on "actions"
he made with a camera, using it as a prosthesis of his own senses. *Hands
Down/Side by Side* (1969; p. 85) is typical: two flanking photographs show
what's "off to the side" (photographed while the artist held the camera to his
side), while a central image, a composite of two pictures, shows Acconci
"spread out at the sides." In other works, most of them located in New York's
Central Park, the artist spins, hops, steps, and otherwise moves while taking
pictures, all according to sets of instructions conceived in advance. On the
West Coast, Bruce Nauman produced his own kind of Body art with the

camera; his works from this era range from three-dimensional holograms to a series of color photographs that humorously illustrate titles such as *Self-Portrait as a Fountain* (1966–67; fig. 5). In 1971 another West Coast Conceptual artist, Douglas Huebler, announced his intention to "photographically document, to the extent of his capacity, the existence of everyone alive."[10]

The influence of these artists is difficult to overestimate. The shared interest of Ruscha, Smithson, and Graham in documenting and examining vernacular structures—itself influenced by what Bernd and Hilla Becher were doing in Germany—is reflected in the work of Gordon Matta-Clark and Lewis Baltz. Haacke's politicized approach to photo/text pieces is echoed in Martha Rosler's *The Bowery in two inadequate descriptive systems* (1974–75; p. 107). Acconci's method of documenting his body with the camera directly influenced Ana Mendieta (p. 120), whose pictures show the shape or trace of her prone body in natural settings. Nauman's sense of play and sense of humor informs the work of Robert Cumming and William Wegman, who also lived in Los Angeles in the early 1970s.

To adequately chart the intentions and relations of all the contemporary artists who made use of photography from the late 1960s through the 1970s would require not only a very long sheet of paper, but also one with a complex, three-dimensional shape. Suffice it to say that photography served artists variously as an alternative to hand-fashioned depiction, as a sign of refusal of traditional modernist values, as a source of documentary and semantic information, as a reference to social realities outside of the art world, and as a system of representation that posed its own metaphysical conundrums. For artists coming of age in the 1970s, and for young photographers on the edges of the art world, the blossoming of interest in photography was an unavoidable phenomenon, and one of great potential interest for their own practices and ideas.

One result of this interest was a loss of the traditional distinction between photographs made by photographers and photographs made by artists. Cumming and Wegman exemplified the new phenomenon of the "crossover" artist, since contemporary art audiences and art-oriented photography audiences admired their work equally. Lewis Baltz, by training a photographer, exhibited his *New Industrial Parks* series at Leo Castelli's prestigious SoHo gallery in 1975. Lucas Samaras, a sculptor, painter, and performance artist,

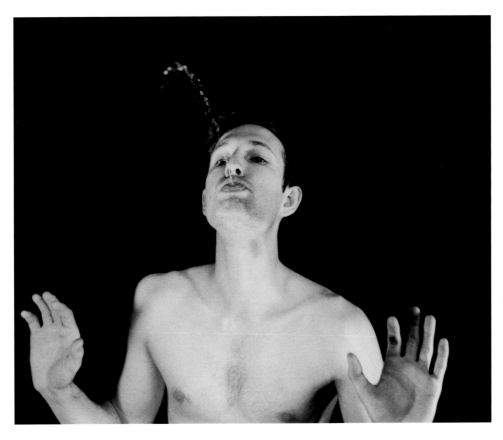

Fig. 5
Bruce Nauman,
*Self-Portrait as a
Fountain*, from
Untitled, 1966–67
(original in color).
Chromogenic
color print,
20 1/16 x 23 15/16
in. (51 x 60.6 cm).
Purchase 70.50.9

showed the manipulated Polaroid photographs he called *Photo-Transformations* (p. 118) at Pace Gallery in 1974. Even the English painter David Hockney, a virtuoso when it comes to figuration, began showing his snapshotlike photographs as independent works of art.

Moreover, many artists began to research the medium's past in search of precedents for their own interests. Mel Bochner, for example, in a 1967 *Artforum* article, referred to Eadweard Muybridge's nineteenthth-century motion-study photographs as forerunners of what he called "the serial attitude" in contemporary art. Robert Smithson and Sol LeWitt also were fascinated with Muybridge's work. Ed Ruscha has spoken of how much Robert Frank's *The Americans* and Walker Evans's *American Photographs*

influenced *Twentysix Gasoline Stations* and his subsequent books.[11] Such crossovers between photography and art, occurring at the intangible level of influence, extended to the practice of contemporaries as well. Carl Andre, the Minimalist sculptor, wrote about the German photographers Bernd and Hilla Becher in *Artforum* in 1972, having recognized that their grids of images of ordinary industrial structures echoed his own fascination with repetition using industrial materials.

The cross-fertilization of what had been mostly independent aesthetic enterprises gave artists license to investigate photography's artistic traditions in their own work. Jan Groover is a case in point: Trained as an abstract painter, she exhibited conceptually based color photographs, presented as triptychs, at Sonnabend Gallery in New York in the early 1970s. In 1978 she switched to making decorative, unabashedly beautiful single images of plants and kitchen utensils, done with all the technical skill and formal élan of Edward Weston and Paul Strand. Increasingly interested in photography's own art traditions, she later learned to make gorgeous black-and-white prints using the antiquated platinum/palladium process.

Not coincidentally, photography became an object of intense critical scrutiny and debate during the 1970s. Susan Sontag's series of skeptical essays about the medium appeared in the *New York Review of Books* starting in 1973 and was published in book form as *On Photography* in 1977. The theoretically informed journal *October* devoted an entire issue to photography in 1978. And the writings of important European theorists, including Roland Barthes, Jean Baudrillard, Walter Benjamin, and Michel Foucault, were published in English-language editions, making their ideas about the social and cultural role of photographic images widely available.[12] At least partly in consequence, photography progressed from being a popular means of making art at the beginning of the decade to being the privileged medium of contemporary art discourse by decade's end.

Much of the critical attention to photography was directed at its functional role in contemporary culture, and to its instrumental role in forming that culture. In other words, photographs were recognized as both reflections and producers of the world in which we live. The commonplace idea that photography's documentary abilities allowed it to objectively reproduce social reality (as in, for example, the practices of photojournalism and portraiture)

was replaced by the conviction that its fictive capabilities (as in, say, advertising and fashion photography) allowed it to create a false sense of reality, a replacement reality that obscured and/or obviated what was really real. Baudrillard's term for this condition was the simulacrum—roughly, a world in which representations of things, not the things themselves, ruled.[13]

Thus postmodern art, which became an identifiable movement with the *Pictures* exhibition at Artists Space in New York in 1977 and which dominated aesthetic discussion well into the 1980s, privileged photography above all else. Although relatively few of the early postmodern artists showed photographs— of the five artists in *Pictures*, only Sherrie Levine became identified specifically with photography—it was the pervasive presence of photographic images, in reproduction and as the common coin of everyday culture, that provided a focus for the movement.[14] With the success of Cindy Sherman's series *Untitled Film Stills* (1977–80; p. 130), and exhibitions of appropriated media images by Richard Prince and Barbara Kruger, postmodernism as an art movement became inextricably linked to photographic practice.

These postmodern artists, together with Sarah Charlesworth, Laurie Simmons, James Welling, and others born during the postwar baby boom, posited a world in which all experience was mediated by lens-produced images—the aptly named "Image World." Like the Pop artists of some twenty years earlier, they focused on popular culture as a way of reflecting the condition of contemporary life. Equally important in terms of the progress of contemporary art, they positioned themselves against the ambitions of Neo-Expressionist painters, whom they viewed as fashionable, retrograde, and chauvinistic. As it had in the late 1960s, photography functioned as an antidote to what was seen as a market-oriented but critically exhausted practice of painting and sculpture.

Hybridity

Within the space of two decades, from 1970 to 1990, photography had been normalized as a medium for contemporary art. It had served the aims of artists as an instrument of conceptual, anti-material practices, as a cultural

manifestation with its own intriguing metaphysical and semantic qualities, and finally as a party to the investigation and so-called deconstruction of lens-based representation. In the course of this progression, photographs became valued objects in a newly expanded marketplace for art. This market grew in part as a consequence of the establishment of new support structures for photography: galleries that presented photographs as saleable artworks, museum departments of photography that collected and exhibited photographs, auctions devoted to vintage prints, photography departments and curricula within colleges and universities, and new publications that served as information sources for collectors, critics, and curators.

The treatment of photography as a medium needing special attention and institutional spaces ran counter to the larger phenomenon of its incorporation into the mainstream of contemporary art. Established galleries such as Leo Castelli, Paula Cooper, Marlborough, Pace, and Sonnabend exhibited photographs along with shows of painting and sculpture. Contemporary art curators began buying the work of Cindy Sherman, Barbara Kruger, and others, barely noticing, or at least barely acknowledging, that it consisted of photographs. Art journals no longer bothered to run "special issues" on photography; instead, what is now known as photo-based art became an unremarkable, inextricable part of their coverage. One sign of the status of the medium at the end of the 1980s was that the so-called culture wars, which in large part devolved around photographs by Robert Mapplethorpe and Andres Serrano, treated photo-based art as representative of the ills of contemporary art, not as exceptions to it.

Photography, it bears repeating, was not the sole agent in the transformation of the postwar art world, nor did it single-handedly disrupt and supplant painting and sculpture as the favored medium of modern art. Rather, it was one of a number of alternatives—including film and video, but also performance, writing, site-specific installation, and more recently Internet art—that singly or in combination served postwar art and artists. These media and practices appeared—performance and installation in the 1950s, video and film in the 1960s—as the modernist notion of the uniqueness of any particular medium was eroding. They were also agents in that erosion.

Why such a multiplicity of media and practices should characterize the visual art of the second half of the twentieth century is a question that future

art historians no doubt will endlessly debate, but at least one probable cause bears mentioning here: Once postwar artists began questioning the very nature and purpose of art, traditional art media inevitably lost their aesthetic imperative. In a sense, Clement Greenberg's assertion about the abstract artist's essential relation to medium was simply inverted. "In turning his attention away from subject matter of common experience, the poet or artist turns it in upon the medium of his own craft," he wrote in his 1939 essay "Avant Garde and Kitsch."[15] The converse, of course, is that when artists (male and female) turn their attention back toward common experience—as artists since Rauschenberg have largely done—the medium of craft ceases to matter.

This is why it is possible (and, I would argue, preferable) to discuss artists such as Peter Campus, Chuck Close, Hollis Frampton, and Bruce Nauman without identifying them as painters, sculptors, filmmakers, video artists, or photographers. Even labels like Photo-Realist or Body artist fail to do justice to the consistency with which the artists express themselves individually using a variety of means and methods. The "purity" of use of a given medium still may command our respect (in the case of, say, Robert Ryman's paintings, Vija Celmins's drawings, or Lee Friedlander's photographs), but it no longer describes our only interest in the work.

Even within the precincts of art photography, hybrid practices derived from printmaking and collage were undercutting the premises of the Stieglitz aesthetic as early as the 1960s. Or earlier: Jerry N. Uelsmann's *Mechanical Man #2* (p. 76), a seamless deceit printed from two negatives, dates from 1959. The photographer most responsible for opening the medium to printmaking ideas was Robert Heinecken, whose series *Are You Rea* (1966–68; fig. 1), is an edition of offset prints based on photograms of magazine pages. Heinecken, who chaired the photography program at UCLA, was an early adopter of the technique of recycling mass-media representations and, despite being known as a photographer, made a point of not owning a camera.

In the 1980s, a generation of artists took to practicing photography as a form of studio art, an idea no doubt cribbed from other artistic practices but also one that reflected on commercial photographers whose setups were grist for the mill of advertising. The tabletop and "tableau" photography that resulted was technically straightforward but without any connection to the real world; what reality appears in pictures by such practitioners as Sandy

Skoglund (trained as a painter), James Casebere (trained as a sculptor), and Lorna Simpson (trained as a photographer) stems from the imagination of the artist. The increase in the use of color film and print materials in the same decade also distanced photographers from their purist forebears, who had considered color too garish and commercial. By the end of the 1980s, photography was appearing in many guises: as Nan Goldin's slide-and-soundtrack performance (and, later, book) *The Ballad of Sexual Dependency* (p. 123), as Mike and Doug Starn's stained, taped, and jury-rigged assemblages (p. 149), and as Adam Fuss's optical abstracts of pure, circling light (p. 190).

If the medium of craft no longer seems crucial in our contemporary art, then what does matter is the connection between artistic content and life, which may explain why photographs have a particular and continuing resonance for today's artists. Photographs are democratic and reproductive; they cross caste lines separating artists from amateurs, aesthetics from functionality, and realism from representation, and they encompass unique prints, limited editions, and endless halftone reproduction. They bridge the gap between art and life, bringing back reports on what the world looks like for display on plain white walls. Even when the lens is taken out of the equation, as it is in the work of Fuss, Ellen Carey, Fred Tomaselli, and Iñigo Manglano-Ovalle, photographs still carry the trace of their referents—arguably even more so when no lens is employed. This makes the process of photography, rather than the medium itself, an ongoing enterprise among contemporary artists. Whether the process is digital or film-based is another matter, but it is a matter of aesthetic choice and not technological necessity.

In Manglano-Ovalle's three-panel work *Iñigo, Elvi, and Iñigo* (1998; p. 226), the totemic arrays of color splotches represent DNA samples taken from the artist, his mother, and his father and analyzed by computer. They vary in obvious ways, yet they also exhibit a kinship that suggests their genetic commonality. The same could be said of the three conceptions of photography within contemporary art sketched here: each has its own codes, but those codes are more alike than dissimilar when viewed at a distance. From the distance of the early twenty-first century, that is to say, the likeness of photography and contemporary art is unmistakable.

Notes

1. Painters used the camera long before photography's invention, in the form of the camera obscura. Much recent art historical scholarship, and some popular accounts of art history, focuses on deciphering the camera obscura's influence. See, for example, Philip Steadman, *Vermeer's Camera: Uncovering the Truth Behind the Masterpieces* (Oxford and New York: Oxford University Press, 2001) and David Hockney, *Secret Knowledge: Rediscovering the Lost Techniques of the Old Masters* (New York: Viking Press, 2001).

2. Edith Gregor Halpert of the Downtown Gallery, Sheeler's dealer in New York, tried to get him to give up photography in favor of painting in the 1930s. See Carol Troyen, "From the Eyes Inward: Paintings and Drawings by Charles Sheeler," in *Charles Sheeler: Paintings and Drawings* (New York: New York Graphic Society, 1987), p. 26.

3. One also could argue that photography has become a medium of art just at the historical moment when it no longer serves primarily as a functional medium; that is, as the main conduit by which we in the West receive social, political, and cultural information of a visual sort. But since this role has been taken over by the likes of film and video, the argument does not apply equally to them.

4. The popular embodiment of the Stieglitz aesthetic in the postwar years was Ansel Adams, himself a tireless promoter of the art of photography. Adams's influence on the photography department of The Museum of Modern Art also helped ensure that Stieglitz's ideas endured.

5. Rauschenberg, quoted in *Sixteen Americans*, ed. Dorothy C. Miller (New York: The Museum of Modern Art, 1959), p. 58.

6. The phrase is the title of an article by Szarkowski in the *New York Times Magazine*, April 13, 1975.

7. John Szarkowski, *The Photographer's Eye* (New York: The Museum of Modern Art, 1966).

8. Neal Benezra and Kerry Brougher, *Ed Ruscha* (Washington, D.C.: Hirshhorn Museum and Sculpture Garden, 2000), p. 205.

9. *Information* was the title of a 1970 exhibition at The Museum of Modern Art, New York.

10. Quoted in Keith Davis, *An American Century of Photography*, 2d ed. (Kansas City, Missouri: Hallmark; New York: Harry N. Abrams, Inc., 1999), p. 420.

11. Phyllis Rosenzweig, "Sixteen (and Counting): Ed Ruscha's Books," in Benezra and Brougher, *Ed Ruscha*, p. 180.

12. *Barthes's Mythologies*, for example, was published in an English-language edition by Jonathan Cape in 1972. His meditation on the essential nature of photography, *Camera Lucida*—an answer to Susan Sontag's *On Photography*—appeared in French in 1980 and in English in 1981.

13. Jean Baudrillard, *Simulations* (New York: Semiotext(e), 1983).

14. *Pictures* was organized by Douglas Crimp and included, in addition to Levine, Troy Brauntuch, Jack Goldstein, Robert Longo, and Philip Smith.

15. Greenberg, "Avant Garde and Kitsch," in Clement Greenberg, *The Collected Essays and Criticism: Perceptions and Judgments, 1939–1944*, ed. John O'Brian (Chicago: University of Chicago Press, 1988), pp. 5–21.

Plates

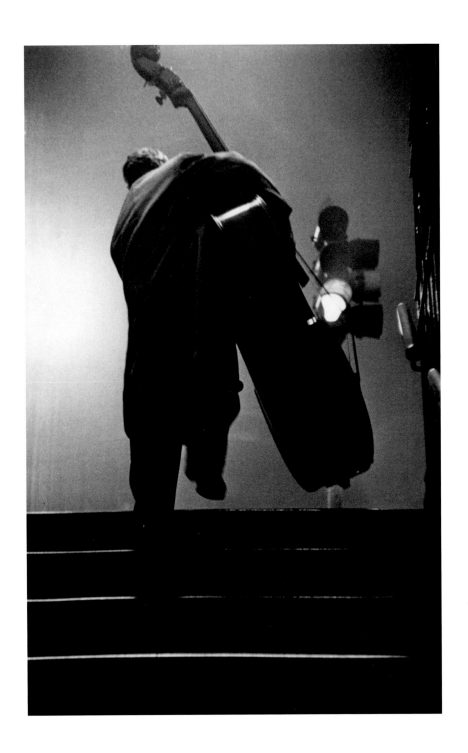

Robert Frank, London, 1952–53

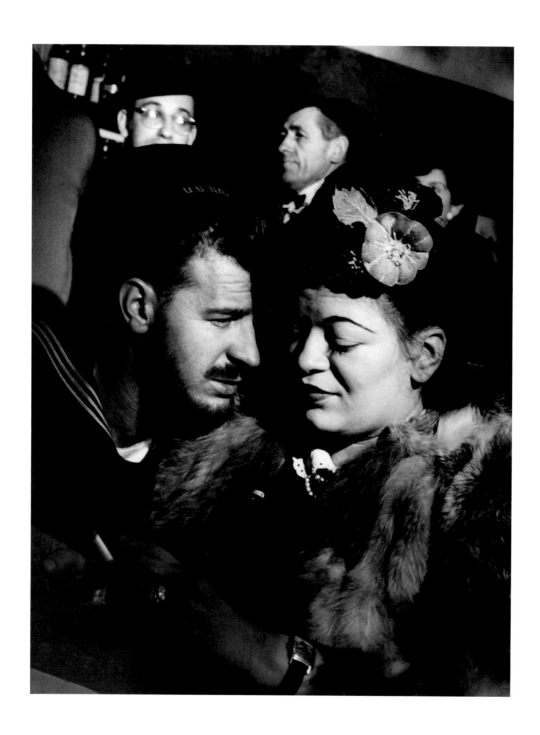

Lisette Model, Sammy's, New York, 1940–44

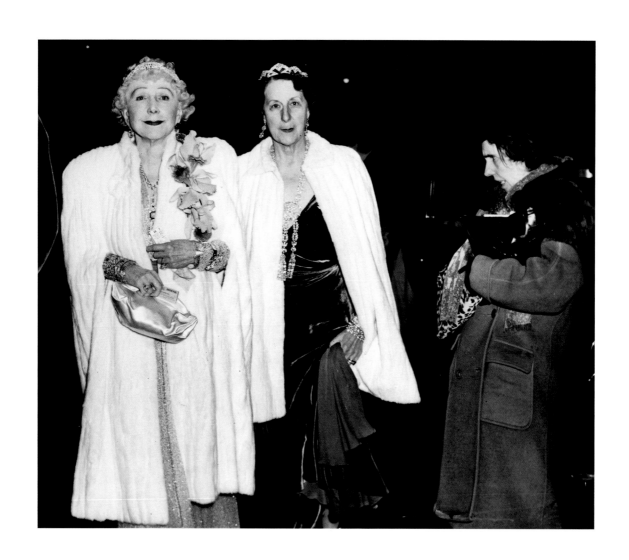

Weegee (Arthur Fellig), The Critic, 1943

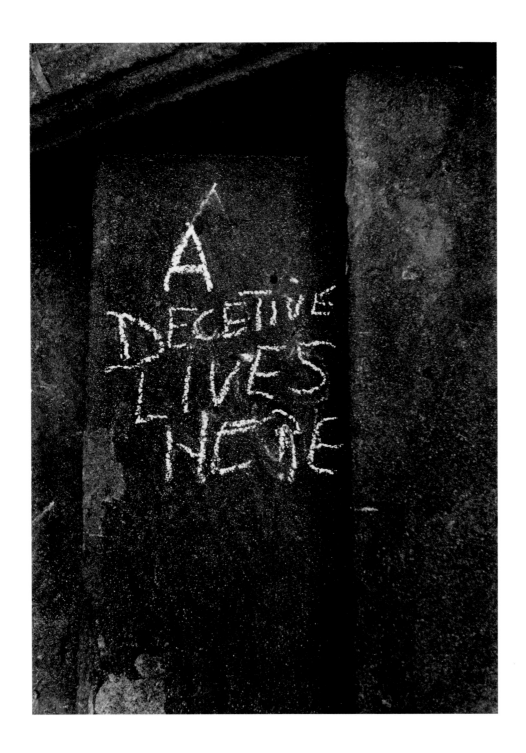

Helen Levitt, New York City, 1940

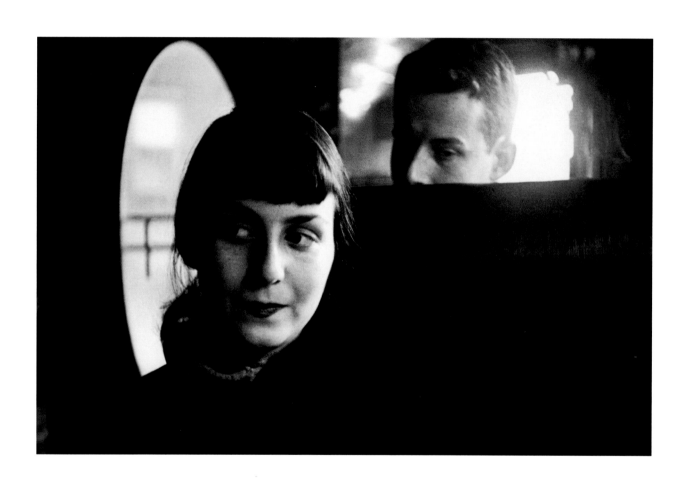

Saul Leiter, *The Village*, 1947

55

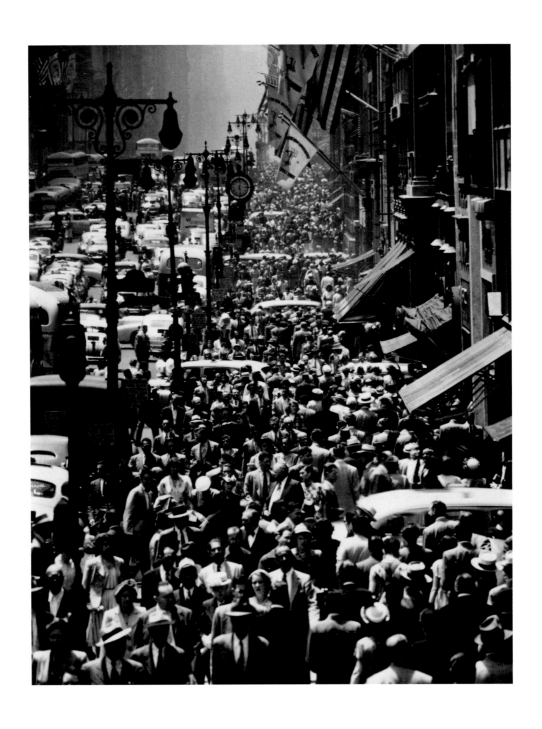

Andreas Feininger, Lunch Rush on Fifth Avenue, New York, c. 1950

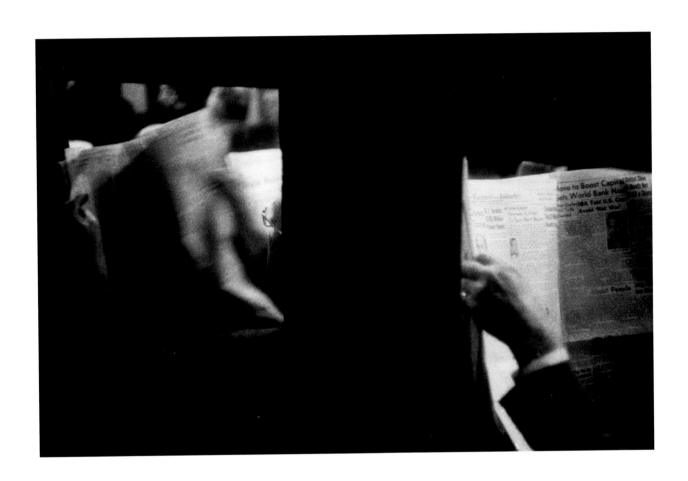

Louis Stettner, Penn Station, 1958

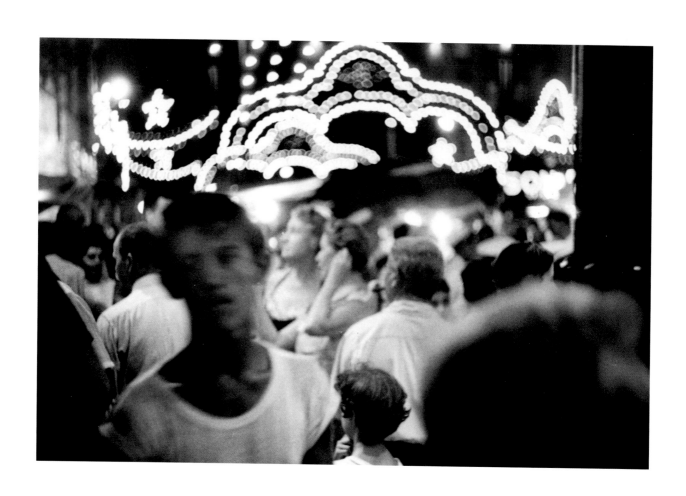

David Vestal, East 13th Street, New York, 1955

58

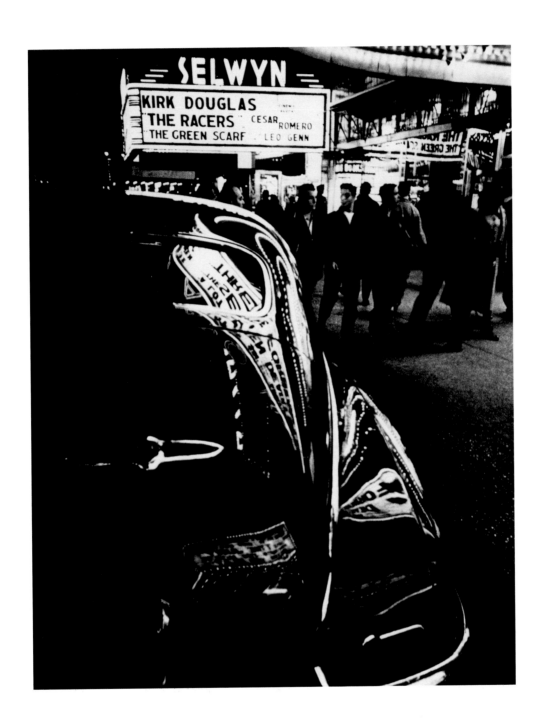

William Klein, Selwyn, 42nd Street, New York, 1955

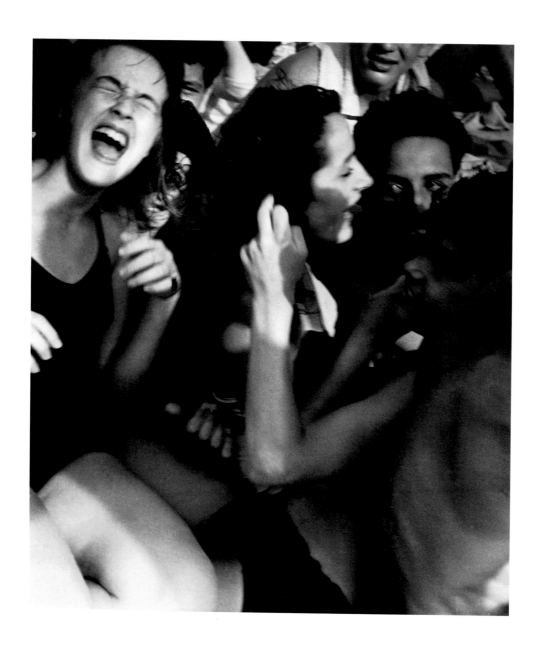

Sid Grossman, Coney Island, 1947–48

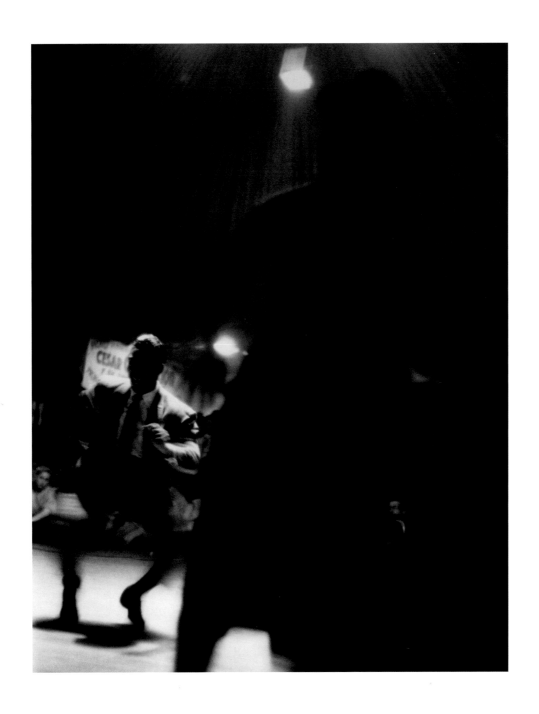

Jerry Dantzic, Mambo Jambo, Palladium Ballroom, New York, 1952

61

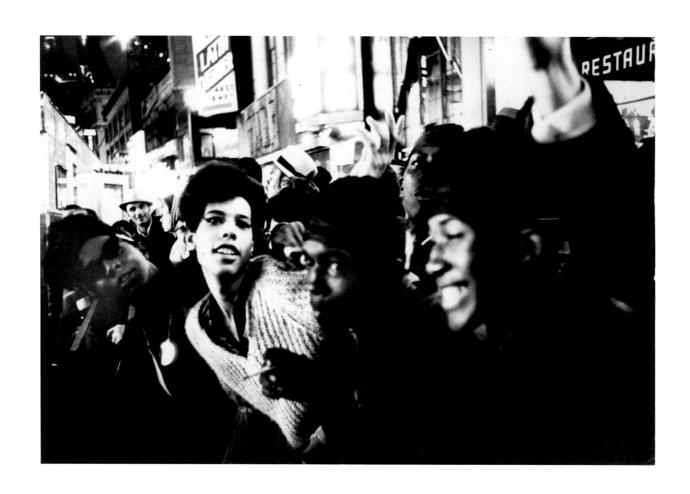

Louis Faurer, Transvestites, Opening of Cleopatra at Palace Theater, New York, 1963

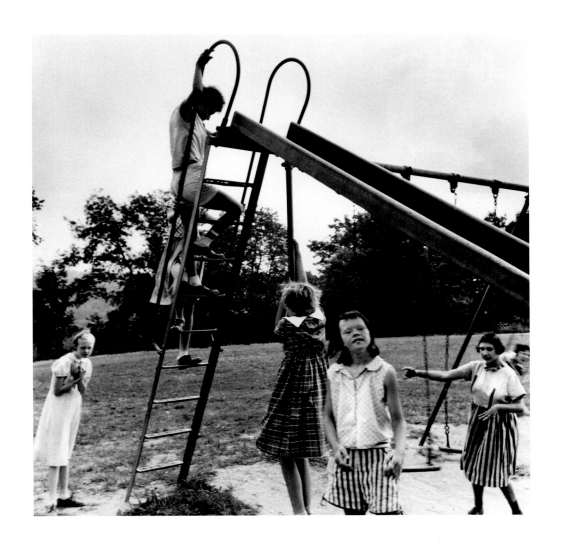

Peter Hujar, Untitled, 1957

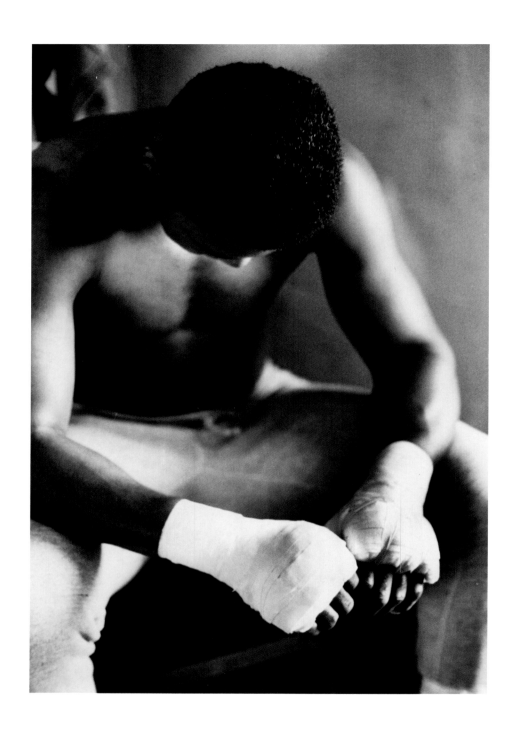

Gordon Parks, Bandaged Hands, Muhammad Ali, 1966

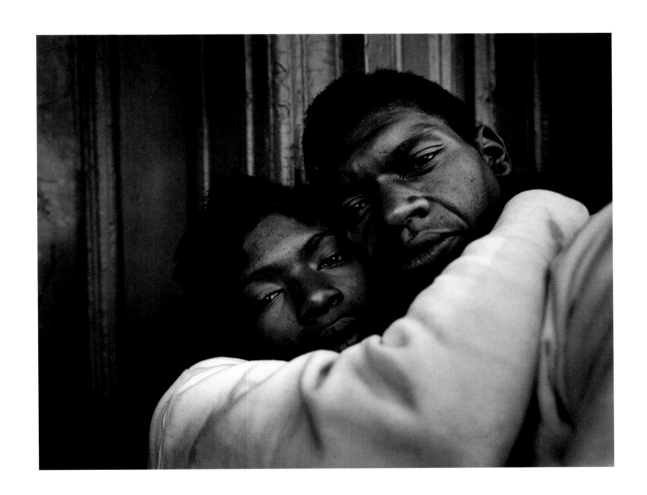

Bruce Davidson, East 100th Street, 1966

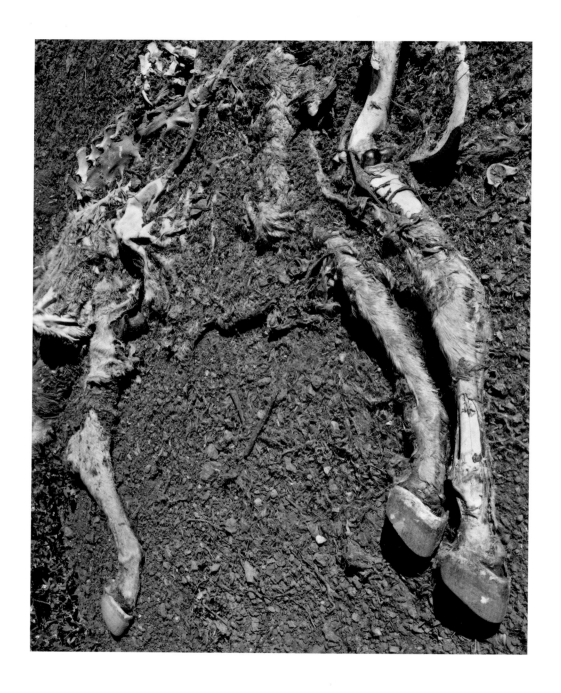

Frederick Sommer, Horse, 1945

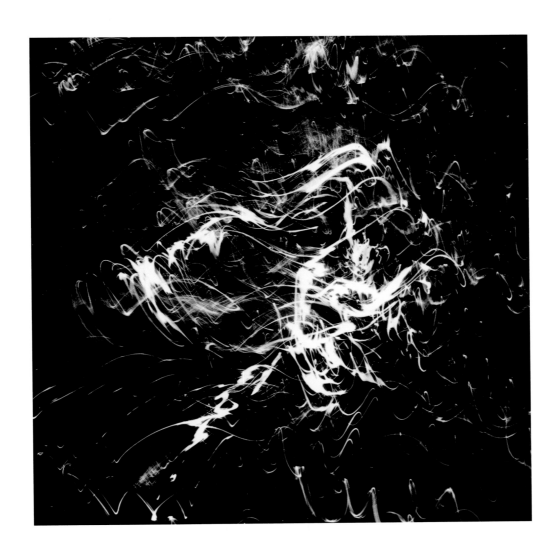

Ralph Eugene Meatyard, Lite #15, 1959

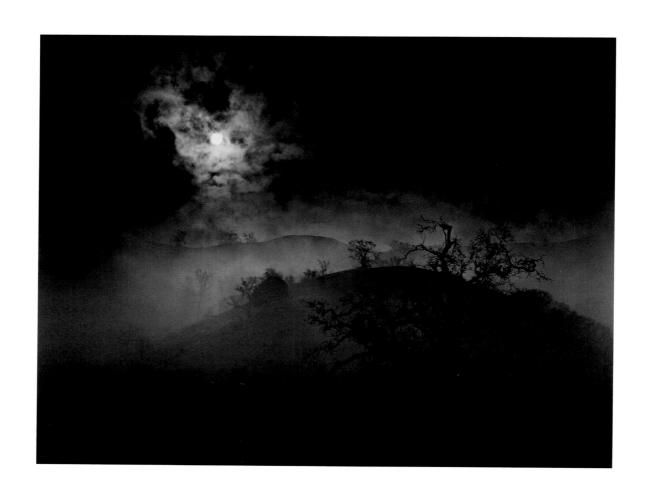

Wynn Bullock. Stark Tree, 1956

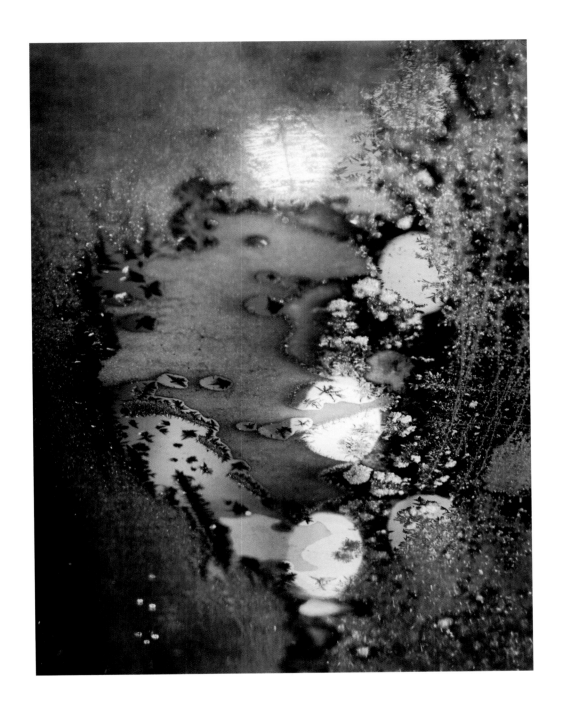

Minor White, Beginnings, 1962

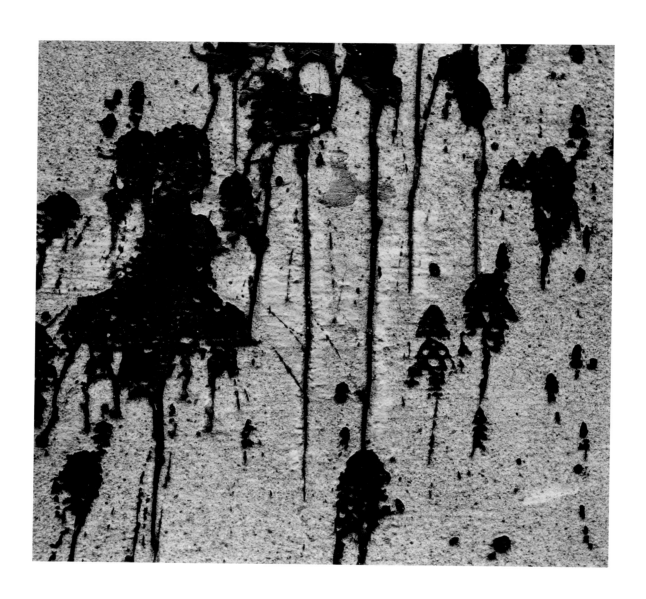

Aaron Siskind, Chicago I, 1949

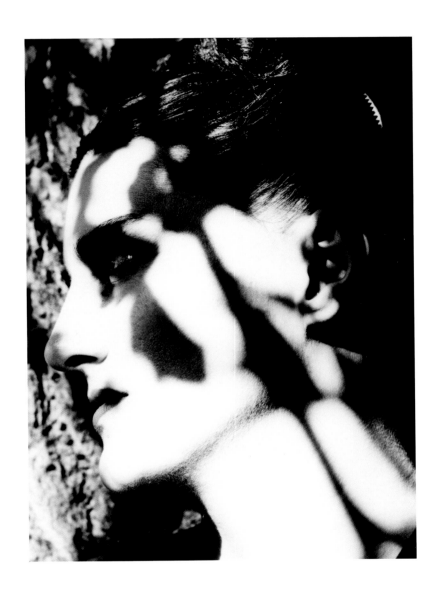

Harry Callahan, Eleanor, Detroit, c. 1941

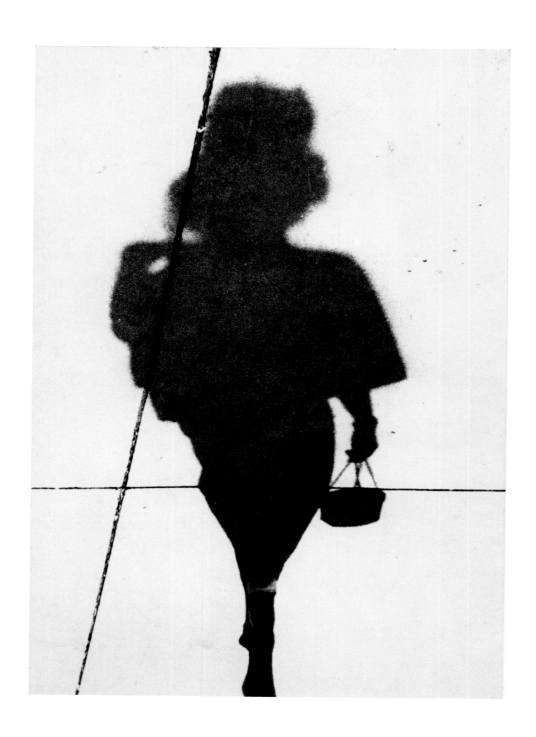

Marvin E. Newman, Untitled, 1951

72

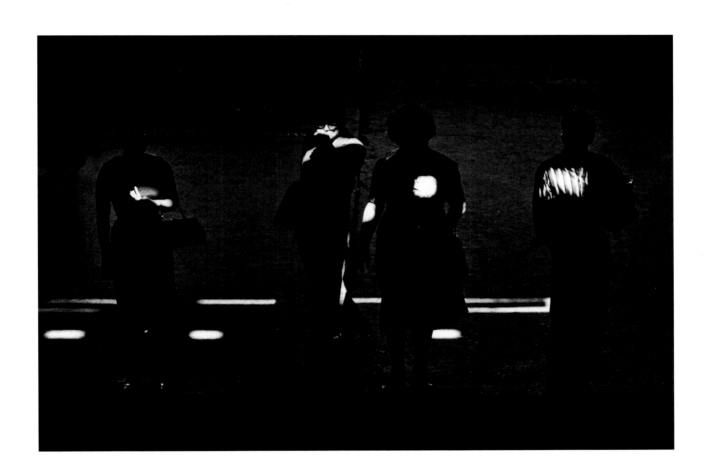

Kenneth Josephson, Chicago, 1961

73

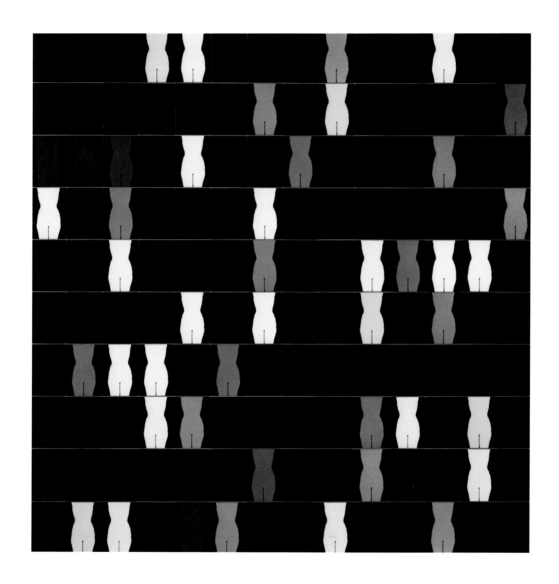

Ray K. Metzker, Nude (Flashed) Torso, 1966

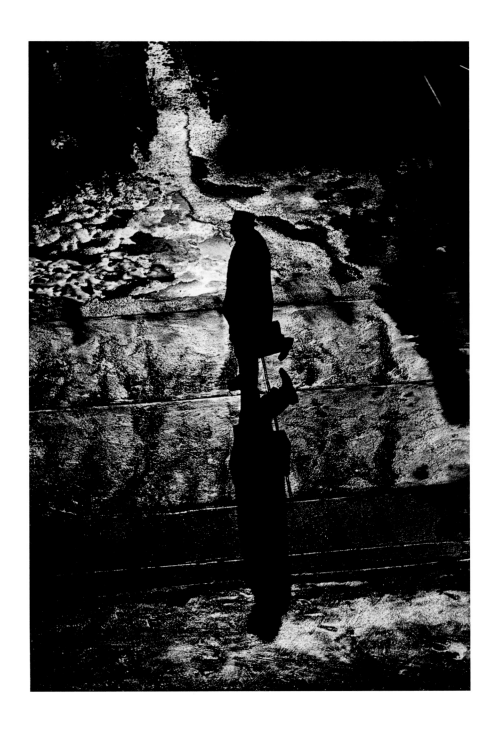

Ray K. Metzker, Philadelphia, 1964

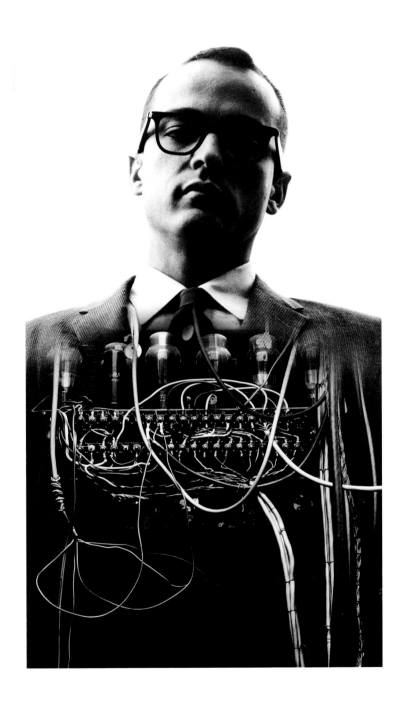

Jerry N. Uelsmann, Mechanical Man #2, 1959

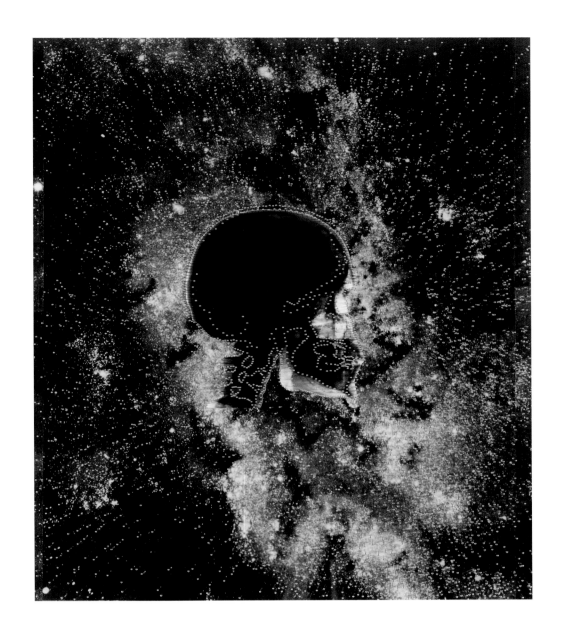

Lucas Samaras, Skull & Milky Way, 1966

77

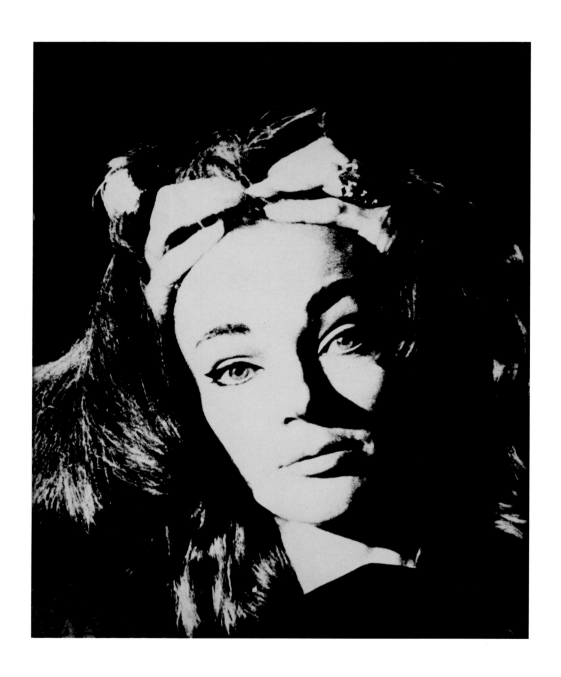

Billy Name, Ivy Nicholson, 1966

78

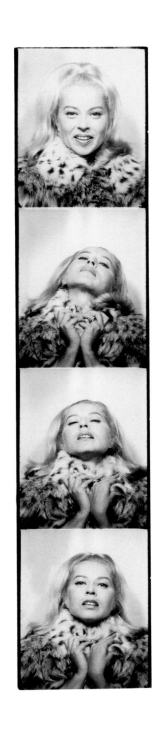

Andy Warhol, Holly Solomon, 1966

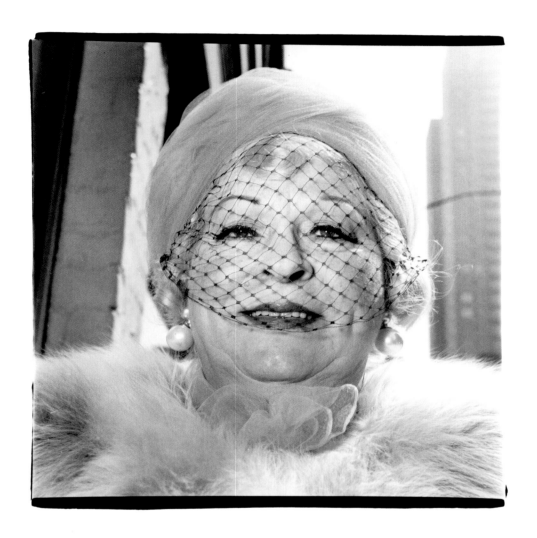

Diane Arbus, Woman with a Veil on Fifth Avenue, N.Y.C., 1968

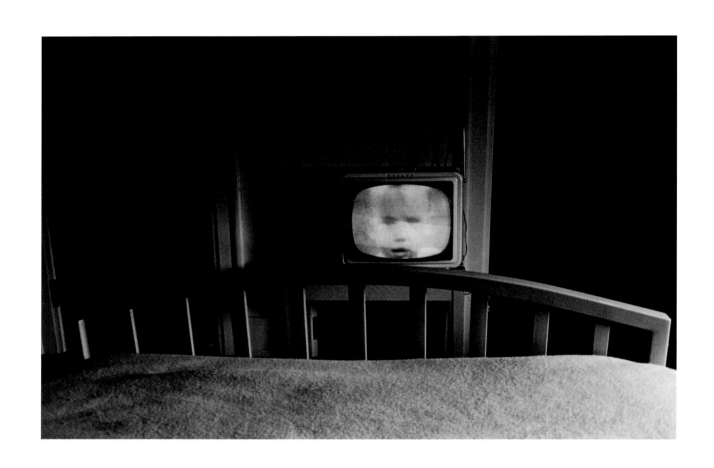

Lee Friedlander, Galax, Virginia, 1962

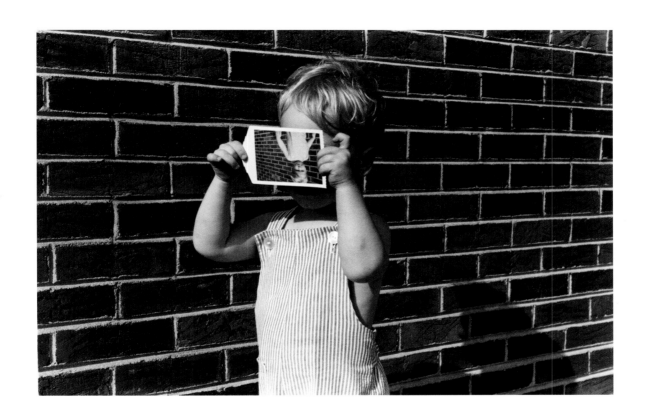

Kenneth Josephson, Matthew, 1965

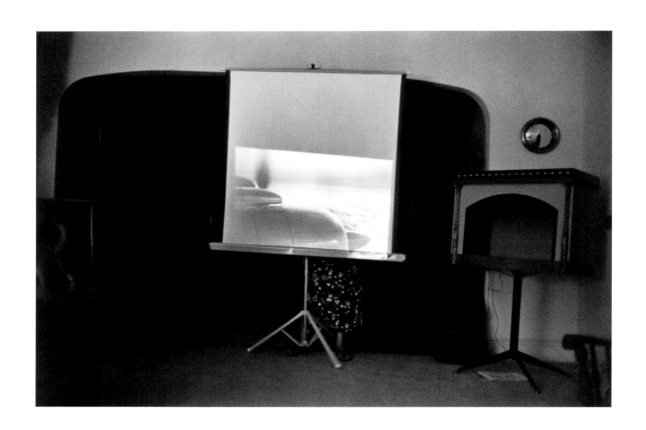

Joel Meyerowitz, New Jersey, 1965

84

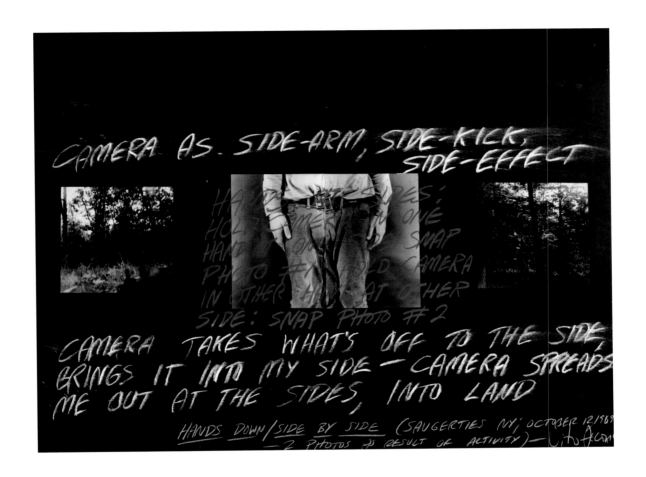

Vito Acconci. Hands Down/Side by Side. 1969

 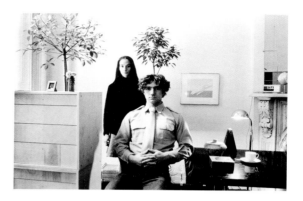

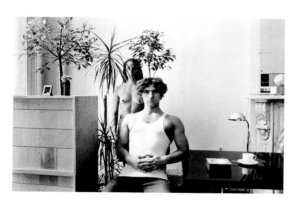 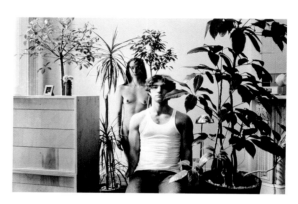

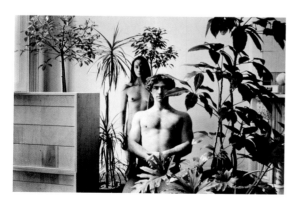 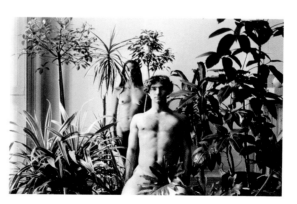

Duane Michals, Paradise Regained, 1968

86

AN ARTIST IS NOT MERELY THE SLAVISH
ANNOUNCER OF A SERIES OF FACTS,
WHICH IN THIS CASE THE CAMERA HAS
HAD TO ACCEPT AND MECHANICALLY
RECORD.

John Baldessari, An Artist Is Not Merely the Slavish Announcer..., 1966–68

Mel Bochner, Roll, 1968

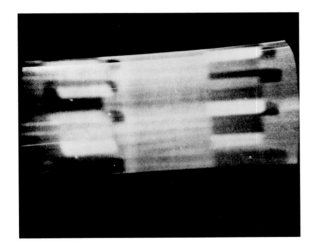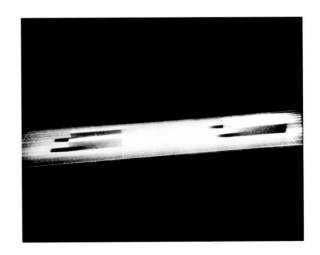

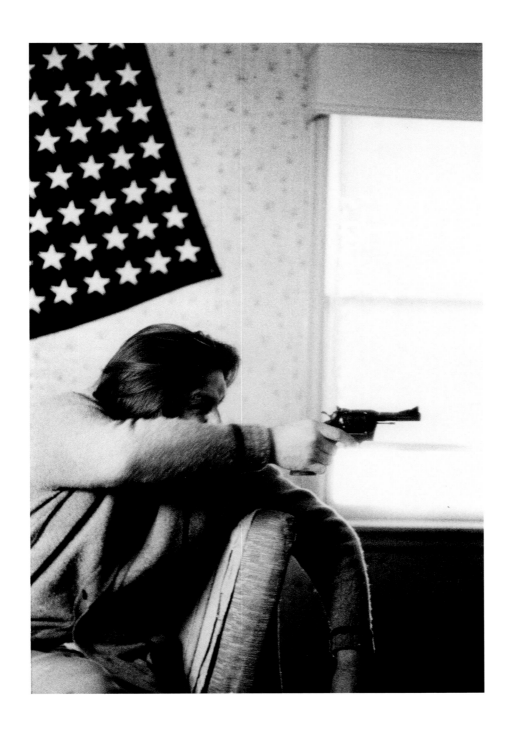

Larry Clark, *Untitled*, 1971

91

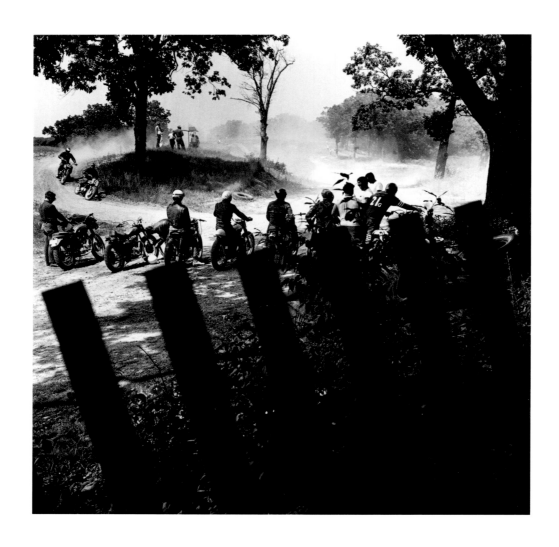

Danny Lyon, Scrambles Track, McHenry, Illinois, 1965

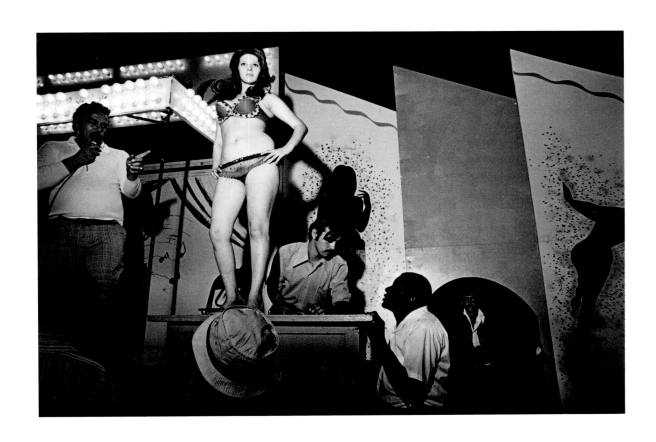

Susan Meiselas, Lena on the Bally Box, Essex Junction, Vermont, 1973

93

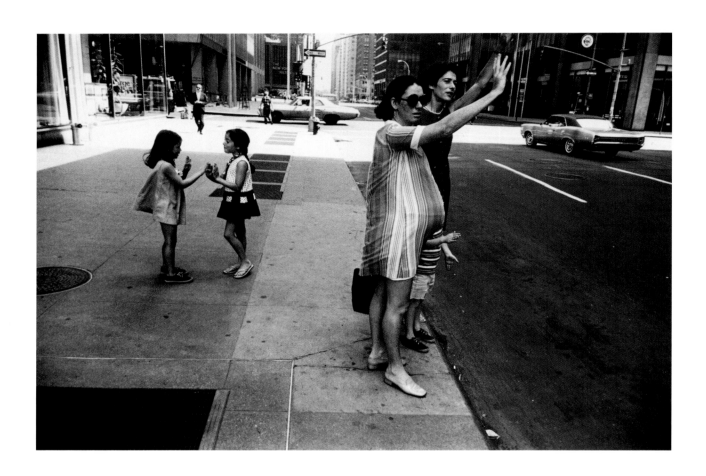

Garry Winogrand, New York, 1968

94

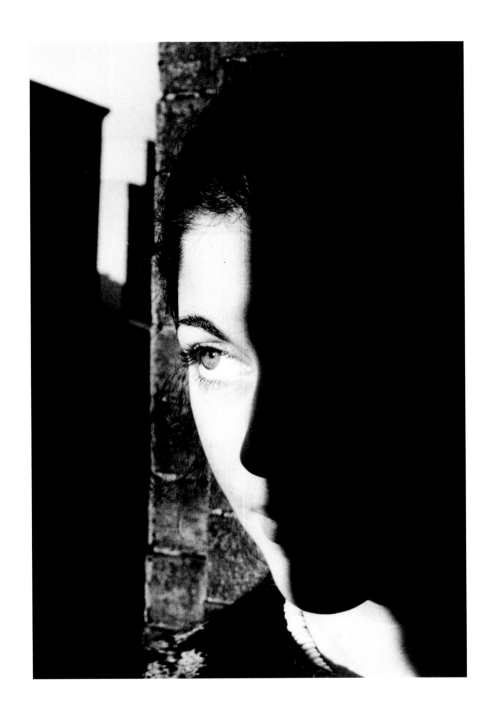

Ralph Gibson, Untitled, 1974

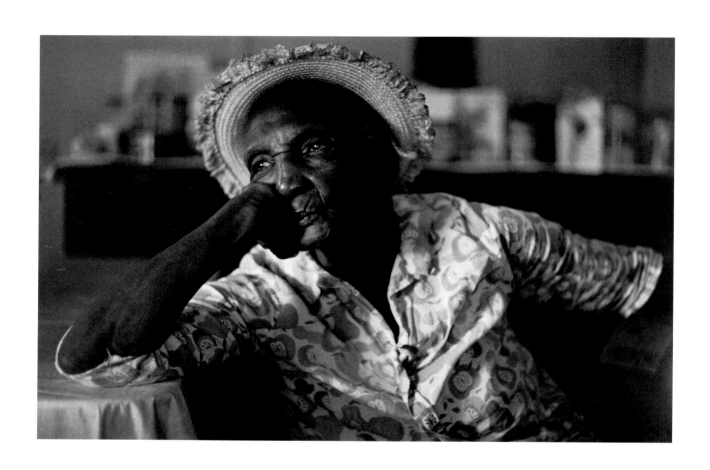

Jeanne Moutoussamy-Ashe, Miss Bertha, South Carolina, 1977

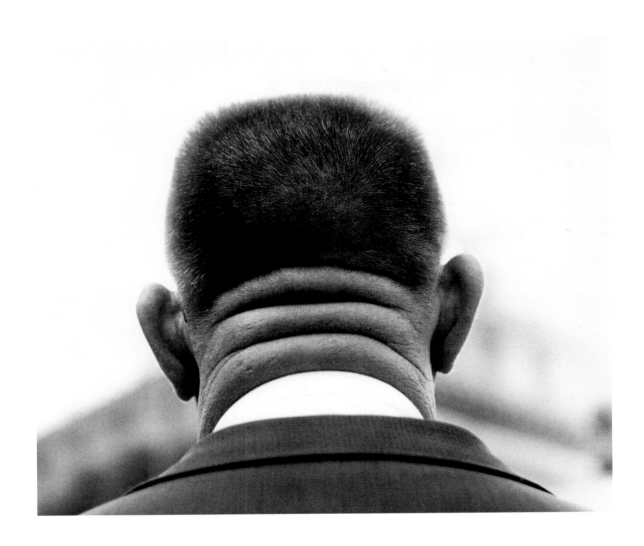

Leon Levinstein, San Francisco, 1973

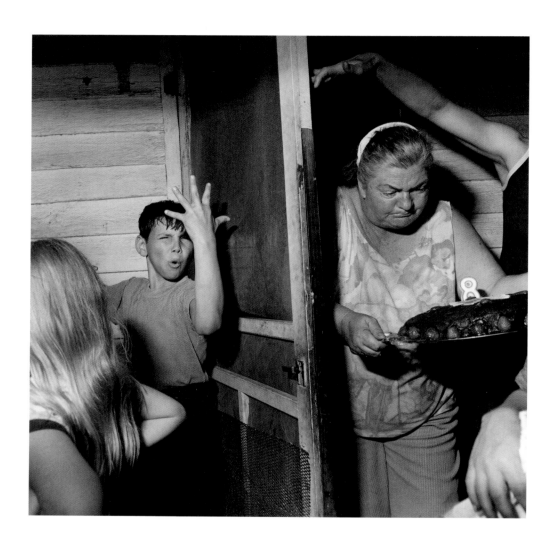

Larry Fink, Pat Sabatine's Eighth Birthday Party, 1977

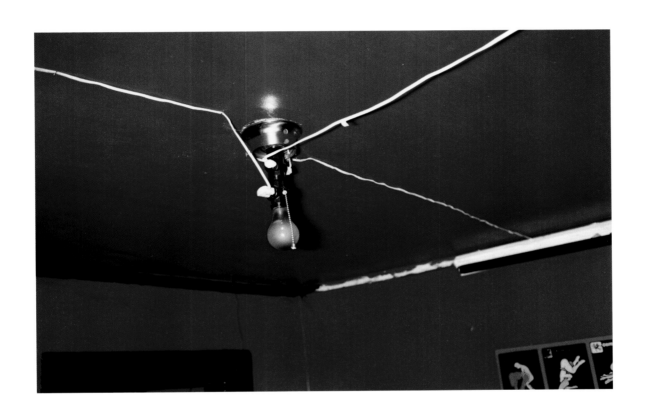

William Eggleston, Greenwood, Mississippi, 1973

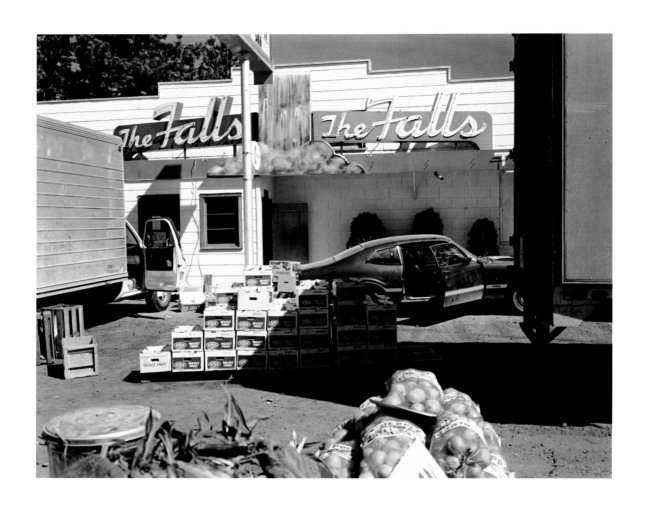

Stephen Shore, U.S. 10, Post Falls, Idaho, August 25, 1974, 1974

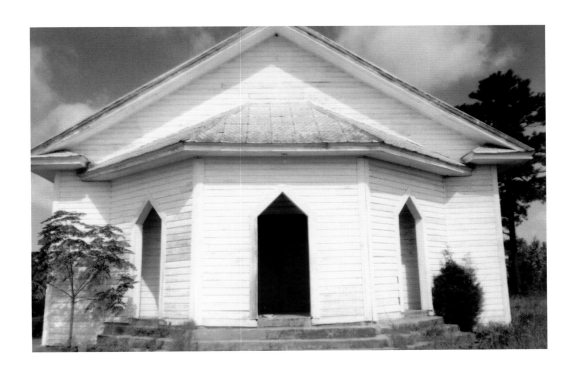

William Christenberry, *Church, Near Moundville, Alabama,* 1976

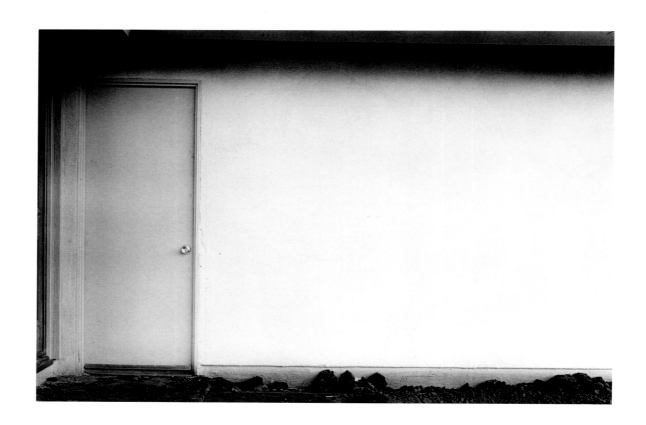

Lewis Baltz, Tract House #10, 1971

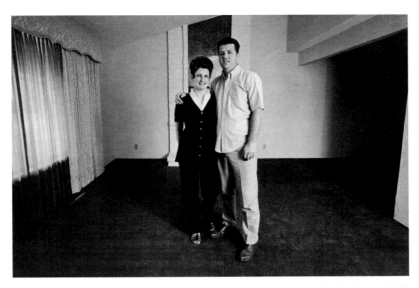

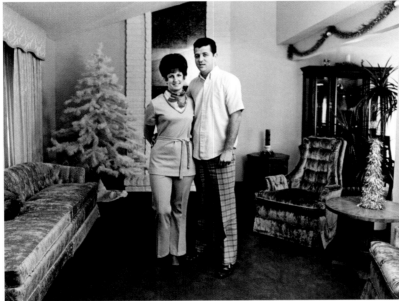

We lived in our house for a year without any living room furniture.
We wanted to furnish the room with things we loved, not early attic or leftovers.
Now we have everything but the pictures and the lamps.

Bill Owens, Untitled, 1970

103

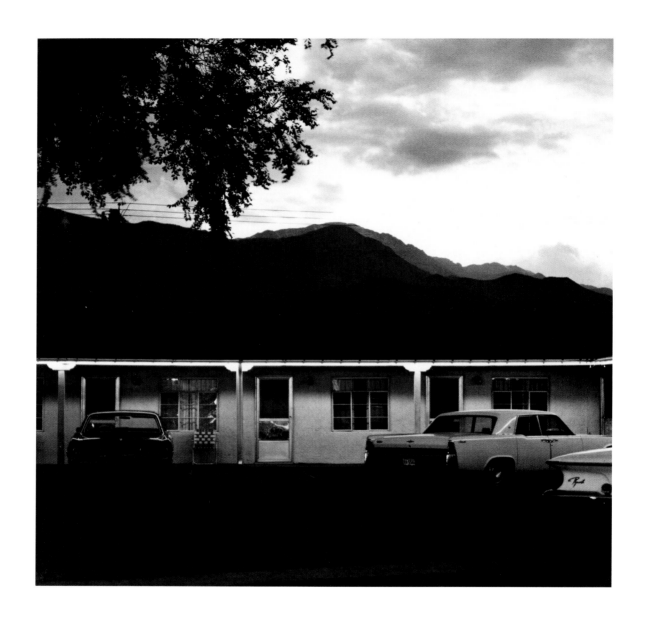

Robert Adams, Motel, 1969

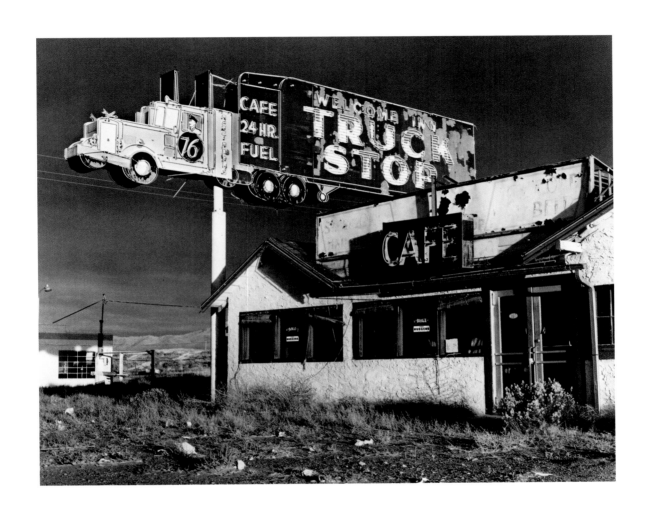

Steve Fitch, Untitled from *American Highway*, 1971–76

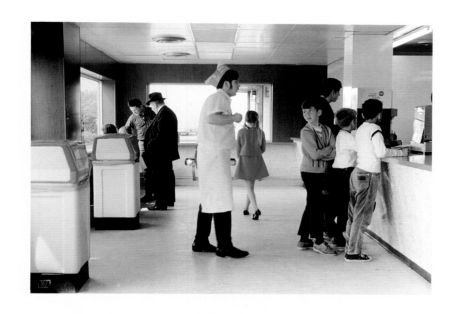

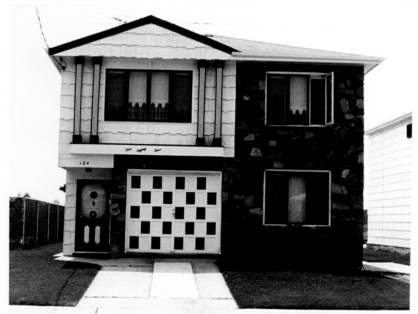

Dan Graham, New Highway Restaurant, Jersey City, 1967; 2 House Home,
Staten Island, New York, 1978, 1967/1978

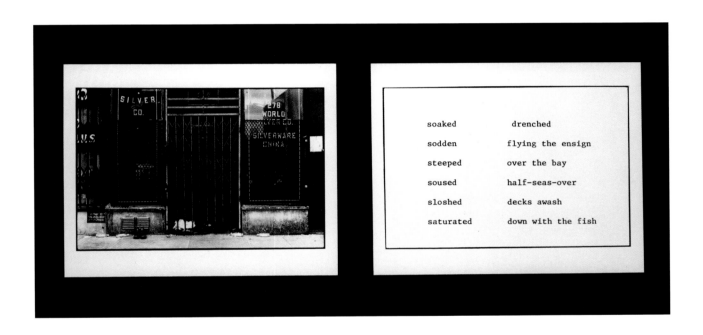

Martha Rosler, The Bowery in two inadequate descriptive systems, 1974–75 (detail)

107

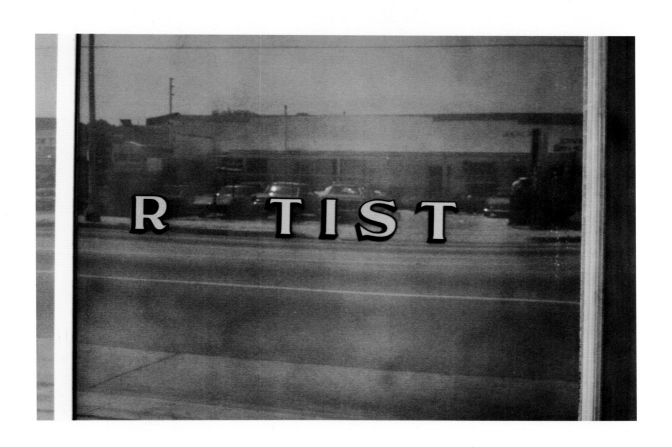

Alexis Smith, R TIST, c. 1980

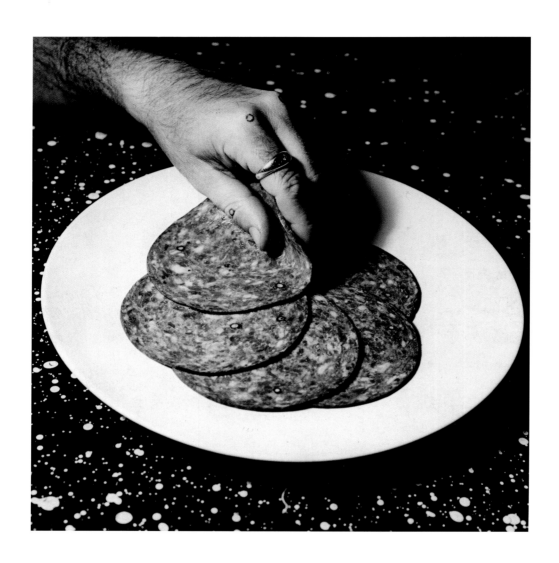

William Wegman, Cotto, 1970

110

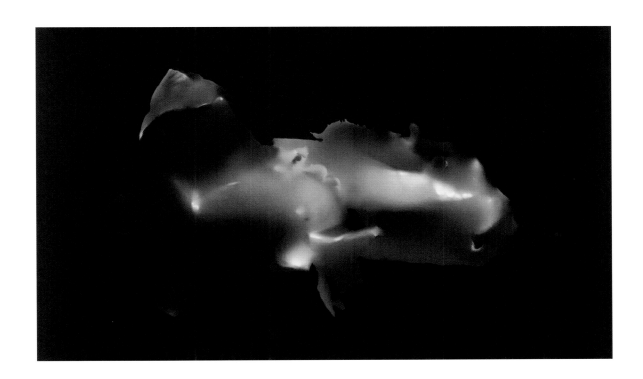

Robert Heinecken, P is for Potato Chips, 1971

Slide Disolve Sequence for <u>GROUND GEL</u>. 1972. Dennis Oppenheim and Chandra Oppenheim. 35mm color film with sound. Excerpt from soundtrack: I don't want to be able to see you...want you to go past me...want to go out there and touch you...You're going past me soon...You're going to take me past myself...I'm going with you...I can't see you now...I want to go out there and touch you...I'm touching you out there...I can be with you...You've taken me with you...I'm out there with you now...I can touch you out there...I can touch you now...You've taken me with you... You've taken me past myself now...

Dennis Oppenheim, Slide Disolve Sequence for <u>GROUND GEL</u>, 1972

112

Gordon Matta-Clark, Conical Intersect, 1975

Robert Cumming, Desk Drawer Stairs—Two Interpretations, 1975

Sandy Skoglund, Peas on a Plate, 1978

115

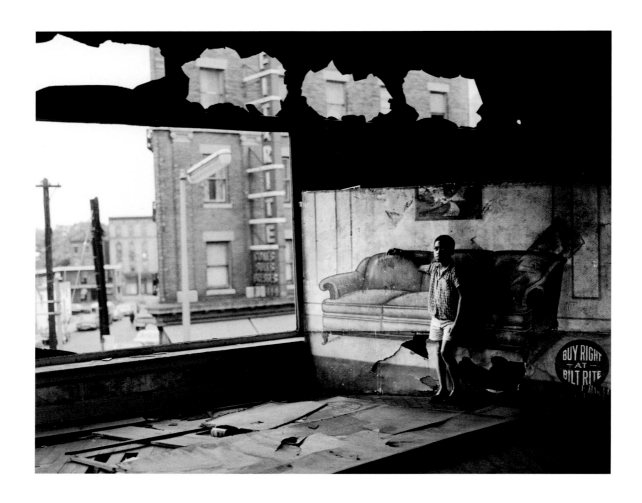

Arthur Tress, Boy in Burnt Out Furniture Store, Newark, N.J., 1969

116

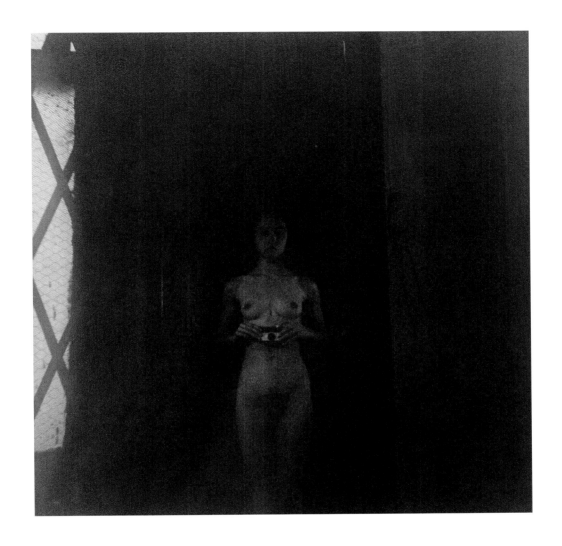

Adrian Piper, *Food for the Spirit*, 1971 (detail)

117

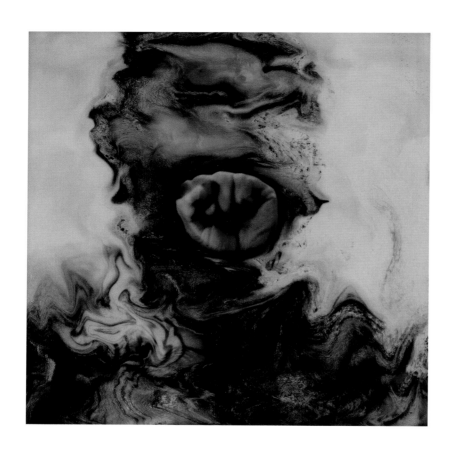

Lucas Samaras, Photo-Transformation, 1973

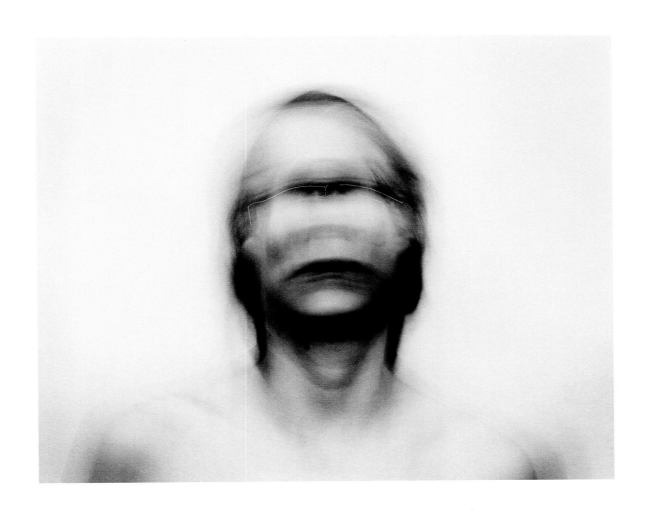

Blythe Bohnen, Self-Portrait: Pivotal Motion from Chin, 1974

119

Ana Mendieta, Untitled (from the Fetish series), 1977

Charles Ray, Untitled, 1973

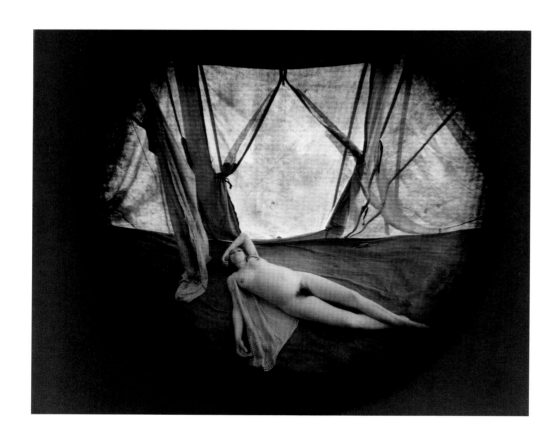

Emmet Gowin, Edith, Newtown, Pennsylvania, 1974

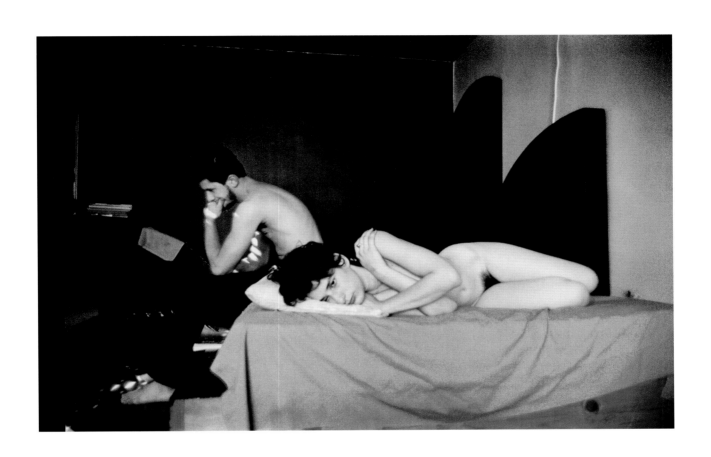

Nan Goldin, Couple in bed, Chicago, 1977

123

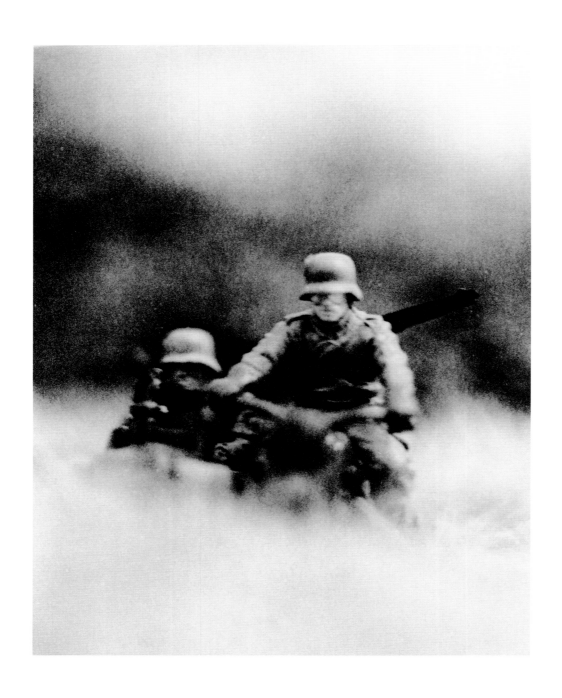

David Levinthal, Untitled, from *Hitler Moves East,* 1975–77

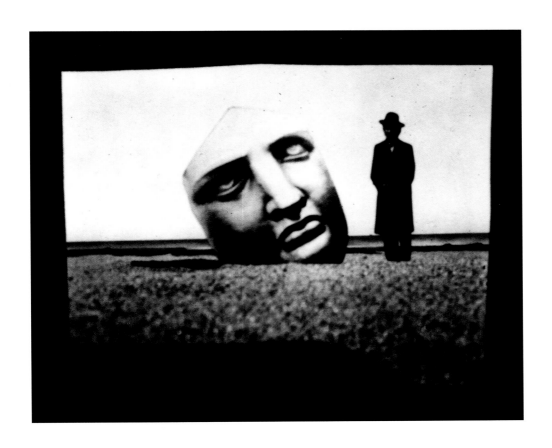

Ruth Thorne-Thomsen, *Liberty Head, Illinois, 1978*

125

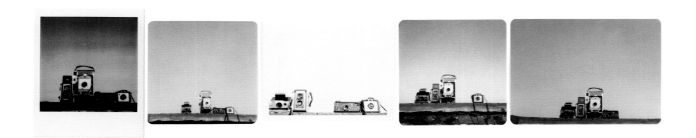

William Anastasi, Untitled (Five Photographs/Five Cameras), 1979

126

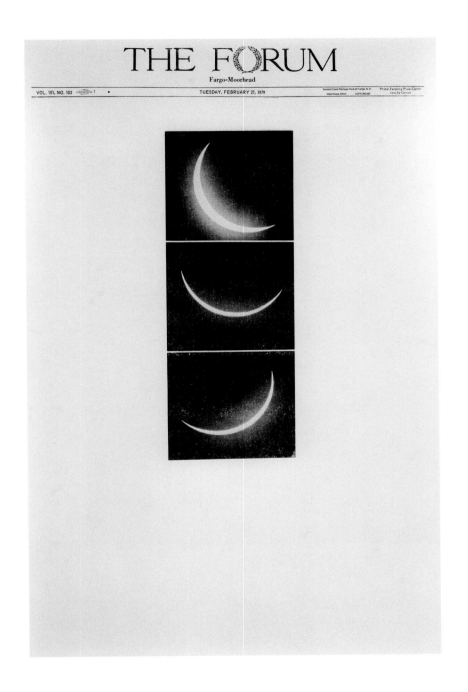

Sarah Charlesworth, The Forum, Fargo-Moorhead,
from *The Arc of the Total Eclipse, February 26, 1979*, 1979

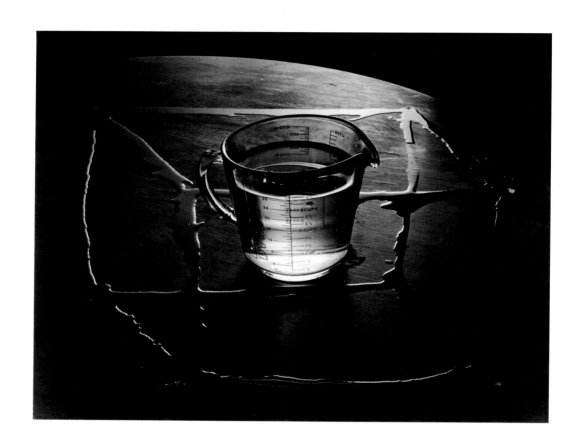

Zeke Berman, Measuring Cup, 1979

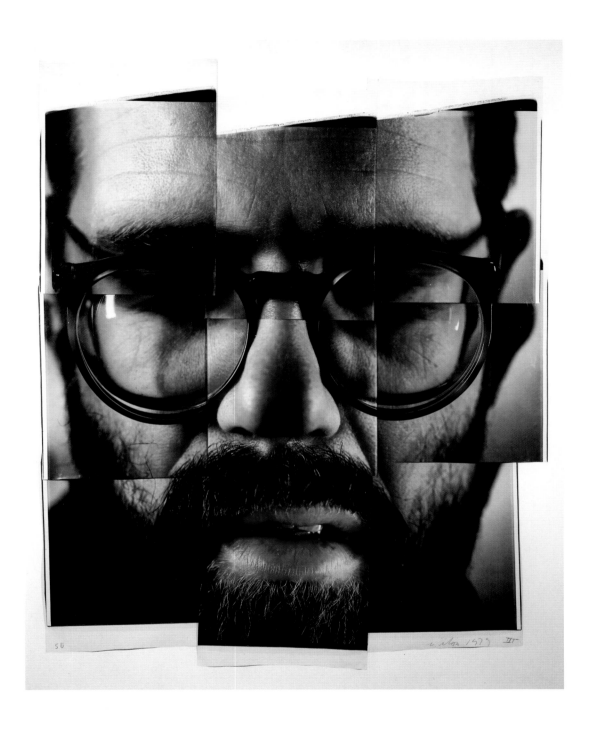

Chuck Close, Self-Portrait/Composite/Nine Parts, 1979

129

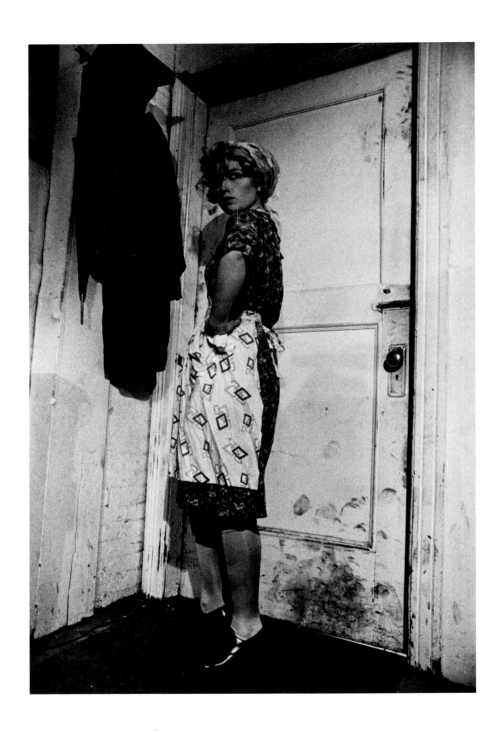

Cindy Sherman, Untitled Film Still #35, 1979

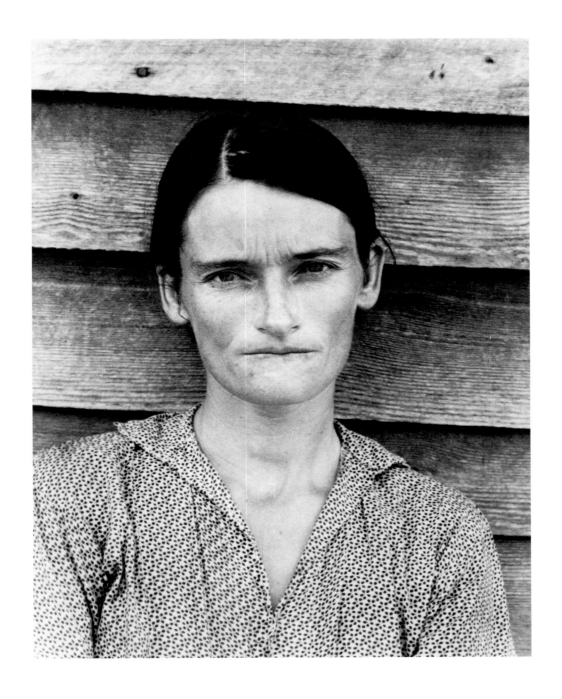

Sherrie Levine, After Walker Evans: 4, 1981

131

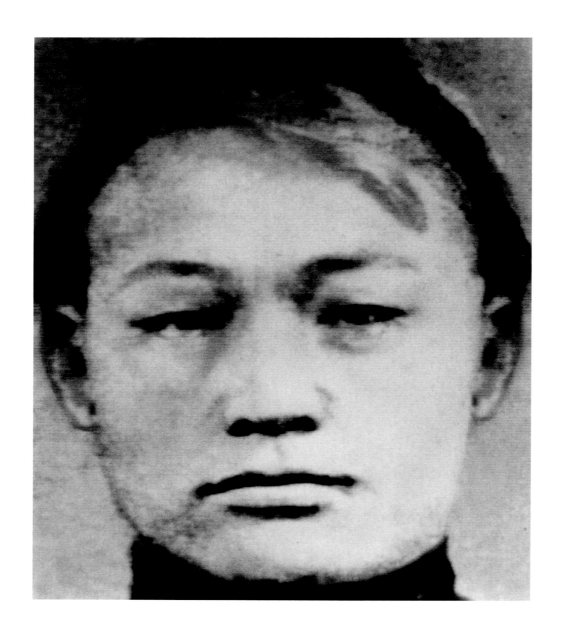

Nancy Burson, Mankind (Oriental, Caucasian and Black weighted according to current population statistics), 1983–85

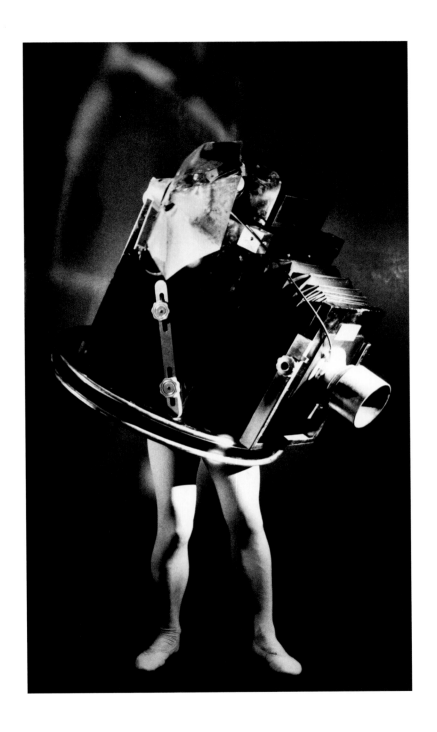

Laurie Simmons, Walking Camera II (Jimmy the Camera), 1987

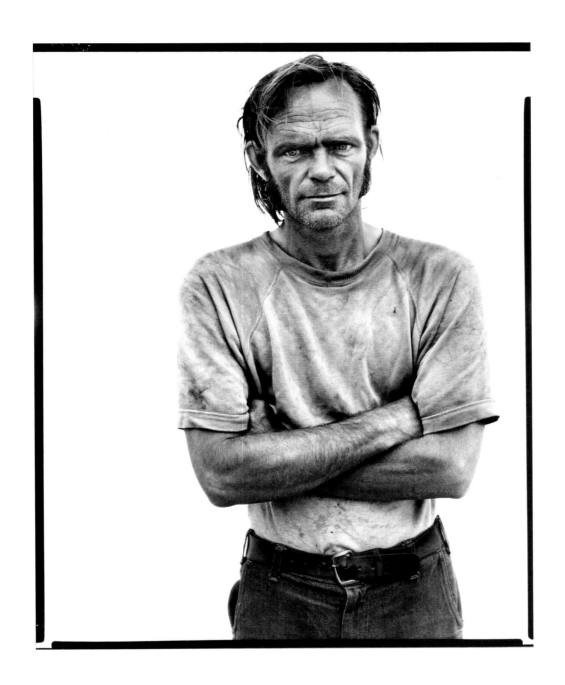

Richard Avedon, Bill Curry, Drifter, Interstate 40, Yukon, Oklahoma, 6/16/80, 1980

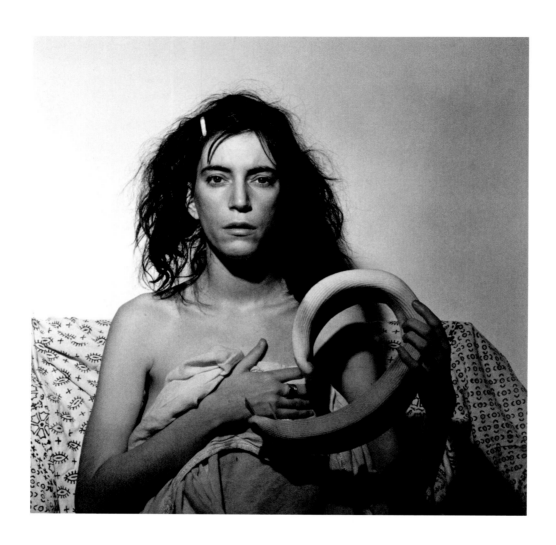

Robert Mapplethorpe, Patti Smith, 1978

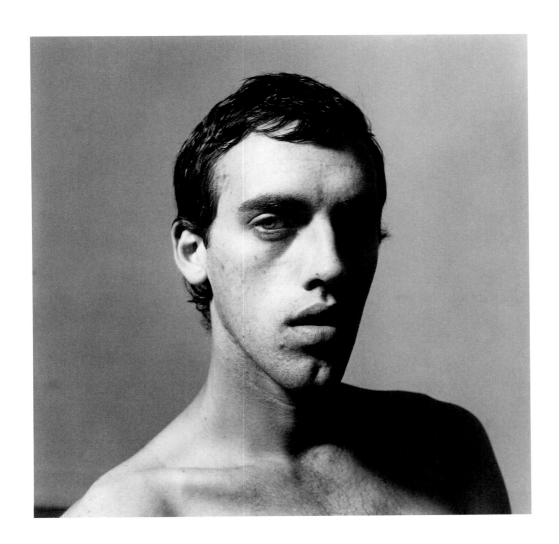

Peter Hujar, David Wojnarowicz, 1981

137

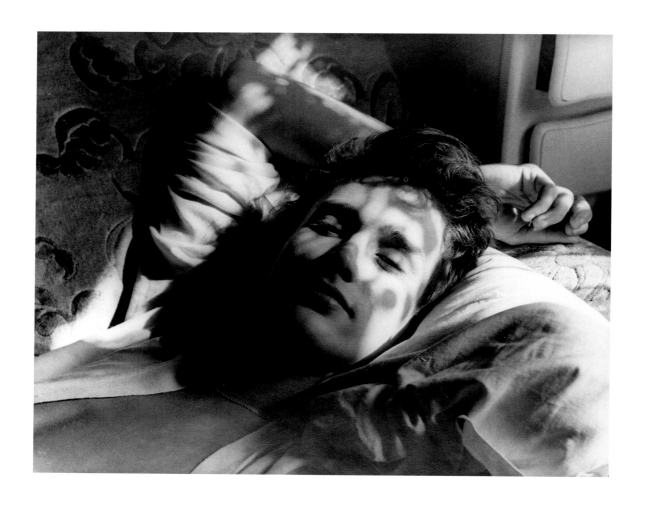

David Armstrong, Chris on the Couch, rue André-Antoine, Paris, 1980

138

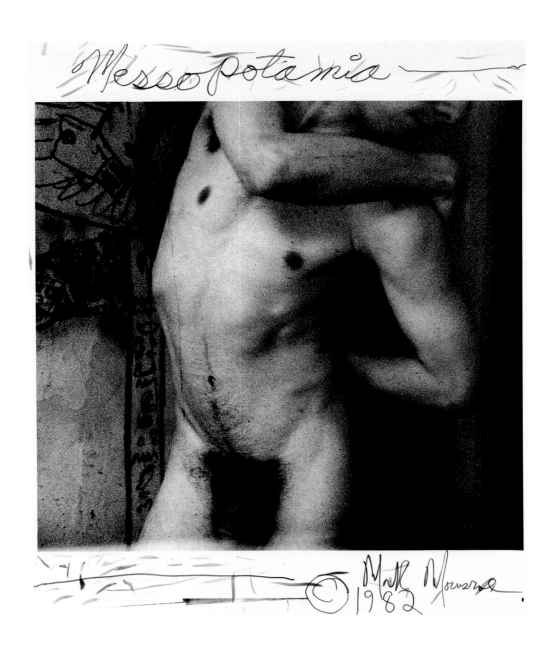

Mark Morrisroe, Messopotamia, 1982

139

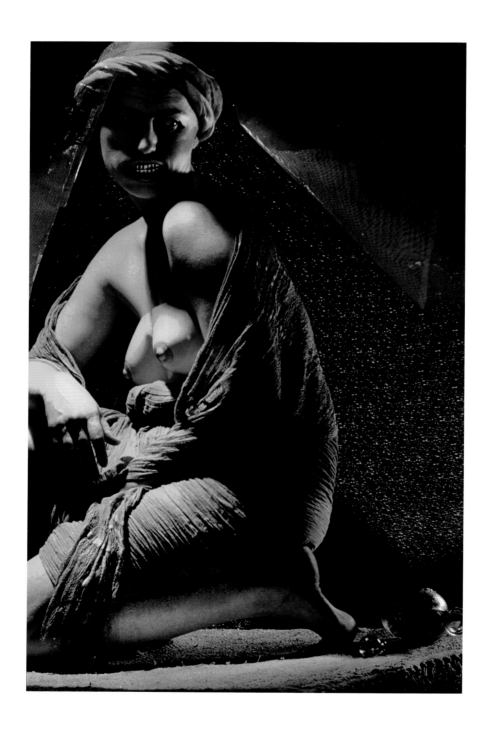

Cindy Sherman, Untitled #146, 1985

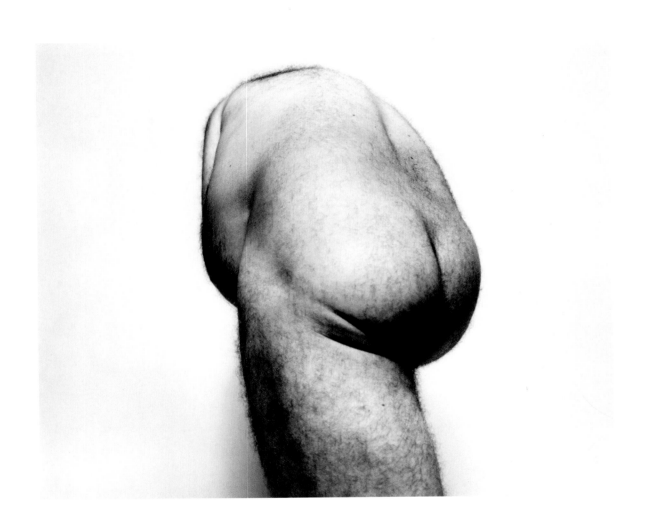

John Coplans, Self-Portrait (Back Torso from Below), 1985

141

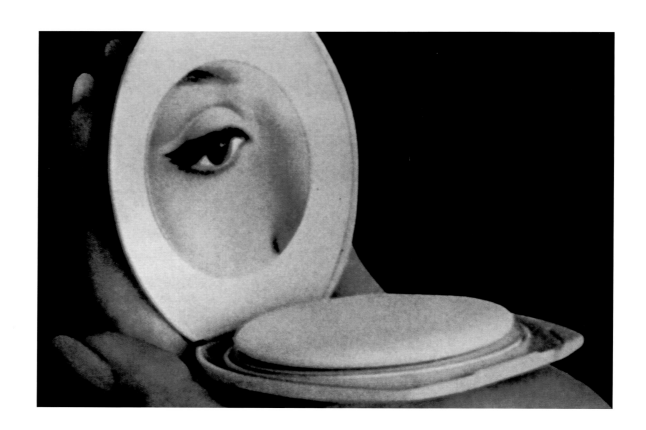

Richard Prince, Untitled, 1983

142

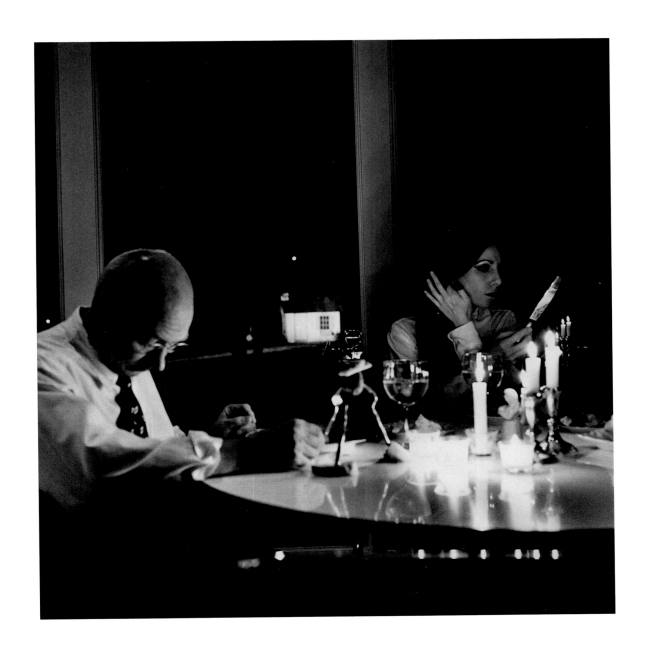

Nic Nicosia, Untitled #5, 1991

143

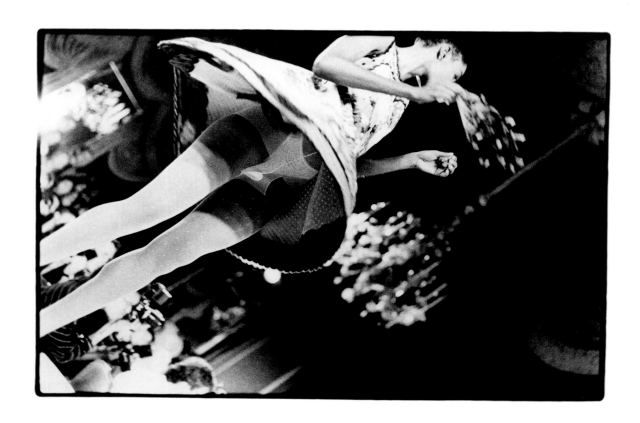

Zoe Leonard, Frontal View, Geoffrey Beene Fashion Show, 1990

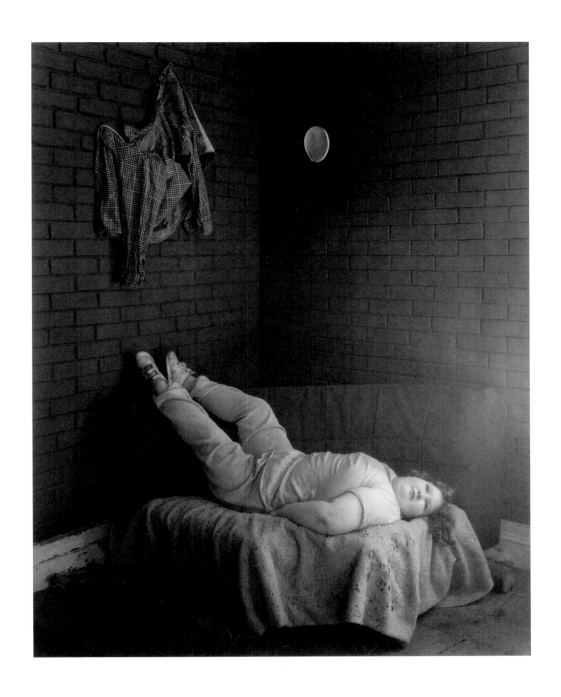

Andrea Modica, Treadwell, New York, 1992

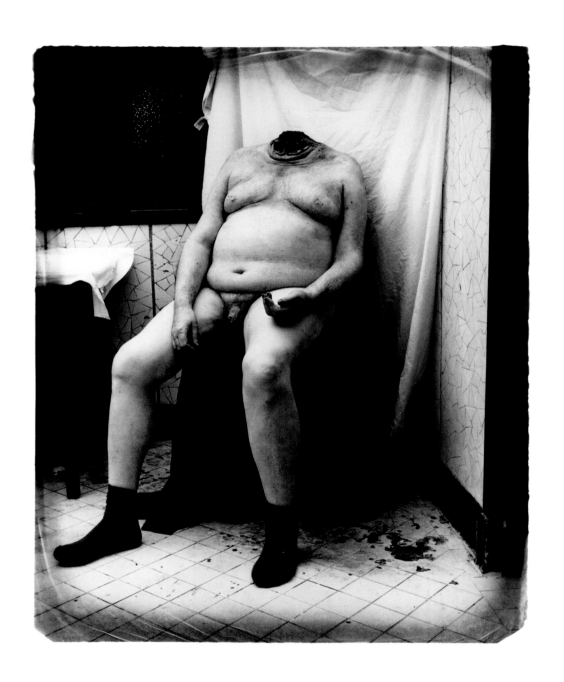

Joel-Peter Witkin, Man without a Head, 1993

146

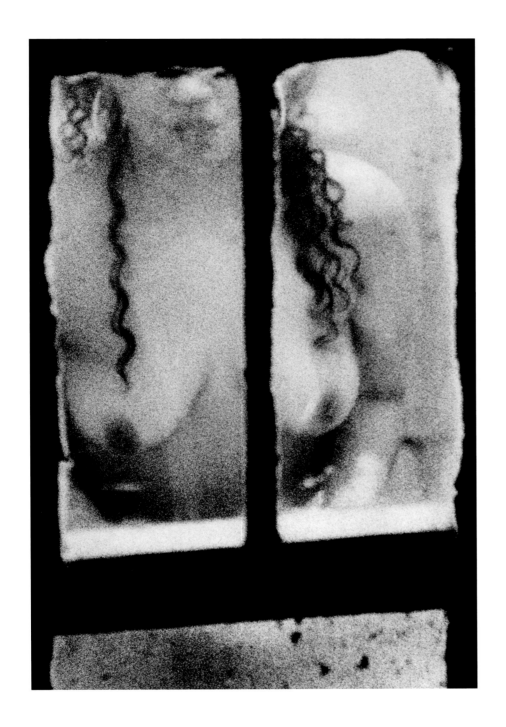

Merry Alpern, #1, The Window Series, 1994

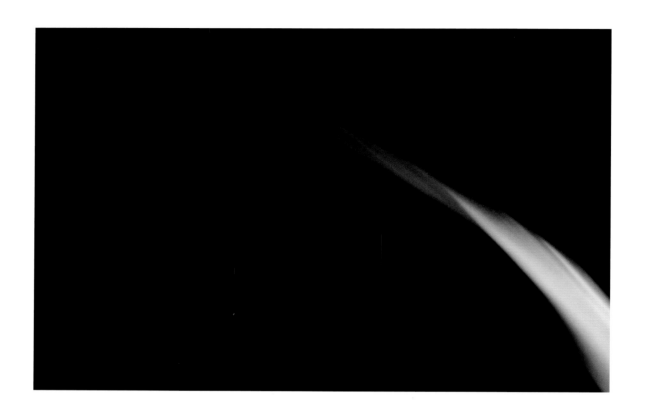

Andres Serrano, *Untitled X (Ejaculate in Trajectory)*, 1989

148

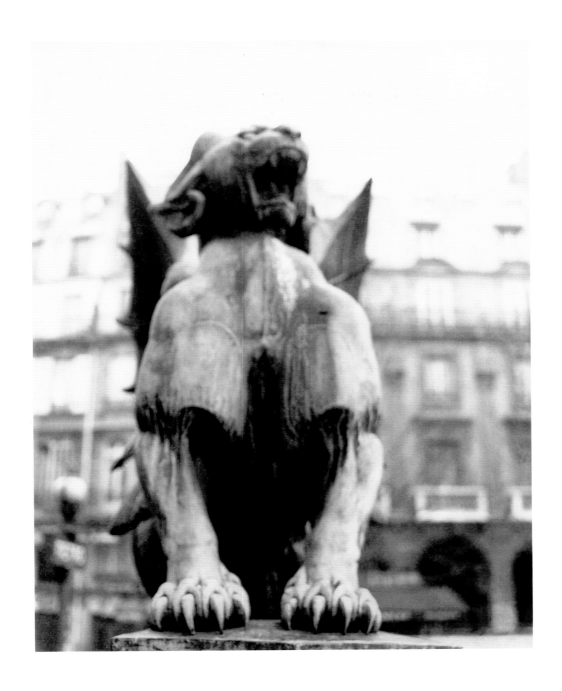

Doug and Mike Starn, Place St. Michel, 1985–87

149

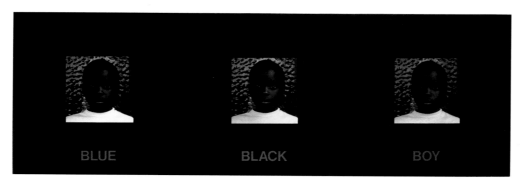

BLUE BLACK BOY

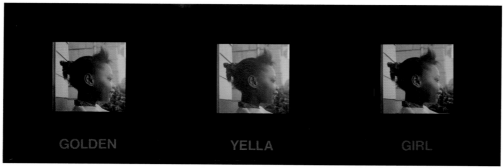

GOLDEN YELLA GIRL

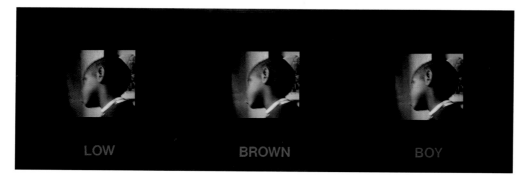

LOW BROWN BOY

Carrie Mae Weems, Blue Black Boy, 1987–88; Golden Yella Girl, 1987–88; Low Brown Boy, 1987–88

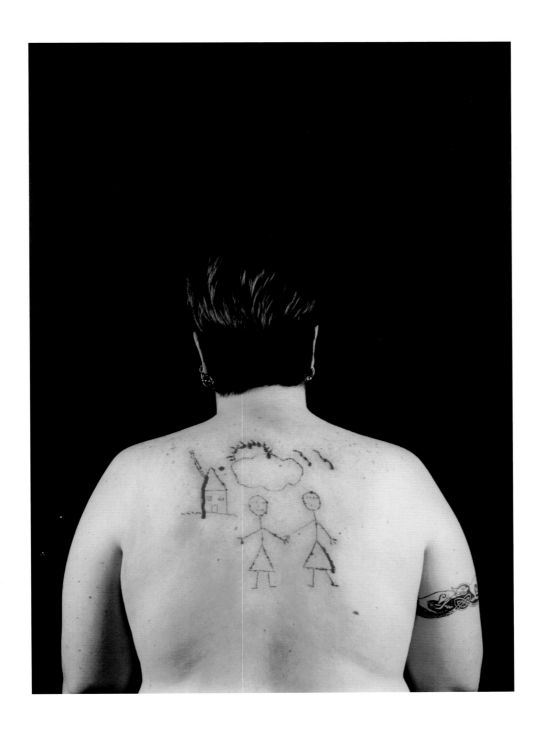

Catherine Opie, Self-Portrait/Cutting, 1993

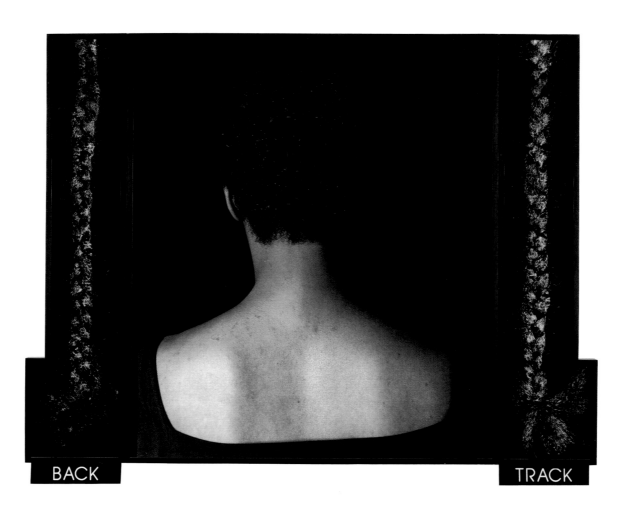

BACK TRACK

Lorna Simpson, 2 Tracks, 1990

152

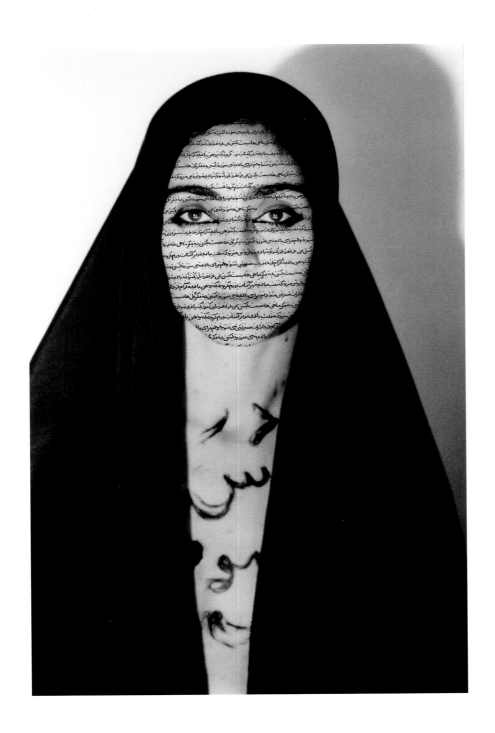

Shirin Neshat, Unveiling, 1993

153

Sometimes I come to hate people because they can't see where I am. I've gone empty, completely empty and all they see is the visual form; my arms and legs, my face, my height and posture, the sounds that come from my throat. But I'm fucking empty. The person I was just one year ago no longer exists; drifts spinning-slowly into the planet somewhere way back there. I'm a xerox of my former self. I can't abstract my own dying any longer. I am a stranger to others and to myself and I refuse to pretend that I am familiar or that I have history attached to my heels. I am glass, clear empty glass. I see the others spinning behind and through me. I see casualness and mundane effect of gesture made by constant repetitions. I look familiar but I am a complete stranger being mistaken for my former selves. I am a stranger and I am moving. I am moving on two legs soon to be on all fours. I am no longer animal vegetable or mineral. I am no longer made of circuits or disks. I am no longer coded and deciphered. I am all emptiness and futility. I am an empty stranger, a carbon copy of my form. I can no longer find what I'm looking for outside of myself. It doesn't exist out there. Maybe it's only in here, inside my head. But my head is glass and my eyes have stopped being cameras, the tape has run out and nobody's words can touch me. No gesture can touch me. I've been dropped into all this from another world and I can't speak your language any longer. See the signs I try to make with my hands and fingers, see the vague movements of my lips among the sheets. I'm a blank spot in a hectic civilization. I'm a dark smudge in the air that dissolves without notice. I feel like a window, maybe a broken window. I am a glass human. I am a glass human disappearing in rain. I am standing among all of you waving my invisible arms and hands. I am shouting my invisible words. I am getting so weary. I am growing tired. I am waving to you from here. I am crawling and looking for the aperture of complete and final emptiness. I am vibrating in isolation among you. I am screaming but it comes out like pieces of clear ice. I am signalling that the volume of all this is too high. I am waving. I am waving my hands. I am disappearing. I am disappearing but not fast enough.

David Wojnarowicz, Untitled, 1992

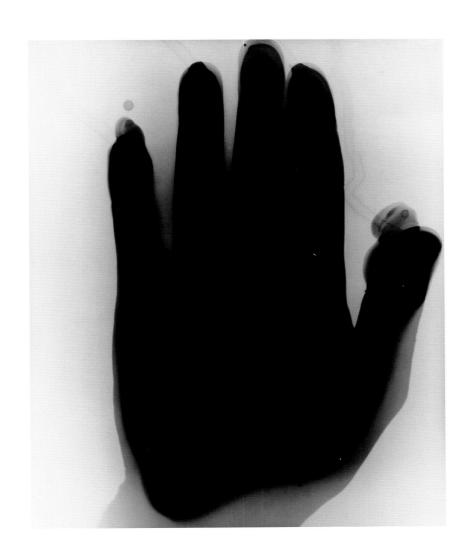

Gary Schneider, After Peter, Fall 1993, 1993

155

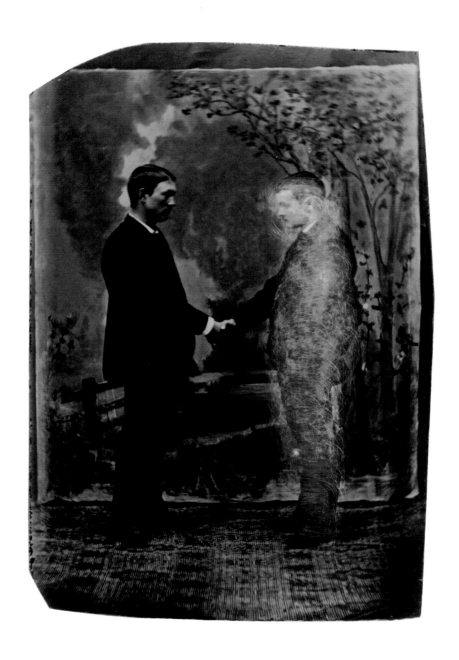

Annette Lemieux, Apparition, 1989

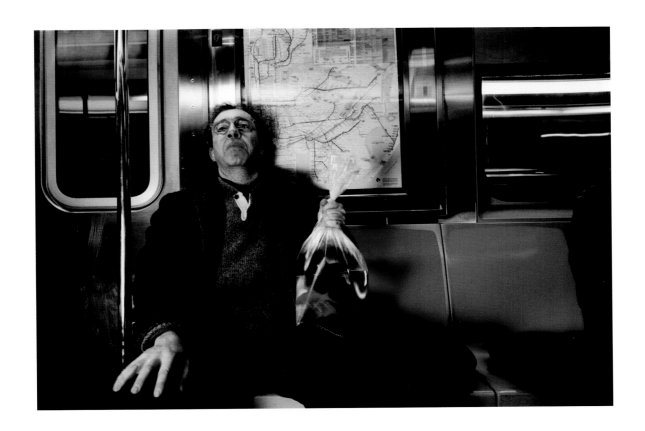

Philip-Lorca diCorcia, Igor, 1987

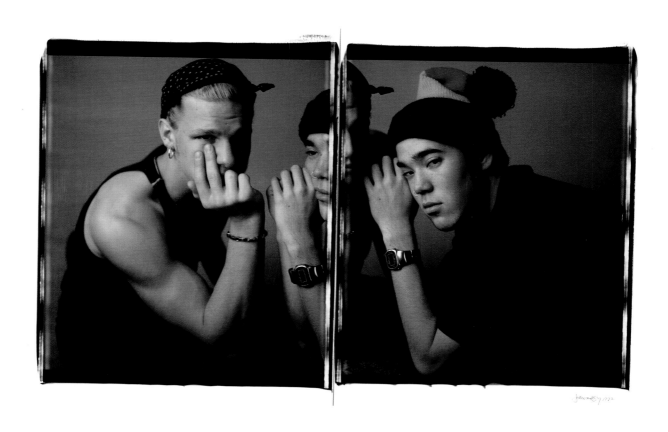

Dawoud Bey, *Hillary and Taro*, 1992

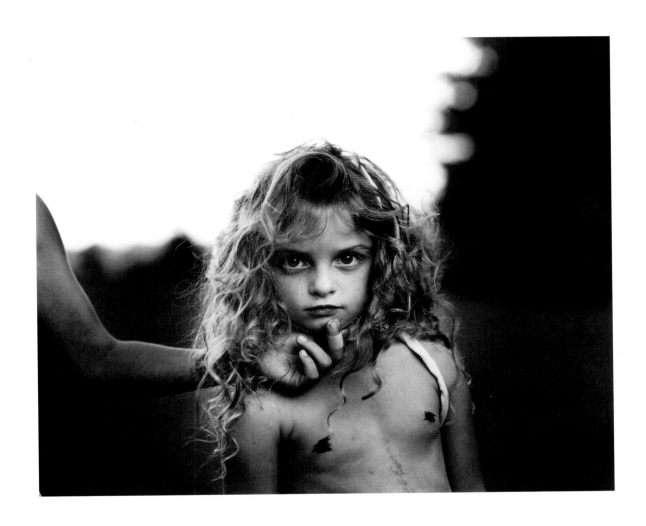

Sally Mann, *Virginia at 5*, 1990

159

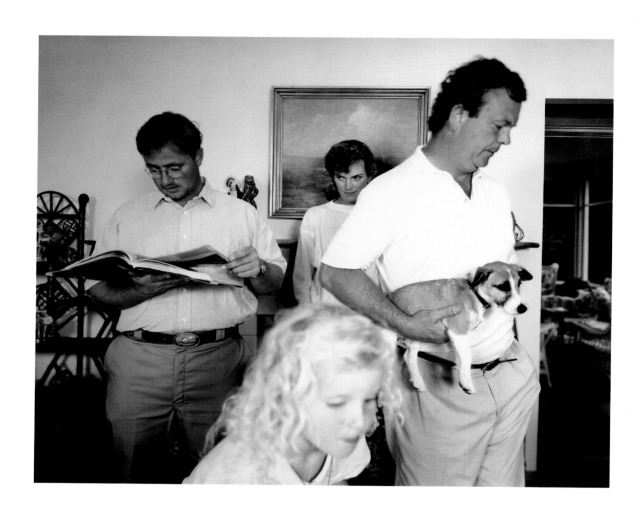

Tina Barney, *The Landscape*, 1988

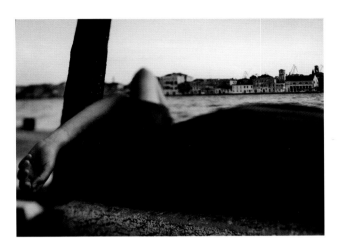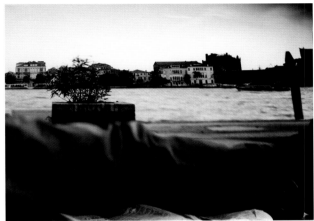

JoAnn Verburg, Nap Along the Zattere, 1997

161

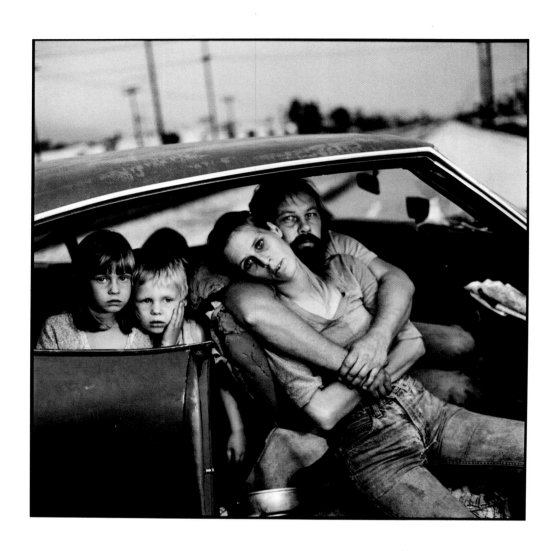

Mary Ellen Mark, The Damm Family in Their Car, Los Angeles, California, 1987

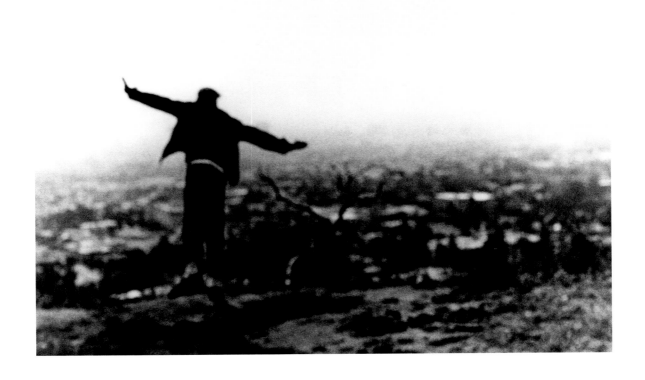

Jim Goldberg, Playing Chicken, Flynn Squat, 1988–89

163

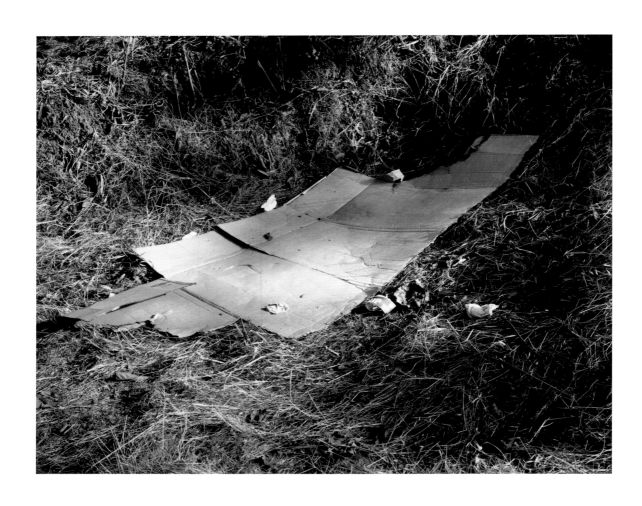

Anthony Hernandez, Landscapes for the Homeless, #17, 1989

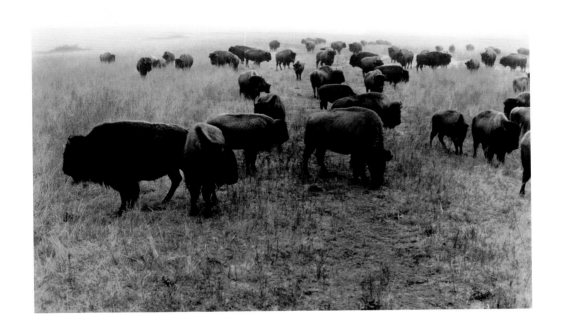

Terry Evans, Bison at Maxwell Game Preserve, Roxbury, Kansas, December 1981, 1981

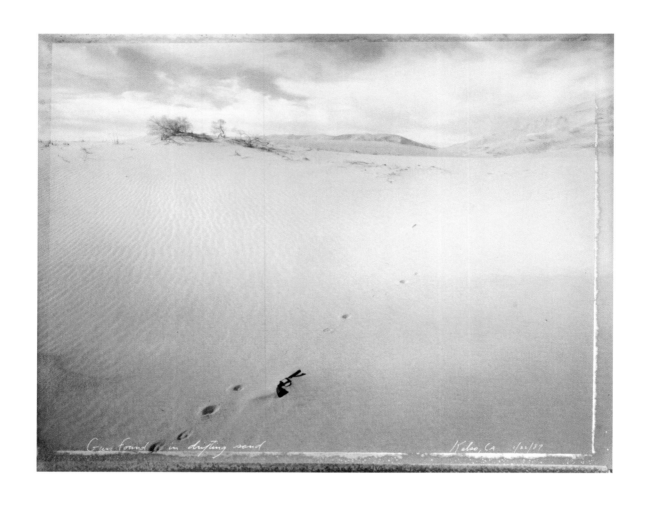

Mark Klett, Gun Found in Drifting Sand, Kelso, California, January 22, 1987, 1987

166

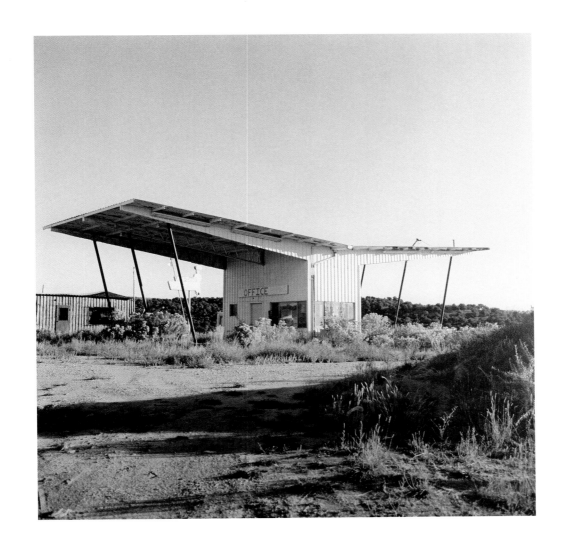

Lynn Davis, Abandoned Motel, Moab, Utah, 1999

167

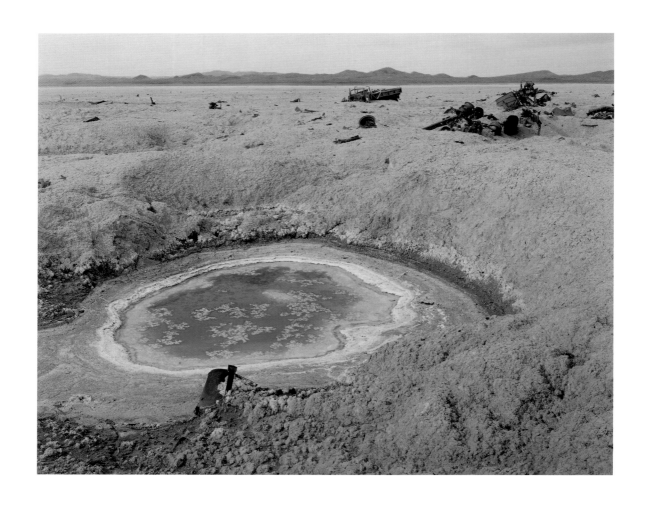

Richard Misrach, Bomb Crater and Destroyed Convoy,
Bravo 20 Bombing Range, Nevada, 1986

168

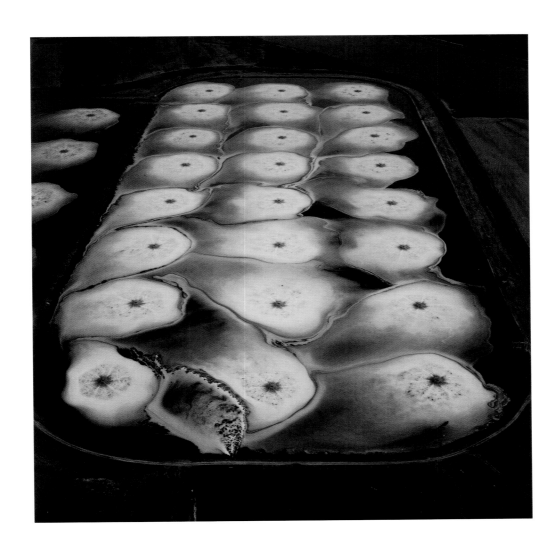

Emmet Gowin, Aeration Pond, Toxic Water Treatment Facility, Pine Bluff, Arkansas, 1989

169

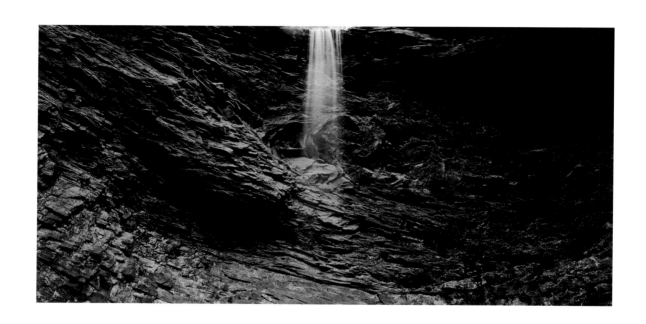

John Pfahl, Ozone Falls, Cumberland Plateau, Tennessee, August 1991, 1991

170

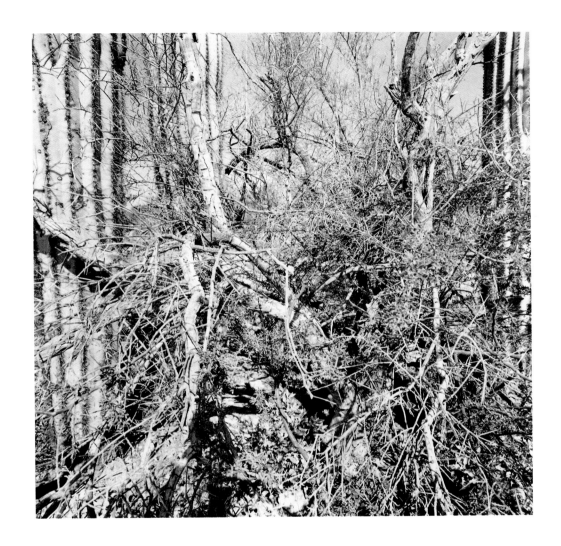

Lee Friedlander, Sonora, 1995

171

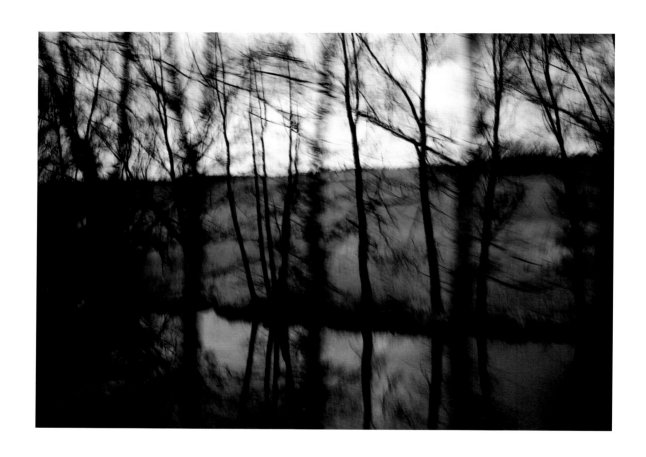

Nan Goldin, Trees by the river, Munich, 1994

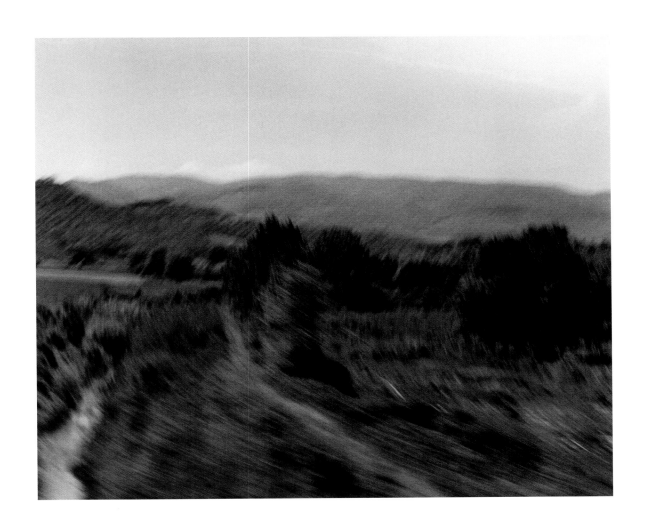

Sharon Harper, Italy Mise en scène viii, 1998

173

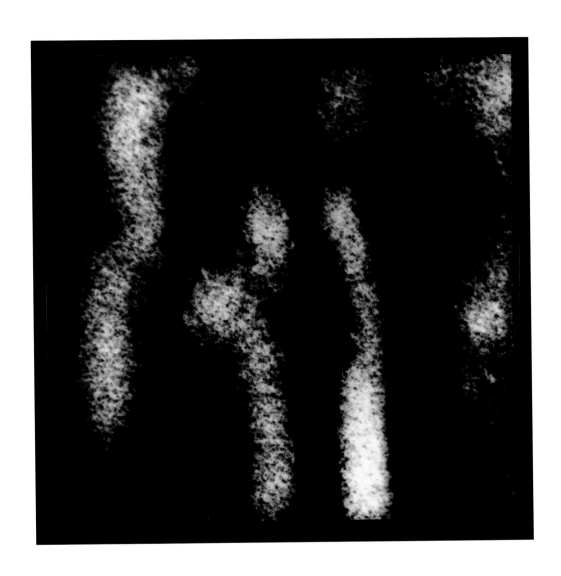

Allan McCollum, Perpetual Photo No. 183 A, 1982–89

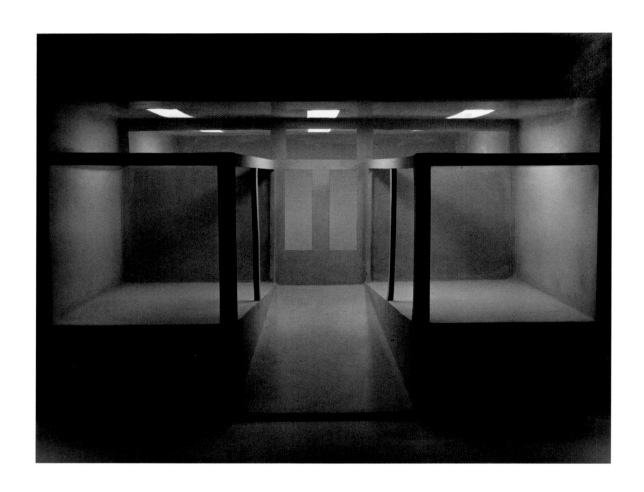

James Casebere, The Storefront, 1982

Uta Barth, *Ground #42, 1994*

177

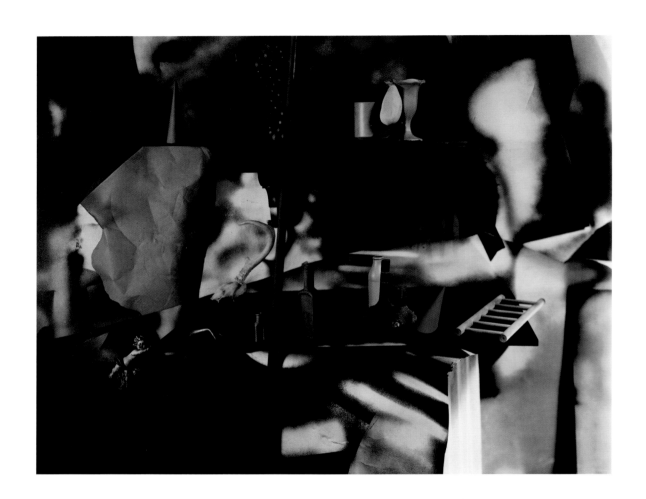

Jan Groover, Untitled, 1989

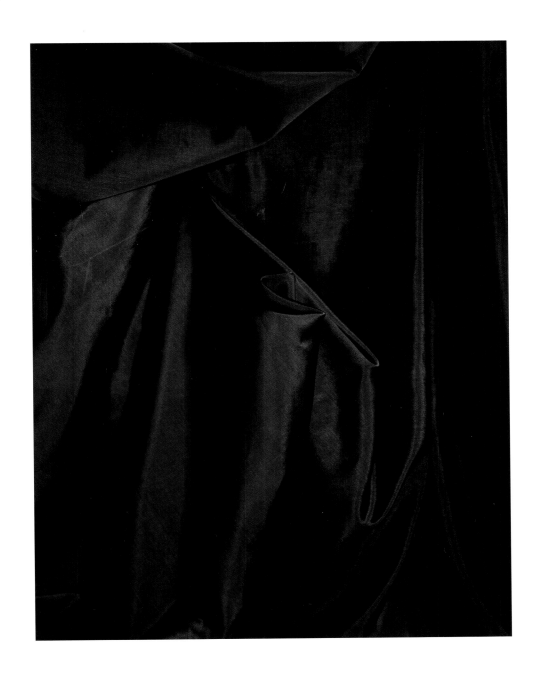

James Welling, XVII, 1988

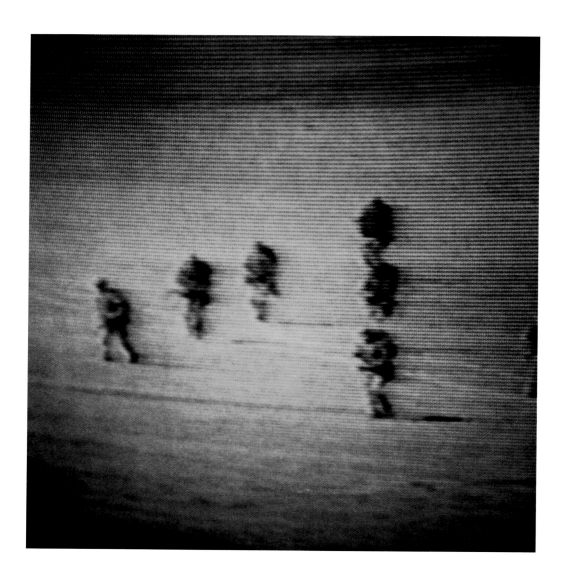

Michal Rovner, Decoy #3, 1991

180

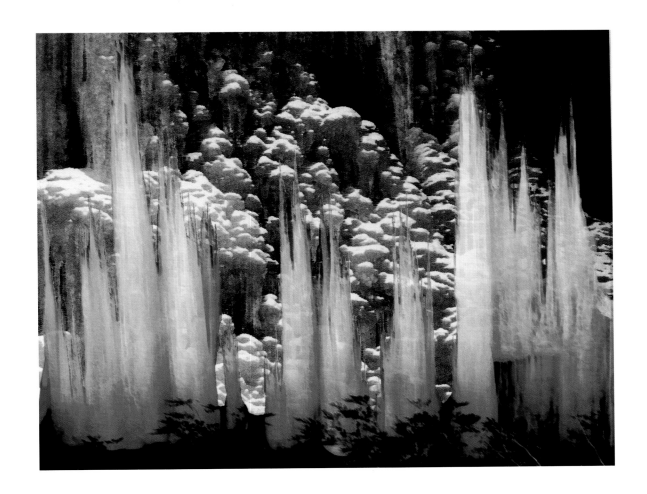

Peter Campus, fire/ice, 1992

181

Ellen Brooks, *Garden Slice*, 1987

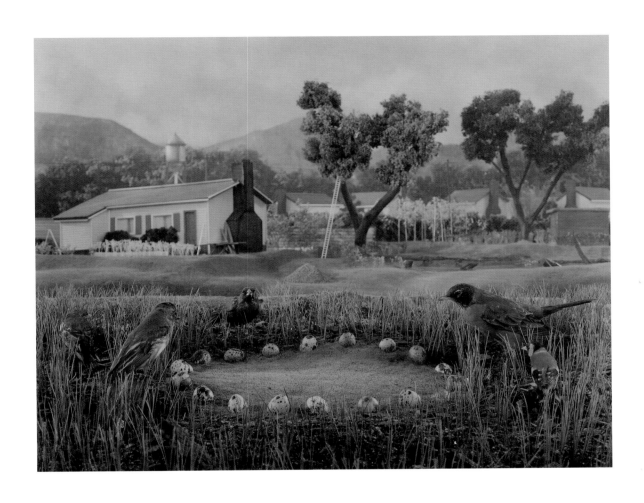

Gregory Crewdson, Untitled (Robin with Ring of Eggs), 1993

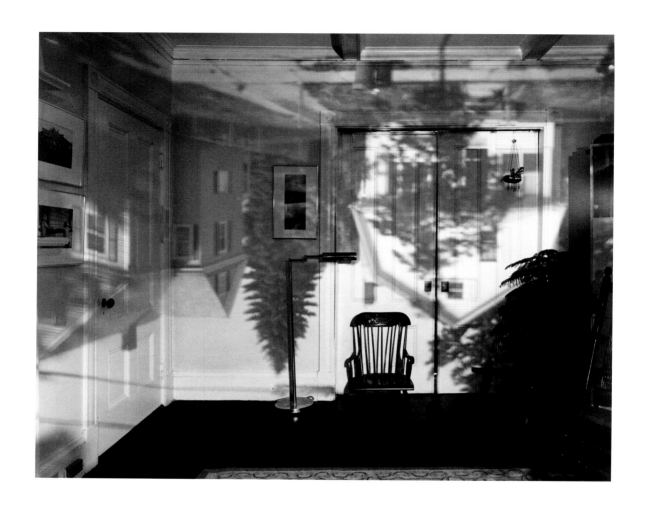

Abelardo Morell, Camera Obscura Image of Houses Across the Street in Our Living Room, 1991

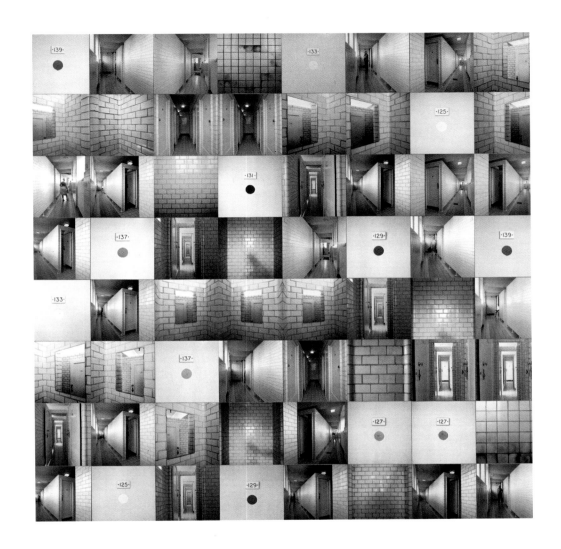

Roni Horn, Ellipsis (II), 1998

185

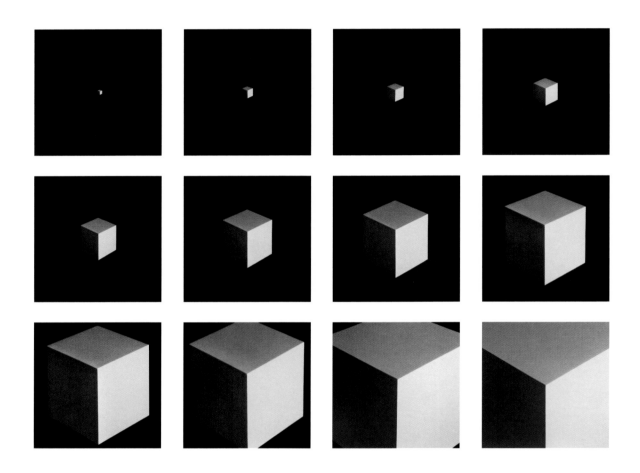

Sol LeWitt, Untitled (Cube), 1998

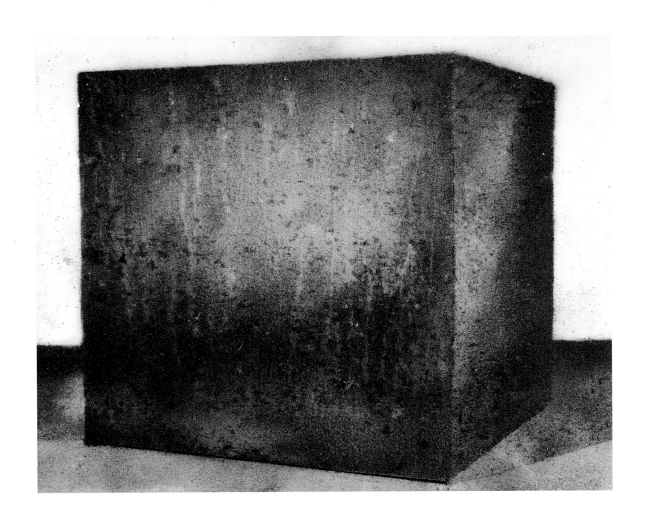

Vik Muniz, Picture of Dust (Tony Smith, Die, 1962, installed at the Whitney Museum in "From the Collection: Photography, Sculpture, and Painting," July 14, 1994–February 26, 1995, 2000

187

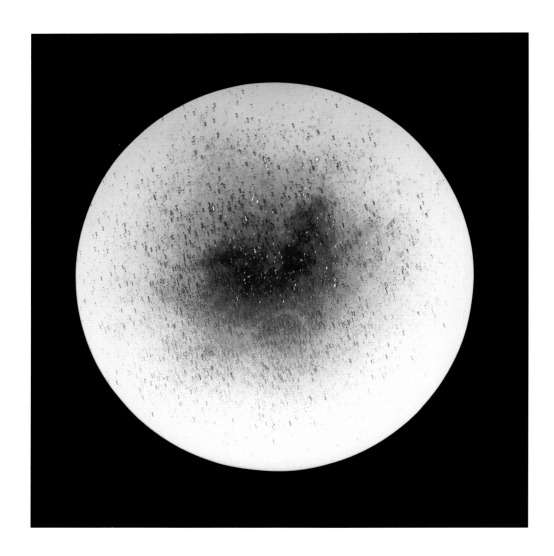

Aaron Rose, Milky Way X, 1993–95

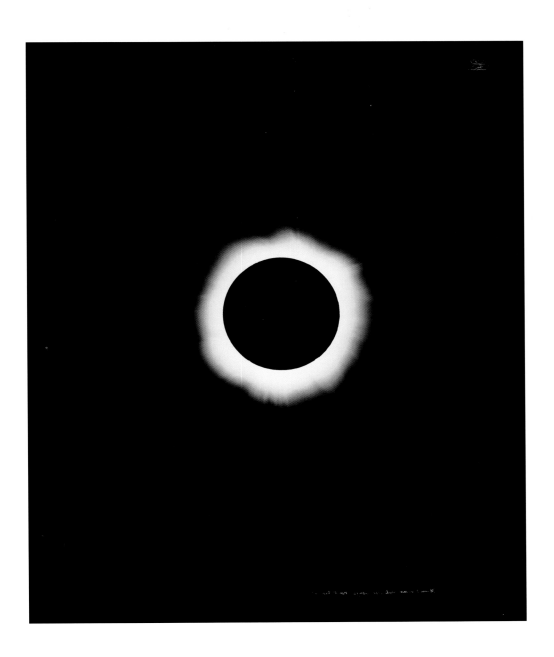

Linda Connor, April 16, 1893 (Solar Eclipse, Chile), 1998

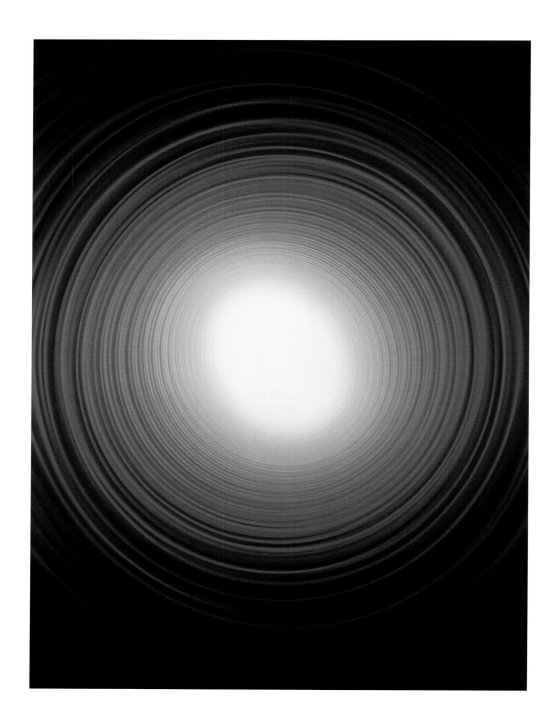

Adam Fuss, Untitled, 1992

David Goldes, Electricity + Water III, 1993

191

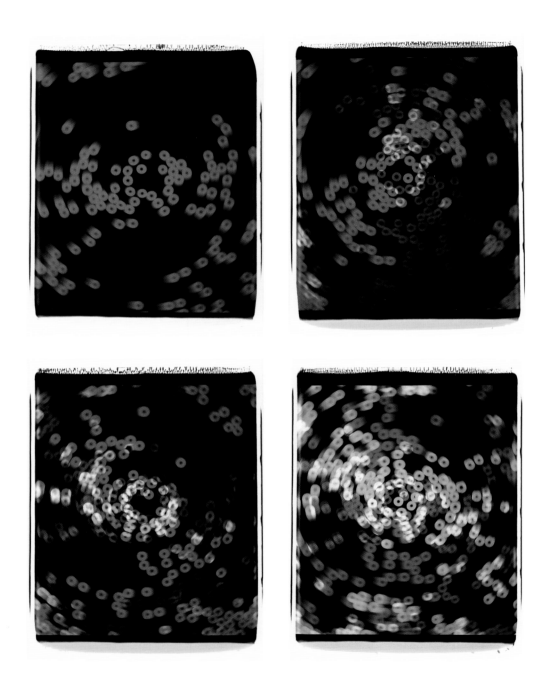

Ellen Carey, No. 42 (Series A), 1995

192

Clifford Ross, Water #15, 1998

Fred Tomaselli, Self-Portrait, 1995

194

Hiroshi Sugimoto, Avalon Theatre, Catalina Island, 1993

195

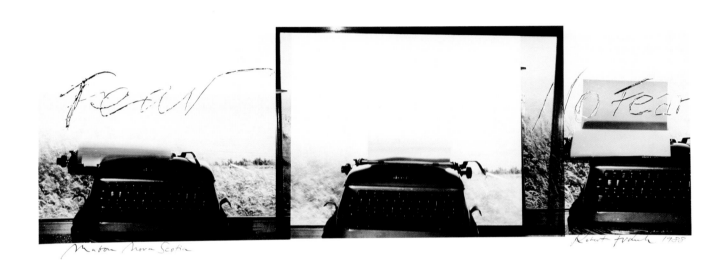

Robert Frank, *Fear—No Fear*, 1988

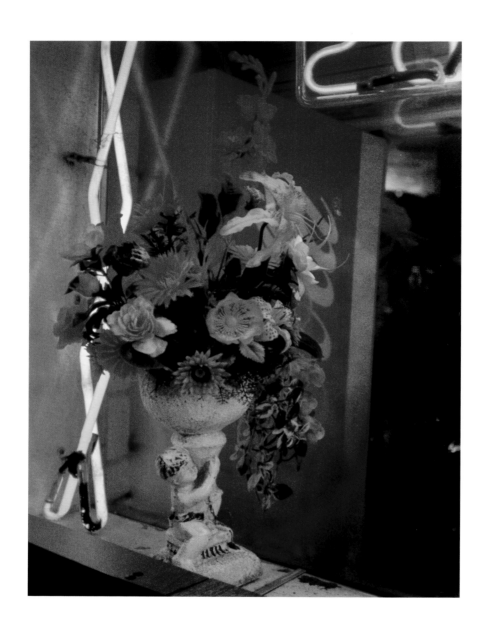

Jack Pierson, Neon Baltimore, 1985

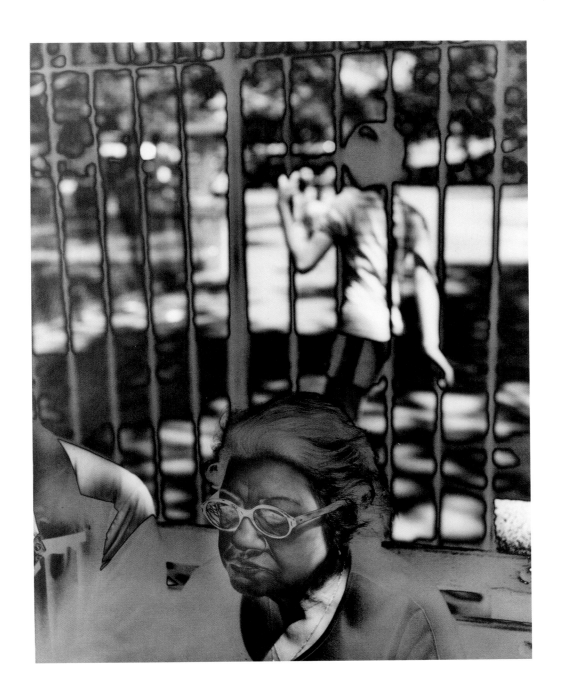

Michael Spano, Between Bars, 1986

199

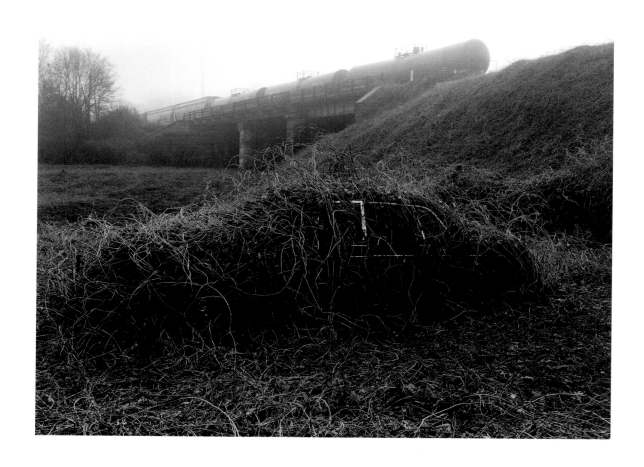

Mark Steinmetz, Athens, Georgia, 1997

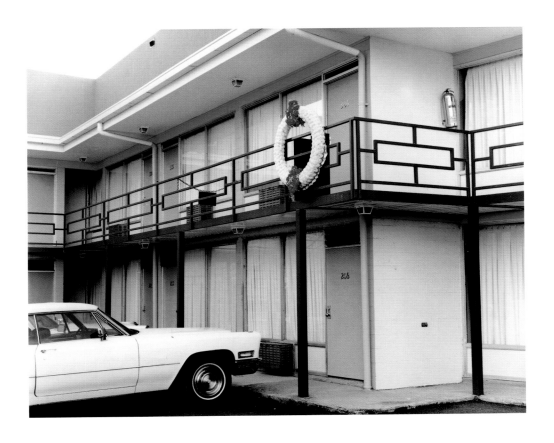

Joel Sternfeld, The National Civil Rights Museum, formerly the Lorraine Motel, 450 Mulberry Street, Memphis, Tennessee, August 1993, 1993

Speaking at a rally on April 3, 1968, Dr. Martin Luther King, Jr., said:

Longevity has its place. But I'm not concerned about that now. I just want to do God's will. And He's allowed me to go up to the mountain. And I've looked over and I've seen the Promised Land. I may not get there with you. But I want you to know tonight that we, as a people, will get to the Promised Land. And I'm happy tonight. I'm not worried about anything. I'm not fearing any man. My eyes have seen the glory of the coming of the Lord.

The next day, he was assassinated on this balcony outside room 306.

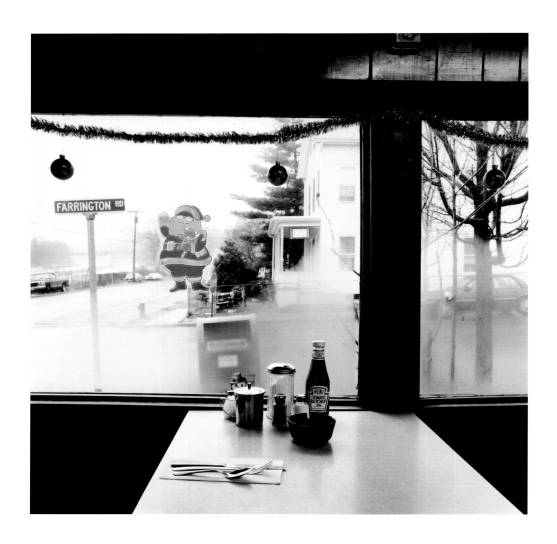

Jeff Brouws, Diner, Croton-on-Hudson, New York, 1991

MY COUSIN CANDI'S WEDDING WITH HER TWO FAVORITE
CUSTOMERS FROM HER JOB AT THE SIRLOIN STOCKADE.

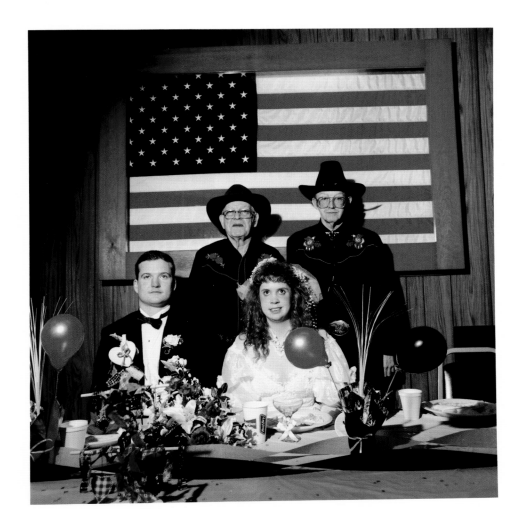

Chris Verene, Untitled (Galesburg #2), 1994

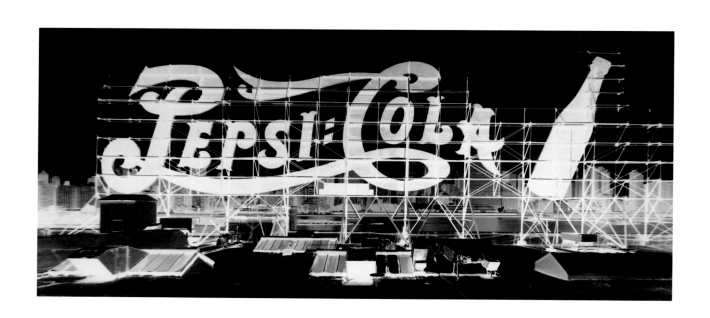

Vera Lutter, Pepsi-Cola, Long Island City, IV: May 19, 1998, 1998

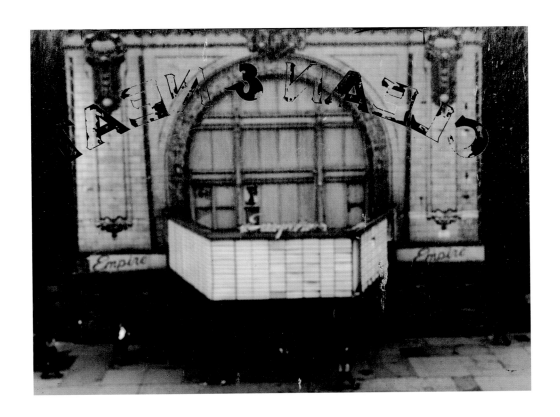

Mitch Epstein, Untitled, New York, 1997

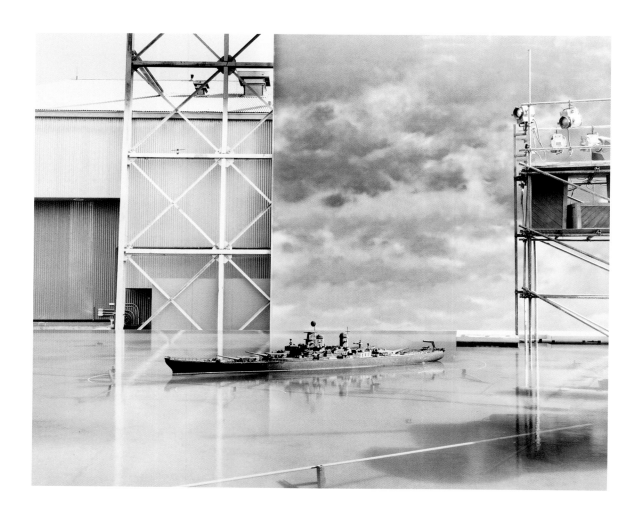

Catherine Wagner, Special Effects Tank, Backstage Studio Tour; Disney-MGM Studios Theme Park, Walt Disney World, Orlando, Florida, 1995

Craig Kalpakjian, Lobby, 1996

207

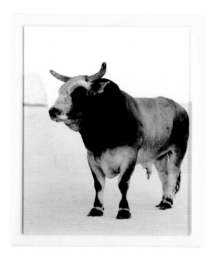 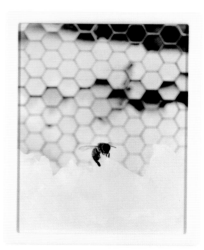 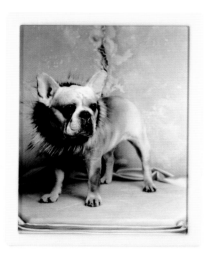

Matthew Barney, CREMASTER 2: Drone Ensemble, 1998

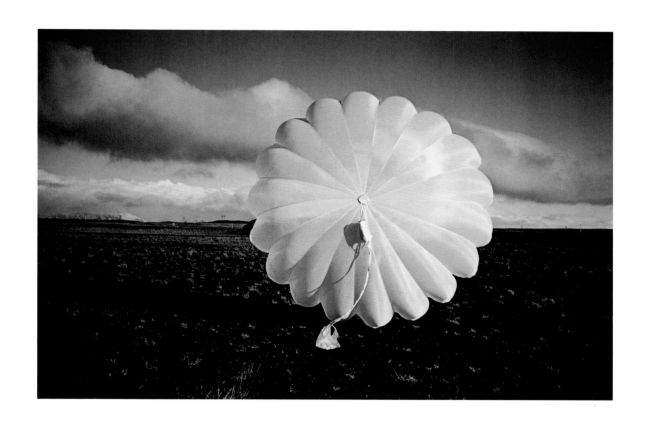

Gabriel Orozco, Parachute in Iceland (South), 1996

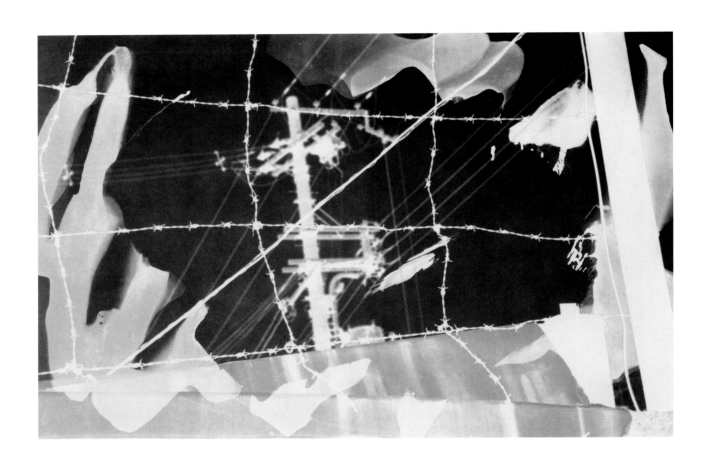

Robert Rauschenberg, Untitled (from the Bleacher series), 1990

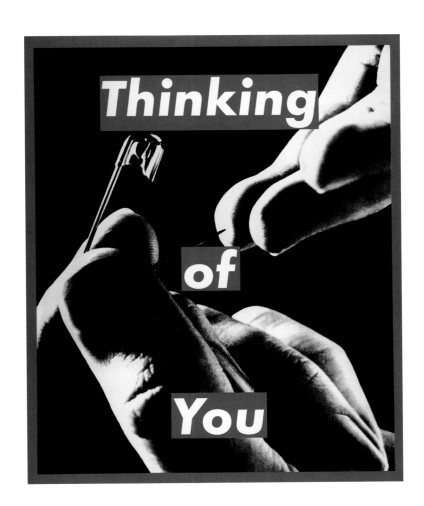

Barbara Kruger, Untitled (Thinking of You), 2000

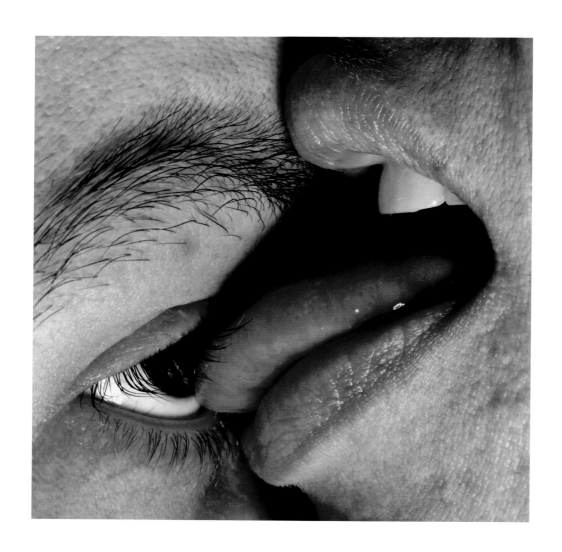

Janine Antoni, Mortar and Pestle, 1999

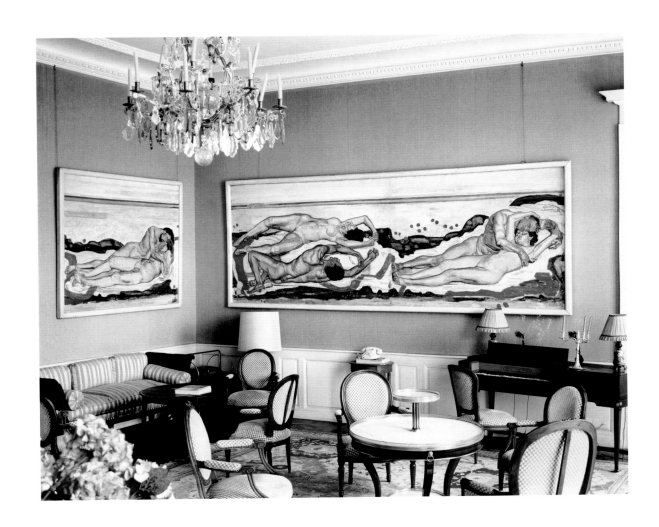

Louise Lawler, *Salon Hodler*, 1992–93

213

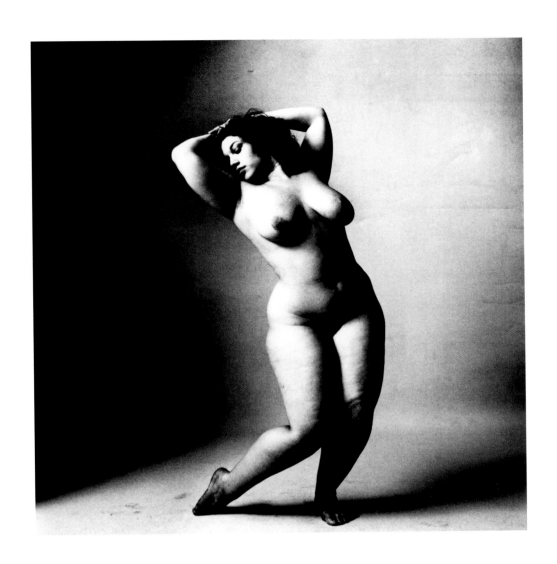

Irving Penn, Alexandra Beller (M), New York, 1999

215

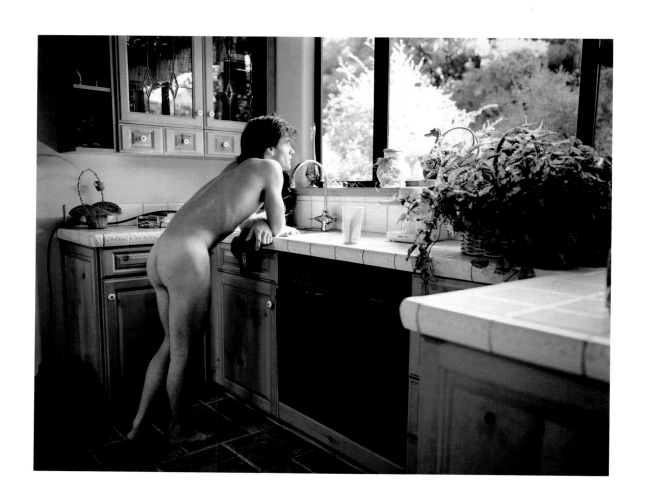

Larry Sultan, Kitchen Window, Topanga Canyon, 1999

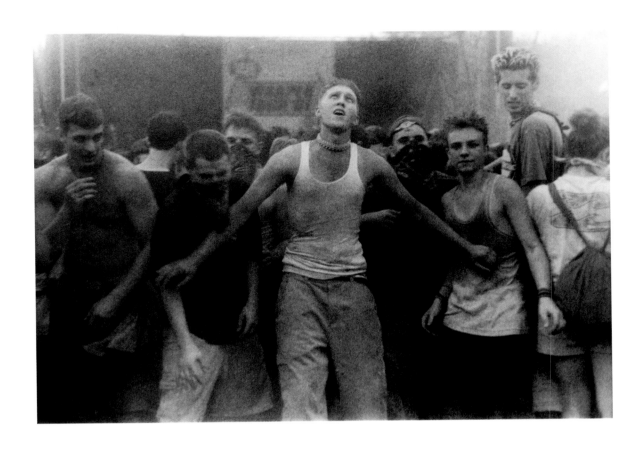

Janine Gordon, *Plant Your Feet on the Ground and Propel*, 2001

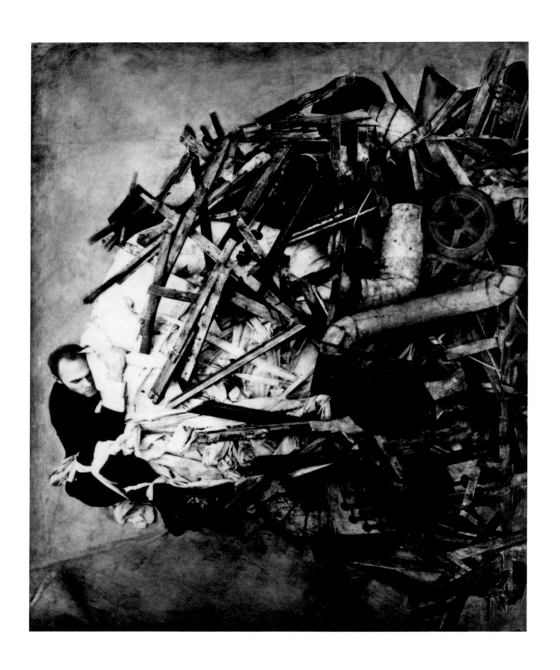

Robert ParkeHarrison, Exhausted Globe, 1997

Hirsch Perlman. Day 16.1. 1998–2001; Day 23.4. 1998–2001

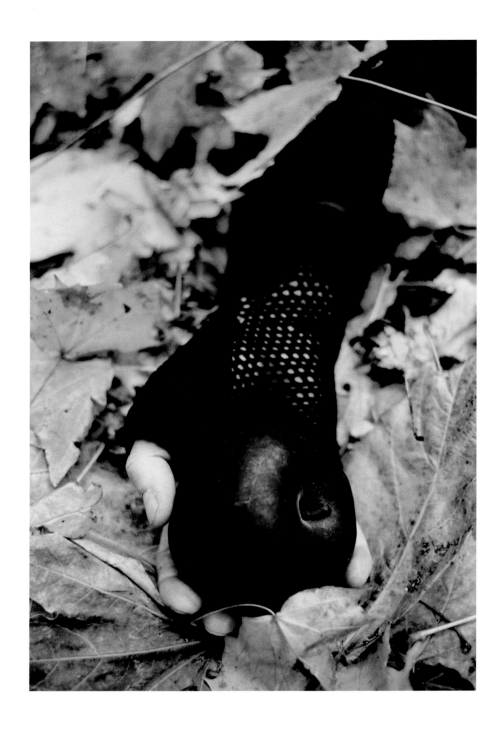

Kiki Smith, Sleeping Witch, 2000

220

Cindy Sherman, Untitled #347, 1999

221

Anna Gaskell. *As the Serpent*, 1996

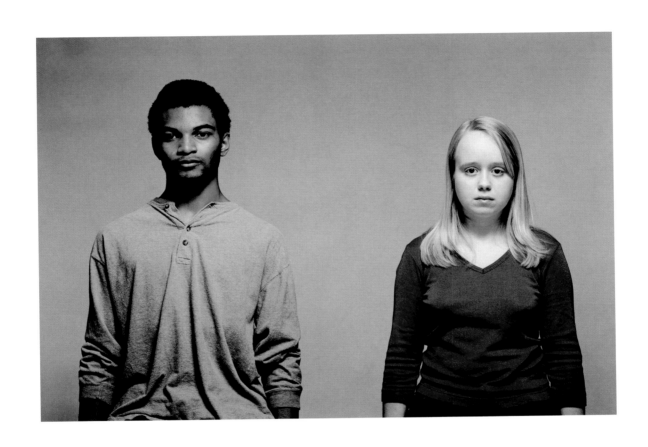

Julie Moos, Friends and Enemies: Drew and Monica, 1999–2000

Chuck Close, Self-Portrait, 2001

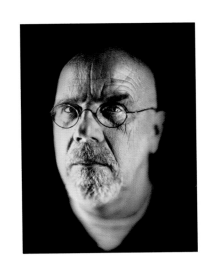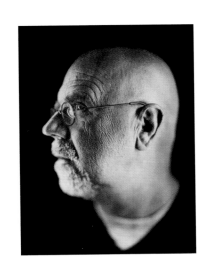

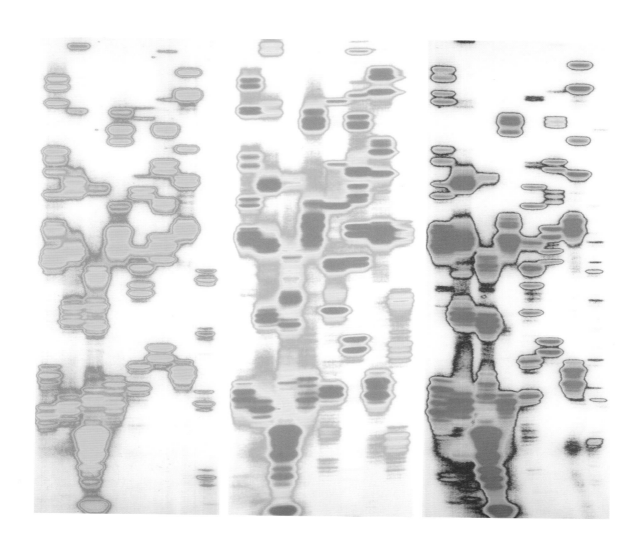

Iñigo Manglano-Ovalle, Iñigo, Elvi, and Iñigo, 1998

226

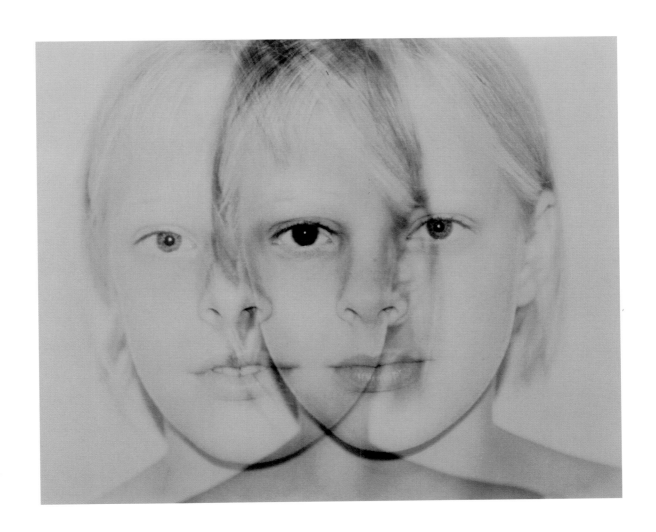

Kristin Oppenheim, Untitled (Thea with Open/Closed Mouth), 2000

List of Illustrations

All works are in the permanent collection of the Whitney Museum of American Art, New York. Dimensions are in inches followed by centimeters; height precedes width precedes depth.

Vito Acconci (b. 1940)
Hands Down/Side by Side, 1969
Three gelatin silver prints and chalk on paperboard, 29 7/8 x 39 15/16 (75.9 x 101.4) overall
Purchase, with funds from the Photography Committee 92.12

Robert Adams (b. 1937)
Motel, 1969, from *The New West*
Gelatin silver print, 5 7/8 x 5 15/16 (14.9 x 15.1)
Purchase, with funds from the Photography Committee 96.12

Merry Alpern (b. 1955)
#1, The Window Series, 1994
Gelatin silver print, 19 3/4 x 15 7/8 (50.2 x 40.3)
Gift of George C. Hutchinson 2001.197

William Anastasi (b. 1933)
Untitled (Five Photographs/Five Cameras), 1979
Three chromogenic color prints, one internal dye diffusion transfer print (Polaroid), and one monochromatic dye diffusion transfer print (Polaroid) mounted on paperboard, 4 1/2 x 20 (11.4 x 50.8) overall
Purchase, with Director's Discretionary Funds 2001.183a–e

Janine Antoni (b. 1964)
Mortar and Pestle, 1999
Chromogenic color print mounted on aluminum, 47 15/16 x 47 15/16 (121.8 x 121.8)
Purchase, with funds from Joanne Leonhardt Cassullo and The Dorothea L. Leonhardt Fund at The Communities Foundation of Texas, Inc. 99.53

Diane Arbus (1923–1971)
Woman with a Veil on Fifth Avenue, N.Y.C., 1968
Gelatin silver print, 10 1/2 x 10 1/4 (26.7 x 26)
Purchase, with funds from Ann G. Tenenbaum, Thomas H. Lee, and the Photography Committee 97.15

David Armstrong (b. 1954)
Chris on the Couch, rue André-Antoine, Paris, 1980
Gelatin silver print, 15 1/16 x 18 13/16 (38.3 x 47.8)
Purchase, with funds from Michèle Gerber Klein 94.16

Richard Avedon (b. 1923)
Bill Curry, Drifter, Interstate 40, Yukon, Oklahoma, 6/16/80, 1980, from *In the American West*
Gelatin silver print mounted on aluminum, 47 x 37 9/16 (119.4 x 95.4)
Gift of Norma and Martin Stevens 98.24

John Baldessari (b. 1931)
An Artist Is Not Merely the Slavish Announcer..., 1966–68
Photoemulsion, varnish, and gesso on canvas, 59 1/8 x 45 1/8 (150.2 x 114.6)
Purchase, with funds from the Painting and Sculpture Committee and gift of an anonymous donor 92.21

Lewis Baltz (b. 1945)
Tract House #10, 1971, from *The Tract Houses*
Gelatin silver print, 5 3/4 x 8 1/2 (14.6 x 21.6)
Purchase, with funds from the Wilfred P. and Rose J. Cohen Purchase Fund, the John I.H. Baur Purchase Fund, the Grace Belt Endowed Purchase Fund, and the Photography Committee 93.70j

Matthew Barney (b. 1967)
CREMASTER 2: Drone Ensemble, 1998
Three chromogenic color prints in acrylic frames, 41 1/2 x 33 7/8 (105.4 x 86) each
Purchase, with funds from the Photography Committee, Steven Ames, Anne and Joel Ehrenkranz, Arthur Fleischer, Kathryn Fleck, and Elizabeth Kabler in honor of Sondra Gilman Gonzalez-Falla 99.161a–c

Tina Barney (b. 1945)
The Landscape, 1988
Chromogenic color print, 45 3/8 x 58 3/8 (115.3 x 148.3)
Gift of Anne and Joel Ehrenkranz 93.11

Uta Barth (b. 1958)
Ground #42, 1994
Chromogenic color print on panel, 11 1/4 x 10 1/2 x 1 7/8 (28.6 x 26.7 x 4.8)
Purchase, with funds from the Photography Committee 95.162

Zeke Berman (b. 1951)
Measuring Cup, 1979
Gelatin silver print, 15 1/4 x 19 5/16 (38.7 x 49.1)
Purchase, with funds from Joanne Leonhardt Cassullo and The Dorothea L. Leonhardt Fund at The Communities Foundation of Texas, Inc. 2000.227

Dawoud Bey (b. 1953)
Hillary and Taro, 1992
Two internal dye diffusion transfer prints (Polaroids), 30 1/8 x 22 (76.5 x 55.9) each
Purchase, with funds from the Photography Committee 94.18a–b

Mel Bochner (b. 1940)
Roll, 1968 (printed 1998)
Eight gelatin silver prints, 20 x 23 7/8 (50.8 x 60.6) each
Purchase, with funds from the Peter Norton Family Foundation 98.90a–h

Blythe Bohnen (b. 1940)
Self-Portrait: Pivotal Motion from Chin, 1974
Gelatin silver print, 14 15/16 x 18 13/16 (37.9 x 47.8)
Gift of Paula and Herbert Molner 92.134.2

Ellen Brooks (b. 1946)
Garden Slice, 1987
Silver dye bleach print
(Cibachrome), 88 x 44 (223.5 x
111.8)
Purchase, with funds from the
Photography Committee 2001.256

Jeff Brouws (b. 1955)
Diner, Croton-on-Hudson, New York,
1991
Chromogenic color print, 18 x 18
(45.7 x 45.7)
Purchase, with funds from
Robinson and Nancy Grover
2002.101

Wynn Bullock (1902–1975)
Stark Tree, 1956
Gelatin silver print, 7 5/8 x 9 1/4
(19. 4 x 23.5)
Purchase, with funds from the
Photography Committee
T.2002.149

Nancy Burson (b. 1948)
*Mankind (Oriental, Caucasian and
Black weighted according to cur-
rent population statistics)*, 1983–85
Gelatin silver print from a digital
file, 8 9/16 x 7 5/16 (21.8 x 18.6)
Gift of The Audrey and Sidney
Irmas Charitable Foundation
92.110

Harry Callahan (1912–1999)
Eleanor, Detroit, c. 1941
Gelatin silver print, 4 1/2 x 3 5/16
(11.4 x 8.4)
Gift of the artist and Pace/MacGill
Gallery 93.51

Peter Campus (b. 1937)
fire/ice, 1992
Pigmented ink-jet print, 6 7/8 x
8 9/16 (17.5 x 21.8)
Gift of Anne and Joel Ehrenkranz
94.13

Ellen Carey (b. 1952)
No. 42 (Series A), 1995
Four dye diffusion transfer prints
(Polaroids), approximately 33 x 22
(83.8 x 55.9) each
Gift of John Coplans 2000.194a–d

James Casebere (b. 1953)
The Storefront, 1982
Gelatin silver print, 14 3/4 x
18 15/16 (37.5 x 48.1)
Purchase, with funds from the
Photography Committee 99.29

Sarah Charlesworth (b. 1947)
*The Forum, Fargo-Moorhead, from
The Arc of the Total Eclipse,
February 26, 1979*, 1979
Gelatin silver print, 23 7/16 x
15 3/16 (59.5 x 38.6)
Purchase, with funds from the
Photography Committee 94.60.27

William Christenberry (b. 1936)
*Church, Near Moundville,
Alabama*, 1976
Chromogenic color print, 3 1/8 x
4 13/16 (7.9 x 12.2)
Gift of Virginia M. Zabriskie
2000.278

Larry Clark (b. 1943)
Untitled, 1971, from *Tulsa*
Gelatin silver print, 8 7/16 x 5 3/4
(21.4 x 14.6)
Purchase, with funds from the
Photography Committee 92.111.4

Chuck Close (b. 1940)
Self-Portrait/Composite/Nine Parts,
1979
Nine internal dye diffusion trans-
fer prints (Polaroids) mounted on
canvas, 76 1/2 x 61 1/2 (194.3 x
156.2) overall
Gift of Barbara and Eugene
Schwartz 91.30

Self-Portrait, 2001
Five daguerreotypes, 8 1/2 x
6 1/2 (21.6 x 16.5) each
Gift of an anonymous donor, in
honor of Michael Richards
2001.272

Linda Connor (b. 1944)
*April 16, 1893 (Solar Eclipse,
Chile)*, 1998
Gelatin silver printing-out print,
23 7/16 x 19 1/2 (59.5 x 49.5)
Purchase, with funds from
Christian K. Keesee 99.14

John Coplans (b. 1920)
*Self-Portrait (Back Torso from
Below)*, 1985
Gelatin silver print, 11 3/16 x
13 13/16 (28.4 x 35.1)
Purchase, with funds from the
Photography Committee 2000.97

Gregory Crewdson (b. 1962)
Untitled (Robin with Ring of Eggs),
1993
Silver dye bleach print
(Ilfochrome), 28 x 35 15/16
(71.1 x 91.3)
Gift of Joanne Leonhardt Cassullo
in memory of Eugene M. Schwartz
96.54

Robert Cumming (b. 1943)
*Desk Drawer Stairs—Two
Interpretations*, 1975
Two gelatin silver prints mounted
on paperboard, 20 1/16 x 30 1/16
(51 x 76.4) overall
Purchase, with funds from Joanne
Leonhardt Cassullo 95.179a–b

Jerry Dantzic (b. 1925)
*Mambo Jambo, Palladium
Ballroom, New York*, 1952
Gelatin silver print, 13 3/8 x 10 1/2
(34 x 26.7)
Purchase, with funds from the
Harriett Ames Charitable Trust
2001.127

Bruce Davidson (b. 1933)
East 100th Street, 1966
Gelatin silver print, 11 x 13 15/16
(27.9 x 35.4)
Gift of Sondra Gilman and Celso
Gonzalez-Falla 98.14.1

Lynn Davis (b. 1944)
Abandoned Motel, Moab, Utah, 1999
Toned gelatin silver print, 18 7/8 x
18 15/16 (47.9 x 48.1)
Purchase, with funds from the
Photography Committee 2002.103

Philip-Lorca diCorcia (b. 1953)
Igor, 1987
Chromogenic color print, 15 5/8 x
22 7/8 (39.7 x 58.1)
Purchase, with funds from the
Photography Committee 2000.27

William Eggleston (b. 1937)
Greenwood, Mississippi, 1973
(printed 1980)
Dye transfer print, 11 5/8 x 17 7/8
(29.5 x 45.4)
Gift of Anne and Joel Ehrenkranz
94.111

Mitch Epstein (b. 1952)
Untitled, New York, 1997
Chromogenic color print, 35 1/8 x
46 5/8 (89.2 x 118.4)
Purchase, with funds from the
Photography Committee 98.63

Terry Evans (b. 1944)
Bison at Maxwell Game Preserve, Roxbury, Kansas, December 1981, 1981 (printed 2001)
Chromogenic color print, 23 7/8 x 19 7/8 (60.6 x 50.5)
Purchase, with funds from the Henry Nias Foundation 2001.251

Louis Faurer (1916–2001)
Transvestites, Opening of Cleopatra at Palace Theater, New York, 1963
Gelatin silver print, 10 3/8 x 14 (26.4 x 35.6)
Purchase, with funds from the Photography Committee T.2002.150

Andreas Feininger (1906–1999)
Lunch Rush on Fifth Avenue, New York, c. 1950
Gelatin silver print, 9 3/4 x 7 9/16 (24.8 x 19.2)
Gift of the Feininger Family 2001.79

Larry Fink (b. 1941)
Pat Sabatine's Eighth Birthday Party, 1977
Gelatin silver print, 13 13/16 x 13 7/8 (35.1 x 35.2)
Gift of Juliette Singer and Ian Spinks, Lauren Singer, and Sally and Stuart Singer 93.115.16

Steve Fitch (b. 1949)
Untitled, from *American Highway,* 1971–76
Gelatin silver print, 9 5/16 x 12 3/4 (23.7 x 32.4)
Gift of an anonymous donor 2001.299

Robert Frank (b. 1924)
London, 1952–53
Gelatin silver print, 13 1/2 x 8 11/16 (34.3 x 22.1)
Purchase, with funds from the Photography Committee in memory of Eugene M. Schwartz 95.169

Fear—No Fear, 1988
Gelatin silver print, 19 15/16 x 23 15/16 (50.6 x 60.8)
Gift of the artist 96.147

Lee Friedlander (b. 1934)
Galax, Virginia, 1962 (printed 1975), from the portfolio *15 Photographs*
Gelatin silver print, 5 13/16 x 8 13/16 (14.8 x 22.4)
Promised gift of Jeanne and Richard S. Press P.2001.10.13

Sonora, 1995
Gelatin silver print, 14 3/4 x 14 13/16 (37.5 x 37.6)
Purchase, with funds from the Photography Committee 96.165

Adam Fuss (b. 1961)
Untitled, 1992
Siver dye bleach photogram (Cibachrome), 65 9/16 x 49 5/8 (166.5 x 126.1)
Purchase, with funds from the Photography Committee 92.72

Anna Gaskell (b. 1969)
As the Serpent, 1996
Chromogenic color print mounted to plexiglass, 48 x 38 (121.9 x 96.5)
Purchase, with funds from the Photography Committee 2002.104

Ralph Gibson (b. 1939)
Untitled, 1974, from *Chiaroscuro*
Gelatin silver print, 12 9/16 x 8 3/8 (31.9 x 21.3)
Gift of Mr. and Mrs. Raymond W. Merritt 95.230

Jim Goldberg (b. 1953)
Playing Chicken, Flynn Squat, 1988–89, from *Raised by Wolves*
Gelatin silver print, 47 15/16 x 71 11/16 (121.8 x 182.1)
Purchase, with funds from the Photography Committee 96.67

David Goldes (b. 1947)
Electricity + Water III, 1993
Gelatin silver print, 22 x 17 1/4 (55.9 x 43.8)
Purchase, with funds from the Photography Committee 2000.16

Nan Goldin (b. 1953)
Couple in bed, Chicago, 1977 (printed 1999), from *The Ballad of Sexual Dependency*
Silver dye bleach print (Ilfochrome), 25 x 37 3/4 (63.5 x 95.9)
Purchase, with funds from the Photography Committee 99.149

Trees by the river, Munich, 1994
Silver dye bleach print (Ilfochrome), 26 x 38 1/2 (66 x 97.8)
Gift of the artist and Matthew Marks Gallery 2001.239

Janine Gordon (b. 1966)
Plant Your Feet on the Ground and Propel, 2001
Gelatin silver print, 30 x 40 (76.2 x 101.6)
Purchase, with funds from the Photography Committee T.2002.326

Emmet Gowin (b. 1941)
Edith, Newtown, Pennsylvania, 1974
Toned gelatin silver print, 7 15/16 x 9 7/8 (20.2 x 25.1)
Gift of the artist and Pace/MacGill Gallery 93.53

Aeration Pond, Toxic Water Treatment Facility, Pine Bluff, Arkansas, 1989
Toned gelatin silver print, 9 11/16 x 9 5/8 (24.6 x 24.5)
Purchase, with funds from the Photography Committee 99.5.3

Dan Graham (b. 1942)
New Highway Restaurant, Jersey City, 1967; *2 House Home, Staten Island, New York,* 1978, 1967/1978
Two chromogenic color prints mounted on paperboard, 34 5/8 x 25 1/16 (88 x 63.7) overall
Purchase, with funds from the Photography Committee 93.2a–b

Jan Groover (b. 1943)
Untitled, 1989
Silver dye bleach print (Cibachrome), 23 x 28 3/8 (58.4 x 72.1)
Purchase, with funds from Elizabeth Kabler and Michèle Gerber Klein 94.100

Sid Grossman (1913–1955)
Coney Island, 1947–48
Gelatin silver print, 8 11/16 x 7 11/16 (22.1 x 19.5)
Purchase, with funds from the Photography Committee 97.98.4

Sharon Harper (b. 1966)
Italy Mise en scène viii, 1998, from
Flug (Flight)
Gelatin silver print, 19 7/8 x 23 7/8
(50.5 x 60.6)
Gift of the artist 2001.284

Robert Heinecken (b. 1931)
P is for Potato Chips, 1971
Gelatin silver photogram with
chalk, 4 1/4 x 7 5/16 (10.8 x 18.6)
Gift of Lilyan S. and Toby Miller
92.96

Anthony Hernandez (b. 1947)
Landscapes for the Homeless, #17,
1989
Silver dye bleach print
(Cibachrome), 29 x 36 13/16
(73.7 x 93.5)
Purchase, with funds from the
Photography Committee 94.21

Roni Horn (b. 1955)
Ellipsis (II), 1998
Sixty-four gelatin silver prints
mounted on Sintra, 96 x 96
(243.8 x 243.8) overall
Purchase, with funds from the
Photography Committee, Anne
and Joel Ehrenkranz, and the
Contemporary Committee
2001.13a–lll

Peter Hujar (1934–1987)
Untitled, 1957
Gelatin silver print, 14 13/16 x
14 5/8 (37.6 x 37.2)
Purchase, with funds from the
Photography Committee 98.28.1

David Wojnarowicz, 1981
Gelatin silver print, 14 3/4 x
14 13/16 (37.5 x 37.6)
Purchase, with funds from the
Photography Committee 93.76

Kenneth Josephson (b. 1932)
Chicago, 1961
Gelatin silver print, 6 1/16 x 9
(15.4 x 22.9)
Purchase, with funds from the
Photography Committee 2000.234

Matthew, 1965
Gelatin silver print, 7 13/16 x 12
(19.8 x 30.5)
Purchase, with funds from the
Photography Committee 2000.236

Craig Kalpakjian (b. 1961)
Lobby, 1996
Silver dye bleach print
(Ilfochrome) mounted to plexiglass
on aluminum, 29 1/4 x 39 1/4
(74.3 x 99.7)
Purchase, with funds from Epson
America, Inc. T.2002.229

William Klein (b. 1928)
Selwyn, 42nd Street, New York,
1955
Gelatin silver print, 11 7/8 x 9 7/16
(30.2 x 24)
Purchase, with funds from the
Photography Committee 96.64

Mark Klett (b. 1952)
*Gun Found in Drifting Sand, Kelso,
California, January 22, 1987*, 1987
Gelatin silver print, 15 x 18 11/16
(38.1 x 47.5)
Gift of the artist and Pace/MacGill
Gallery 93.56

Barbara Kruger (b. 1945)
Untitled (Thinking of You), 2000
Photographic screenprint on vinyl,
123 x 101 (312.4 x 256.5)
Purchase, with funds from the
Katherine Schmidt Shubert Fund
2000.217

Louise Lawler (b. 1947)
Salon Hodler, 1992–93
Silver dye bleach print
(Ilfochrome), 48 x 57 7/16 (121.9 x
145.9)
Purchase, with funds from the
Photography Committee 94.23

Saul Leiter (b. 1923)
The Village, 1947
Gelatin silver print, 8 15/16 x 13 1/2
(22.7 x 34.3)
Purchase, with funds from the
Photography Committee 97.98.5

Annette Lemieux (b. 1957)
Apparition, 1989, from the
portfolio *The Indomitable Spirit*
Chromogenic color print, 18 x
12 1/4 (45.7 x 31.1)
Gift of Anne and Joel Ehrenkranz
92.38.5

Zoe Leonard (b. 1961)
*Frontal View, Geoffrey Beene
Fashion Show*, 1990
Gelatin silver print, 40 1/2 x 27 1/4
(102.9 x 69.2)
Purchase, with funds from the
Photography Committee 92.73

Sherrie Levine (b. 1947)
After Walker Evans: 4, 1981
Gelatin silver print, 10 x 8
(25.4 x 20.3)
Purchase, with funds from the
Photography Committee 96.2

Leon Levinstein (1910–1988)
San Francisco, 1973
Gelatin silver print, 13 5/8 x 16 1/16
(34.6 x 40.8)
Purchase, with funds from the
Photography Committee 97.98.8

David Levinthal (b. 1949)
Untitled, from *Hitler Moves East*,
1975–77
Kodalith print, 9 3/4 x 7 11/16
(24.8 x 19.5)
Purchase, with funds from The
Sondra and Charles Gilman, Jr.
Foundation, Inc. 93.59

Helen Levitt (b. 1913)
New York City, 1940
Gelatin silver print, 8 x 5 3/4
(20.3 x 14.6)
Purchase, with funds from the
Photography Committee 97.98.9

Sol LeWitt (b. 1928)
Untitled (Cube), 1998
Twelve gelatin silver prints,
10 1/2 x 10 1/2 (26.7 x 26.7) each
Purchase, with funds from the
Robert Mapplethorpe Foundation,
Inc. 98.58a–l

Vera Lutter (b. 1960)
*Pepsi-Cola, Long Island City, IV:
May 19, 1998*, 1998
Gelatin silver print mounted on
canvas, 55 1/4 x 123 (140.3 x 312.4)
Purchase, with funds from the
Photography Committee 2000.219

Danny Lyon (b. 1942)
*Scrambles Track, McHenry,
Illinois*, 1965, from *The Bikeriders*
Gelatin silver print, 5 15/16 x
5 15/16 (15.1 x 15.1)
Purchase, with funds from the
Photography Committee 98.28.2

Iñigo Manglano-Ovalle (b. 1961)
Iñigo, Elvi, and Iñigo, 1998
Three chromogenic color prints
mounted to plexiglass on
aluminum, 60 x 23 (152.4 x
58.4) each
Purchase, with funds from the
Photography Committee
2000.101a–c

Sally Mann (b. 1951)
Virginia at 5, 1990
Gelatin silver print, 18 15/16 x 23
(48.1 x 58.4)
Purchase, with funds from the
Rosenstiel Foundation 93.45

Robert Mapplethorpe (1946–1989)
Patti Smith, 1978
Gelatin silver print, 13 13/16 x
13 7/8 (35.1 x 35.2)
Jack E. Chachkes Bequest 95.146

Mary Ellen Mark (b. 1940)
*The Damm Family in Their Car,
Los Angeles, California*, 1987
Gelatin silver print, 14 1/2 x
14 5/8 (36.8 x 37.1)
Purchase, with funds from
Raymond W. Merritt 2001.162

Gordon Matta-Clark (1943–1978)
Conical Intersect, 1975
Silver dye bleach print
(Cibachrome), 39 13/16 x 29 15/16
(101.1 x 76)
Purchase, with funds from the
Photography Committee 92.71

Allan McCollum (b. 1944)
Perpetual Photo No. 183 A, 1982–89
Toned gelatin silver print with
wood frame, 46 7/16 x 44 15/16 x
2 1/8 (118 x 114.1 x 5.4)
Purchase, with funds from the
Photography Committee 96.155

Ralph Eugene Meatyard
(1925–1972)
Lite #15, 1959
Gelatin silver print, 7 1/2 x 7 7/16
(19.1 x 18.9)
Gift of Steven E. Gross 99.94.2

Susan Meiselas (b. 1948)
*Lena on the Bally Box, Essex
Junction, Vermont*, 1973, from
Carnival Strippers
Gelatin silver print, 7 15/16 x
11 5/16 (20.2 x 28.7)
Purchase, with funds from the
Photography Committee 2000.33

Ana Mendieta (1948–1985)
Untitled (from the Fetish series),
1977
Chromogenic color print, 20 x
13 1/4 (50.8 x 33.7)
Purchase, with funds from the
Photography Committee 92.112

Ray K. Metzker (b. 1931)
Philadelphia, 1964
Gelatin silver print, 8 3/4 x 5 7/8
(22.2 x 14.9)
Purchase, with funds from Henry
M. Buhl in honor of Sondra
Gilman Gonzalez-Falla 2000.94

Nude (Flashed) Torso, 1966
140 gelatin silver prints mounted
on plexiglass, 25 3/8 x 23 1/2 (64.5 x
59.7) overall
Gift of Lilyan S. and Toby Miller
92.93

Joel Meyerowitz (b. 1938)
New Jersey, 1965
Gelatin silver print, 8 5/16 x 13 1/4
(21.1 x 33.7)
Purchase, with funds from Artur
Walther 98.92

Duane Michals (b. 1932)
Paradise Regained, 1968
Six gelatin silver prints, 3 5/16 x 5
(8.4 x 12.7) each
Gift of Joseph M. Cohen
T.2002.246

Richard Misrach (b. 1949)
*Bomb Crater and Destroyed
Convoy, Bravo 20 Bombing Range,
Nevada*, 1986
Chromogenic color print mounted
on paperboard
Purchase, with funds from The
Sondra and Charles Gilman, Jr.
Foundation, Inc. 93.72

Lisette Model (1901–1983)
Sammy's, New York, 1940–44
Gelatin silver print, 13 3/4 x
10 13/16 (34.9 x 27.5)
Purchase, with funds from the
Photography Committee 97.98.12

Andrea Modica (b. 1960)
Treadwell, New York, 1992
Platinum palladium print, 9 3/4 x
7 7/8 (24.8 x 20)
Purchase, with funds from the
Photography Committee 96.157

Julie Moos (b. 1965)
*Friends and Enemies: Drew and
Monica*, 1999–2000
Chromogenic color print, 48 x 68
(121.9 x 172.7)
Purchase, with funds from the
Photography Committee
T.2002.327

Abelardo Morell (b. 1948)
*Camera Obscura Image of Houses
Across the Street in Our Living
Room*, 1991
Gelatin silver print, 18 x 22 7/16
(45.7 x 57)
Purchase, with funds from Anne
and Joel Ehrenkranz 2000.19

Mark Morrisroe (1959–1989)
Messopotamia, 1982
Chromogenic color print with
hand-applied color, 20 x 16
(50.8 x 40.6)
Gift of Barbara and Eugene
Schwartz 94.150

Jeanne Moutoussamy-Ashe
(b. 1951)
Miss Bertha, South Carolina, 1977
Gelatin silver print, 10 15/16 x
13 7/8 (27.8 x 35.2)
Gift of Michael I. Jacobs in honor
of Sylvia Wolf 2001.188

Vik Muniz (b. 1961)
*Picture of Dust (Tony Smith, Die,
1962, installed at the Whitney
Museum in "From the Collection:
Photography, Sculpture, and
Painting," July 14, 1994–February
26, 1995)*, 2000
Chromogenic color print, 70 3/4 x
88 1/8 (179.7 x 223.8)
Gift of Brent Sikkema, New York,
and the artist 2001.56

Billy Name (b. 1940)
Ivy Nicholson, 1966, from the
portfolio *Ivy Nicholson*
Gelatin silver print, 10 5/8 x 8 11/16
(27 x 22.1)
Purchase, with funds from the
Photography Committee 95.47

Shirin Neshat (b. 1957)
Unveiling, 1993, from *Women
of Allah*
Gelatin silver print and ink,
59 3/4 x 39 3/4 (151.8 x 101)
Purchase, with funds from the
Photography Committee 2000.267

Marvin E. Newman (b. 1927)
Untitled, 1951
Gelatin silver print, 7 3/4 x 5 7/16
(19.7 x 13.8)
Purchase, with funds from the
Photography Committee 2000.218

Nic Nicosia (b. 1951)
Untitled #5, 1991
Oil on gelatin silver print, 36 x 36
(91.4 x 91.4)
Purchase, with funds from the
Photography Committee 96.65

Catherine Opie (b. 1961)
Self-Portrait/Cutting, 1993
Chromogenic color print, 39 5/8 x
29 15/16 (100.7 x 76.1)
Purchase, with funds from the
Photography Committee 94.64

Dennis Oppenheim (b. 1938)
*Slide Disolve Sequence for
GROUND GEL*, 1972
Seventy-four chromogenic color
prints, one gelatin silver print, and
ink on paperboard, 41 5/16 x 92 1/6
(104.9 x 233.8) overall
Gift of the artist 93.128a–b

Kristin Oppenheim (b. 1959)
*Untitled (Thea with Open/Closed
Mouth)*, 2000
Chromogenic color print, 17 5/8 x
21 5/8 (44.8 x 54.9)
Purchase, with funds from the
Photography Committee
T.2002.228

Gabriel Orozco (b. 1962)
Parachute in Iceland (South), 1996
Silver dye bleach print
(Ilfochrome), 12 3/8 x 18 11/16
(31.4 x 47.5)
Purchase, with funds from
Michael Ward Stout 97.36

Bill Owens (b. 1938)
Untitled, 1970, from *Suburbia*
Two gelatin silver prints, 6 1/8 x 9
and 7 x 9 (15.6 x 22.9 and 17.8 x
22.9)
Purchase, with funds from the
Photography Committee T.2002.14

Robert ParkeHarrison (b. 1968)
Exhausted Globe, 1997
Photogravure with beeswax, 19 x
15 11/16 (48.3 x 39.9)
Gift of Shanna and Robert
ParkeHarrison and Bonni Benrubi
Gallery 2000.29

Gordon Parks (b. 1912)
Bandaged Hands, Muhammad Ali,
1966
Gelatin silver print, 13 5/16 x 9 1/4
(33.8 x 23.5)
Purchase, with funds from Joanne
Leonhardt Cassullo, The Dorothea
L. Leonhardt Fund at The
Communities Foundation of Texas,
Inc., and Michèle Gerber Klein
98.59

Irving Penn (b. 1917)
Alexandra Beller (M), New York,
1999
Gelatin silver print, 11 1/16 x 10 3/4
(28.1 x 27.3)
Purchase, with funds from the
Photography Committee 2001.255

Hirsch Perlman (b. 1960)
Day 16.1, 1998–2001
Gelatin silver print, vinyl, tape, oil,
and pushpins, 24 x 30 (61 x 76.2)
Purchase, with funds from the
Photography Committee, the
Contemporary Committee, and
Joanne Leonhardt Cassullo and
The Dorothea L. Leonhardt
Foundation, Inc. T.2002.328

Day 23.4, 1998–2001
Gelatin silver print, vinyl, tape, oil,
and pushpins, 24 x 30 (61 x 76.2)
Purchase, with funds from the
Photography Committee, the
Contemporary Committee, and
Joanne Leonhardt Cassullo and
The Dorothea L. Leonhardt
Foundation, Inc. T.2002.331

John Pfahl (b. 1939)
*Ozone Falls, Cumberland Plateau,
Tennessee, August 1991*, 1991
Chromogenic color print, 22 x 30
(55.9 x 76.2)
Promised gift of Jeanne and
Richard S. Press P.2002.29

Jack Pierson (b. 1960)
Neon Baltimore, 1985
Chromogenic color print,
39 15/16 x 30 (101.4 x 76.2)
Purchase, with funds from the
Robert Mapplethorpe Foundation,
Inc. 93.48

Adrian Piper (b. 1948)
Food for the Spirit, 1971 (detail,
printed 1997)
Fourteen gelatin silver prints,
20 x 16 (50.8 x 40.6) each
Purchase, with funds from the
Photography Committee
98.28.3a–n

Richard Prince (b. 1949)
Untitled, 1983, from the portfolio
The Indomitable Spirit
Chromogenic color print,
15 13/16 x 23 1/16 (40.2 x 58.6)
Gift of Anne and Joel Ehrenkranz
92.38.7

Robert Rauschenberg (b. 1925)
Untitled (from the Bleacher Series),
1990, from the portfolio
The Indomitable Spirit
Bleached gelatin silver print,
9 1/8 x 13 7/8 (23.2 x 35.2)
Gift of Anne and Joel Ehrenkranz
92.38.8

Charles Ray (b. 1953)
Untitled, 1973 (printed 1989)
Gelatin silver print, 26 x 39
(66 x 99.1)
Purchase, with funds from the
Richard and Dorothy Rodgers
Fund and the Photography
Committee 93.74

Aaron Rose (b. 1939 or 1940)
Milky Way X, 1993–95
Toned gelatin silver print, 10 1/4 x
10 1/4 (26 x 26)
Purchase, with funds from The
Samuel and May Rudin
Foundation 97.133

Martha Rosler (b. 1943)
*The Bowery in two inadequate
descriptive systems*, 1974–75
(detail)
Forty-five gelatin silver prints of
text and image on twenty-four
backing boards, 11 13/16 x
23 5/8 (30 x 60) each
Purchase, with funds from John L.
Steffens 93.4.1–24a–b

Clifford Ross (b. 1952)
Water #15, 1998
Gelatin silver print, 19 3/4 x 16 1/4
(50.2 x 41.3)
Gift of Anne and Joel Ehrenkranz
2000.1

Michal Rovner (b. 1957)
Decoy #3, 1991
Chromogenic color print, 49 1/2 x
48 1/2 (125.7 x 123.2)
Purchase, with funds from the
Harriett Ames Charitable Trust
97.88

Lucas Samaras (b. 1936)
Skull & Milky Way, 1966
Gelatin silver print from X-ray
negative, pins, and photolitho-
graph, 28 7/8 x 24 3/4 x 3 1/2
(73.3 x 62.9 x 8.9)
Gift of Howard and Jean Lipman
91.34.6

Photo-Transformation, 1973
Internal dye diffusion transfer
print (Polaroid), 3 1/16 x 3
(7.8 x 7.6)
Gift of Lilyan S. and Toby Miller
94.163

Gary Schneider (b. 1954)
After Peter, Fall 1993, 1993
Toned gelatin silver print,
36 3/16 x 29 3/16 (91.9 x 74.1)
Gift of John Erdman 99.111

Andres Serrano (b. 1950)
*Untitled X (Ejaculate in
Trajectory)*, 1989
Silver dye bleach print
(Cibachrome) mounted on plexi-
glass, 39 15/16 x 59 15/16 (101.4 x
152.2)
Purchase, with funds from the
Photography Committee 97.18

Cindy Sherman (b. 1954)
Untitled Film Still #35, 1979
Gelatin silver print, 9 7/16 x 6 3/8
(24 x 16.2)
Gift of Barbara and Eugene
Schwartz 88.50.4

Untitled #146, 1985
Silver dye bleach print
(Cibachrome), 71 9/16 x 48 1/8
(181.8 x 122.2)
Purchase, with funds from Eli and
Edythe L. Broad 87.49

Untitled #347, 1999
Gelatin silver print, 22 x 22
(55.9 x 55.9)
Purchase, with funds from Anne
and Joel Ehrenkranz in honor of
Sondra Gilman Gonzalez-Falla
99.159

Stephen Shore (b. 1947)
*U.S. 10, Post Falls, Idaho,
August 25, 1974*, 1974
Chromogenic color print, 7 11/16 x
9 11/16 (19.5 x 24.6)
Gift of the artist and Pace/MacGill
Gallery 93.62

Laurie Simmons (b. 1949)
*Walking Camera II (Jimmy the
Camera)*, 1987
Gelatin silver print, 82 13/16 x
47 1/2 (210.3 x 120.7)
Purchase, with funds from the
Photography Committee 94.107

Lorna Simpson (b. 1960)
2 Tracks, 1990
Three gelatin silver prints with
frames and two plastic plaques,
48 7/8 x 62 9/16 x 1 11/16 (124.1 x
158.9 x 4.3) overall
Gift of Raymond J. Learsy and
Gabriella De Ferrari 91.59.4a–e

Aaron Siskind (1903–1991)
Chicago 1, 1949
Gelatin silver print, 10 5/8 x 11 1/8
(27 x 28.3)
Purchase, with funds from the
Photography Committee 99.6

Sandy Skoglund (b. 1946)
Peas on a Plate, 1978
Silver dye bleach print
(Cibachrome), 22 x 28 (55.9 x 71.1)
Purchase, with funds from the
Photography Committee 2000.14

Alexis Smith (b. 1949)
R TIST, c. 1980
Chromogenic color print mounted
on board, 7 5/16 x 9 5/16 (18.6 x
25.2)
Gift of Joanne Leonhardt Cassullo
and The Dorothea L. Leonhardt
Foundation, Inc., in honor of
Sondra Gilman Gonzalez-Falla
95.106

Kiki Smith (b. 1954)
Sleeping Witch, 2000
Chromogenic color print, 15 7/8 x
23 11/16 (40.3 x 60.2)
Purchase, with funds from Anne
and Joel Ehrenkranz 2001.154

Frederick Sommer (1905–1999)
Horse, 1945
Gelatin silver print, 9 9/16 x 7 9/16
(24.3 x 19.2)
Purchase, with funds from the
Photography Committee 99.5.1

Michael Spano (b. 1949)
Between Bars, 1986
Gelatin silver print from solarized
negative, 34 3/8 x 26 13/16 (87.3 x
68.1)
Gift of Lilyan S. and Toby Miller
92.98

Doug and Mike Starn (b. 1961)
Place St. Michel, 1985–87
Toned gelatin silver print, 19 15/16
x 15 13/16 (50.6 x 40.2)
Gift of an anonymous donor
91.105.2

Mark Steinmetz (b. 1961)
Athens, Georgia, 1997
Gelatin silver print, 12 3/8 x
17 1/8 (31.4 x 43.5)
Purchase, with funds from the
Harriett Ames Charitable Trust
2001.234

Joel Sternfeld (b. 1944)
*The National Civil Rights Museum,
formerly the Lorraine Motel, 450
Mulberry Street, Memphis,
Tennessee, August 1993*, 1993, from
On This Site
Chromogenic color print, 18 1/2 x
23 (47 x 58.4)
Purchase, with funds from the
Photography Committee 2002.100

Louis Stettner (b. 1922)
Penn Station, 1958
Gelatin silver print, 8 3/4 x 13 7/16
(22.2 x 34.1)
Purchase, with funds from the
Photography Committee 98.67.3

Hiroshi Sugimoto (b. 1948)
Avalon Theatre, Catalina Island,
1993
Gelatin silver print, 16 9/16 x 21 3/8
(42.1 x 54.3)
Purchase, with funds from the
Photography Committee 95.48

Larry Sultan (b. 1946)
Kitchen Window, Topanga Canyon,
1999, from *The Valley*
Chromogenic color print, 38 3/8 x
48 (97.5 x 121.9)
Promised gift of Jeanne and
Richard S. Press T.2002.198

Ruth Thorne-Thomsen (b. 1943)
Liberty Head, Illinois, 1978, from
Expeditions
Toned gelatin silver print, 3 1/2 x
4 1/2 (8.9 x 11.4)
Purchase, with funds from the
Robert Mapplethorpe Foundation,
Inc., in honor of Sondra Gilman
Gonzalez-Falla 99.162

Fred Tomaselli (b. 1956)
Self-Portrait, 1995
Colored pencil on gelatin silver
photogram, 15 7/8 x 19 7/8 (40.3 x
50.5)
Purchase, with funds from the
Drawing Committee 96.104

Arthur Tress (b. 1940)
*Boy in Burnt Out Furniture Store,
Newark, N.J.*, 1969
Gelatin silver print, 15 x 18 7/8
(38.1 x 47.94)
Gift of Richard Lorenz in memory
of Ignatius Michael Lorenz 97.45.4

Jerry N. Uelsmann (b. 1934)
Mechanical Man #2, 1959
Gelatin silver print, 11 9/16 x 5 1/2
(29.4 x 14)
Purchase, with funds from Joanne
Leonhardt Cassullo and Kathryn
Fleck 2000.13

JoAnn Verburg (b. 1950)
Nap Along the Zattere, 1997
Two chromogenic color prints,
24 1/8 x 34 1/8 (61.3 x 86.7) each
Purchase, with funds from the
Photography Committee 98.64a–b

Chris Verene (b. 1969)
Untitled (Galesburg #2), 1994
Chromogenic color print, 15 1/2 x
15 5/8 (39.4 x 39.7)
Gift of Adair and Joe Massey in
honor of Maxwell L. Anderson
2000.65

David Vestal (b. 1924)
East 13th Street, New York, 1955
Gelatin silver print, 9 1/16 x 13 5/8
(23 x 34.6)
Purchase, with funds from the
Photography Committee 97.39

Catherine Wagner (b. 1953)
*Special Effects Tank, Backstage
Studio Tour; Disney-MGM Studios
Theme Park, Walt Disney World,
Orlando, Florida*, 1995
Gelatin silver print, 17 5/8 x 21 5/8
(44.8 x 54.9)
Purchase, with funds from the
Photography Committee 2000.226

Andy Warhol (1928–1987)
Holly Solomon, 1966
Gelatin silver print, 7 13/16 x 1 9/16
(19.8 x 4)
Gift of The Andy Warhol
Foundation for the Visual Arts and
purchase, with funds from the
Photography Committee 94.123

Weegee (Arthur Fellig)
(1899–1968)
The Critic, 1943
Gelatin silver print, 10 1/2 x 12 1/2
(26.7 x 31.8)
Gift of Denise Rich 96.90.2

Carrie Mae Weems (b. 1953)
Blue Black Boy, 1987–88
Three toned gelatin silver prints
with Prestype and frame, 16 3/16 x
49 1/2 x 1 1/2 (41.1 x 125.7 x 3.8)
Purchase, with funds from the
Photography Committee 2001.257

Golden Yella Girl, 1987–88
Three toned gelatin silver prints
with Prestype and frame, 16 3/4 x
49 1/2 x 1 1/2 (42.5 x 125.7 x 3.8)
Purchase, with funds from the
Photography Committee 2001.258

Low Brown Boy, 1987–88
Three toned gelatin silver prints
with Prestype and frame,
16 15/16 x 49 1/2 x 2 (43 x
125.7 x 5.1)
Gift of the artist T.2002.147

William Wegman (b. 1943)
Cotto, 1970
Gelatin silver print, 7 7/8 x 7 3/4
(20 x 19.7)
Purchase, with funds from the
Mrs. Percy Uris Purchase Fund
and the Photography Committee
92.14

James Welling (b. 1951)
XVII, 1988
Chromogenic color print, 28 9/16 x
24 1/4 (72.6 x 61.6)
Gift of the artist and Jay Gorney
Modern Art 96.43

Minor White (1908–1976)
Beginnings, 1962
Gelatin silver print, 12 7/16 x 9 1/2
(31.6 x 24.1)
Purchase, with funds from the
Photography Committee 98.66

Garry Winogrand (1928–1984)
New York, 1968, from the portfolio
Women Are Better than Men
Gelatin silver print, 8 13/16 x
13 5/16 (22.4 x 33.8)
Gift of Mr. and Mrs. Raymond W.
Merritt 98.40.1

Joel-Peter Witkin (b. 1939)
Man without a Head, 1993
Gelatin silver print, 32 11/16 x
26 1/4 (83 x 66.7)
Gift of the artist and Pace/MacGill
Gallery 93.58

David Wojnarowicz (1954–1992)
Untitled, 1992
Gelatin silver print, with screen-
print text in red ink, 38 1/4 x 25 7/8
(97.2 x 65.7)
Purchase, with funds from The
Sondra and Charles Gilman, Jr.
Foundation, Inc., the Robert
Mapplethorpe Foundation, Inc.,
and the Richard and Dorothy
Rodgers Fund 92.74

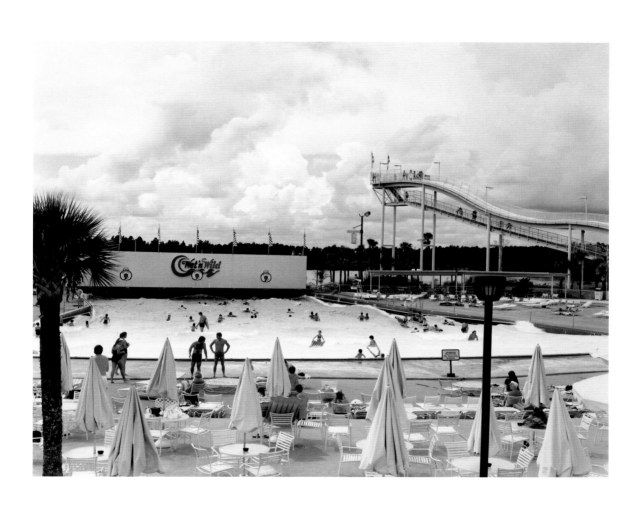

Index

Note: Page numbers in italic refer to photographs.

Photograph and Reproduction Credits

All photography by Matt Flynn unless noted.

Vito Acconci: Geoffrey Clements. Robert Adams: Courtesy Fraenkel Gallery, San Francisco, and Matthew Marks Gallery, New York. Merry Alpern: © Merry Alpern, courtesy Bonni Benrubi Gallery, New York. Janine Antoni: Sheldan C. Collins. Diane Arbus: © 1972 The Estate of Diane Arbus, LLC. Richard Avedon: © 1980 Richard Avedon. Matthew Barney: Sheldan C. Collins. Uta Barth: Sheldan C. Collins. Mel Bochner: Geoffrey Clements. Wynn Bullock: © 2002 Wynn Bullock, Bullock Family Photography LLC, all rights reserved; courtesy Archive Consulting and Management Services LLC, New York, and Laurence Miller Gallery, New York. Harry Callahan: © The Harry Callahan Estate, courtesy Pace/MacGill Gallery, New York. Peter Campus: Geoffrey Clements. Ellen Carey: Courtesy the artist and JHB Gallery, New York. William Christenberry: © William Christenberry, courtesy Pace/MacGill Gallery, New York. Larry Clark: Geoffrey Clements. Chuck Close: *Self-Portrait/ Composite/Nine Parts*, Geoffrey Clements; *Self-Portrait*, courtesy David Adamson Editions. Gregory Crewdson: Courtesy the artist and Luhring Augustine, New York. Robert Cumming: © Robert Cumming/ Licensed by VAGA, New York, NY. Jerry Dantzic: © 2002 Jerry Dantzic Archives. Bruce Davidson: © Bruce Davidson/ Magnum Photos, Inc. Philip-Lorca diCorcia: © Philip-Lorca diCorcia, courtesy Pace/ MacGill Gallery, New York. William Eggleston: © William Eggleston/A + C Anthology; Sheldan C. Collins. Louis Faurer: © Estate of Louis Faurer/Licensed by VAGA, New York, NY. Andreas Feininger: © Andreas Feininger, courtesy Bonni Benrubi Gallery, New York. Robert Frank: © Robert Frank, courtesy Pace/MacGill Gallery, New York. Lee Friedlander: Courtesy Fraenkel Gallery, San Francisco. Ralph Gibson: © Ralph Gibson, courtesy Howard Greenberg Gallery, New York. Jim Goldberg: © Jim Goldberg, courtesy Pace/MacGill Gallery, New York. Nan Goldin: © Nan Goldin; Sheldan C. Collins. Emmet Gowin: © Emmet Gowin, courtesy Pace/MacGill Gallery, New York; *Aeration Pond, Toxic Water Treatment Facility, Pine Bluff, Arkansas*, Geoffrey Clements. Sid Grossman: © Miriam Grossman Cohen, courtesy Howard Greenberg Gallery,

New York. Robert Heinecken: © Robert Heinecken, courtesy Pace/MacGill Gallery, New York. Roni Horn: Courtesy Matthew Marks Gallery, New York. Peter Hujar: © The Estate of Peter Hujar, courtesy Matthew Marks Gallery, New York; *David Wojnarowicz*, Geoffrey Clements. Kenneth Josephson: © Kenneth Josephson and Rhona Hoffman Gallery, Chicago. William Klein: © William Klein, courtesy Howard Greenberg Gallery, New York. Barbara Kruger: Sheldan C. Collins. Louise Lawler: Sheldan C. Collins. Sherie Levine: Courtesy Paula Cooper Gallery, New York; © Walker Evans Archive, The Metropolitan Museum of Art; Geoffrey Clements. Leon Levinstein: © Stuart Karu, courtesy Howard Greenberg Gallery, New York. David Levinthal: Geoffrey Clements. Sol LeWitt: © 2002 Sol LeWitt/Artists Rights Society (ARS), New York; Geoffrey Clements. Danny Lyon: Courtesy Edwynn Houk Gallery, New York, and Bleak Beauty Books. Sally Mann: © Sally Mann, courtesy Edwynn Houk Gallery, New York. Robert Mapplethorpe: © The Estate of Robert Mapplethorpe, used by permission. Mary Ellen Mark: © Mary Ellen Mark. Gordon Matta-Clark: © Estate of Gordon Matta-Clark/Artists Rights Society (ARS), New York; Geoffrey Clements. Ralph Eugene Meatyard: © The Estate of Ralph Eugene Meatyard, courtesy Fraenkel Gallery, San Francisco. Susan Meiselas: © Susan Meiselas/Magnum Photos, Inc. Ana Mendieta: Geoffrey Clements. Duane Michals: © Duane Michals, courtesy Pace/MacGill Gallery, New York. Richard Misrach: Geoffrey Clements. Andrea Modica: Geoffrey Clements. Abelardo Morell: © Abelardo Morell, courtesy Bonni Benrubi Gallery, New York. Mark Morrisroe: Courtesy American Fine Arts Co. at PHAG, Inc. Vik Muniz: © Vik Muniz/ Licensed by VAGA, New York, NY; art © 2002 The Estate of Tony Smith/Artists Rights Society (ARS), New York; photograph by Jerry L. Thompson. Billy Name: Billy Name/OvoWorks. Catherine Opie: Courtesy Regen Projects, Los Angeles; Geoffrey Clements. Kristin Oppenheim: John Berens. Gabriel Orozco: Courtesy the artist and Marian Goodman Gallery, New York. Robert ParkeHarrison: © Robert ParkeHarrison, courtesy Bonni Benrubi Gallery, New York. Gordon Parks: Geoffrey Clements. Irving Penn: © 1999 Irving Penn. Robert Rauschenberg: © Robert Rauschenberg/Licensed by VAGA, New York, NY. Charles Ray: Courtesy Regen Projects, Los Angeles; Geoffrey Clements. Clifford Ross: © Clifford Ross, courtesy

Sonnabend Gallery, New York; Sheldan C. Collins. Michal Rovner: Sheldan C. Collins. Lucas Samaras: © Lucas Samaras. Andres Serrano: Courtesy Paula Cooper Gallery, New York. Cindy Sherman: *Untitled #146*, Geoffrey Clements. Stephen Shore: Geoffrey Clements. Laurie Simmons: Geoffrey Clements. Lorna Simpson: Geoffrey Clements. Aaron Siskind: Geoffrey Clements. Kiki Smith: © Kiki Smith. Frederick Sommer: © The Estate of Frederick Sommer, courtesy Pace/MacGill Gallery, New York; Geoffrey Clements. Doug and Mike Starn: © 2002 Mike & Doug Starn/Artists Rights Society (ARS), New York; Sheldan C. Collins. Joel Sternfeld: © Joel Sternfeld, courtesy Pace/MacGill Gallery, New York. Louis Stettner: © 2002 Artists Rights Society (ARS), New York/ADAGP, Paris. Chris Verene: Sheldan C. Collins. Catherine Wagner: © Catherine Wagner, CCA, Disney. Andy Warhol: © 2002 Andy Warhol Foundation for the Visual Arts/Artists Rights Society (ARS), New York; Sheldan C. Collins. Weegee: © Weegee/International Center of Photography/Getty Images. Minor White: Reproduction courtesy The Minor White Archive, Princeton University; © 1989 by The Trustees of Princeton University, all rights reserved; Sheldan C. Collins. Garry Winogrand: © The Estate of Garry Winogrand, courtesy Fraenkel Gallery, San Francisco; Geoffrey Clements. Joel-Peter Witkin: Courtesy Fraenkel Gallery, San Francisco. David Wojnarowicz: Geoffrey Clements

Introduction by Sylvia Wolf:
Fig. 1: © Berenice Abbott/Commerce Graphics Ltd., Inc.; Geoffrey Clements. Fig. 2: Reprinted with permission of Joanna T. Steichen; Geoffrey Clements. Fig. 3: Geoffrey Clements. Fig. 4: Geoffrey Clements. Fig. 5: Geoffrey Clements. Fig. 6: © Estate of Ilse Bing, courtesy Edwynn Houk Gallery, New York. Fig. 7: Geoffrey Clements

Essay by Andy Grundberg:
Fig. 1: © Robert Heinecken, courtesy Pace/MacGill Gallery, New York. Figs. 2, 3: © 1967, 1969 Edward Ruscha; published by The Cunningham Press, Alhambra, California. Fig. 4: © Joseph Kosuth/Artists Rights Society (ARS), New York; courtesy the artist and Sean Kelly Gallery, New York. Fig. 5: © 2002 Bruce Nauman/Artists Rights Society (ARS), New York; Geoffrey Clements